DIGITAL
PHOTOGRAPHY
AN INTRODUCTION

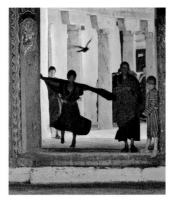

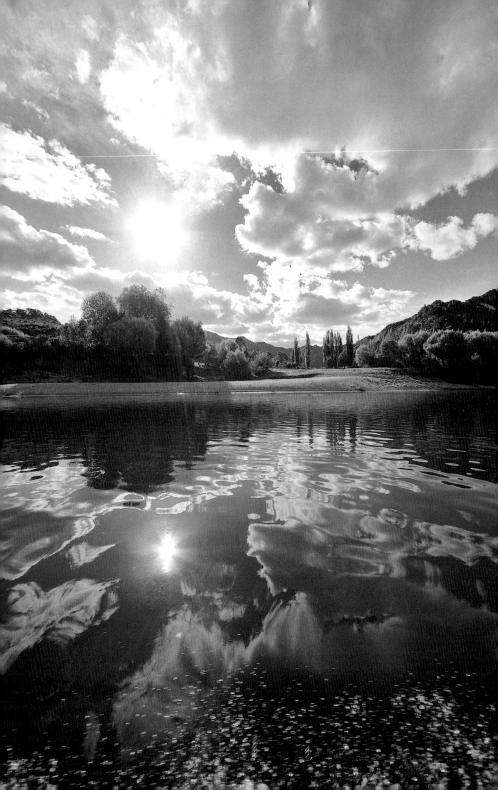

DIGITAL
PHOTOGRAPHY
AN INTRODUCTION

PREVIOUSLY PUBLISHED AS DIGITAL PHOTOGRAPHER'S HANDBOOK

TOM ANG

LONDON, NEW YORK, MUNICH,
MELBOURNE, AND DELHI **DK**

Contents

To Wendy

Project Editor Nicky Munro
US Editor Charles Wills
Senior Art Editor Gillian Andrews
Senior Production Editor Luca Frassinetti
Production Controller Sarah Hewitt

Managing Editor Stephanie Farrow
Managing Art Editor Lee Griffiths

Original edition produced on
behalf of Dorling Kindersley by
HILTON/SADLER
63 Greenham Road, London N10 1LN
Editorial Director Jonathan Hilton
Design Director Peggy Sadler

First American edition 2002
Second American edition 2007
Published in the United States by
DK Publishing, 375 Hudson Street,
New York, New York 10014

This revised edition published in the
United States in 2010 by DK Publishing.

10 11 12 13 14 10 9 8 7 6 5 4 3 2 1
176520—January 2010

Published in Great Britain by
Dorling Kindersley Limited.

A catalog record for this book is
available from the Library of Congress.

ISBN: 978-0-7566-5837-3

DK books are available at special discounts when
purchased in bulk for sales promotions, premiums,
fund-raising, or educational use. For details, contact:
DK Publishing Special Markets, 375 Hudson Street,
New York, New York 10014 or SpecialSales@dk.com.

Printed in Singapore by Star Standard

Find out more at
www.dk.com

Chapter 1
Fundamentals

Chapter 2
A compendium of ideas

Introduction

Some 160 years after the invention of photography, an enemy rose above the horizon. Digital imaging threatened to sweep away film, make the darkroom redundant, and to exile the hard-won craft skills of picture-making. In a short time the threat grew as numerous new enemies appeared, in the shape of more and more digital cameras, scanners, image-manipulation software, and the web, all banding together to raze conventional photography to the ground.

Photographers watched with steadily increasing apprehension, but the threat turned out to be the best friend photography could have hoped for. Instead of opposing conventional photography, digital technologies have in fact revitalized whole swathes of photographic practice. Traditional techniques— in use of both the camera and lens, as well as darkroom manipulations— retained their relevance as the foundation upon which many digital advances were based; this is reflected in references to film-based techniques scattered through the book. Indeed, the union of conventional photography with digital technology has turned out to be incredibly fertile, providing us with new worlds of practical, creative, and enjoyable potentialities.

Digital Photography: An Introduction celebrates the maturing of digital photography into one of the greatest and most widely available creative forces at work this century. So here you will find all the love and enthusiasm I have for conventional photography and its subtle craft skills for creating telling, effective, and rewarding images. At the same time, I hope to share with you my thrill and wonder at the flexibility, power, and economies that are possible with digital photography. By learning how to bring out the power of digital

photography, you will find—if you are already a keen photographer—that your enthusiasm and energy for photography will be increased tenfold; and if you are not experienced, you will find that photography has the power to reveal to you the richness and variety of the world that are second to none.

This book brings together a wide range of technical information and practical advice and reveals numerous tips and tricks of the trade. It combines a complete account of professional picture-making skills with a thorough grounding in image-manipulation techniques. And it is all offered in order to help you improve, enjoy, and understand the medium of communication that is photography.

Digital Photography: An Introduction has proven to be a handy companion to photography for thousands of people. Now in its third edition, it contains much brand-new information to ensure it is fully up to date. I hope it will help you on your own journey of visual, technical, and creative adventures, leading to personal discovery. Ultimately, I hope this book will give you the knowledge and inspiration to surpass its teachings.

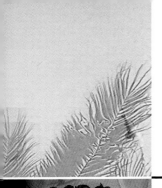

Fundamentals

Digital pathways

The pathways through photography start with the digital capture of an image. Primarily you will capture, or "take," an image using your digital camera. But you may also obtain images downloaded from a website or sent wirelessly by cell phone. Images may be transferred from a video camera or copied from storage media such as a CD, DVD, or flash memory (*see pp. 210-11*).

Being digital, your image is similar to any word-processor document, spreadsheet, or other computer file. You can store it on your computer hard-disc, as well as on any removable medium;

you can exchange the file between networked computers—wirelessly or through cables; and you can send it around the world via the internet. Like any computer file, however, it must be in a form that will be recognized by your chosen software before you can use it for image manipulation, combine it with text or other images, or print it out.

The digital journey

The image in digital form is versatile and flexible in the extreme. The degree of control

Digital cameras
Just like stills cameras, many video cameras and cell phones can capture images that you can use or share immediately.

Internet
Millions of images can be downloaded from the web. You may not even have to pay for them if they are not for business use.

Subject

Removable media
You may be able to source images from CDs or DVDs given away with magazines or donated by family and friends.

Computer
Digital image files and image-manipulation and management software meet in the computer. There you can perfect your images for their final use, combine images, and sort them for future use. From the computer you can also share them via networks or send them anywhere in the world.

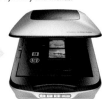

Scanner
Using a scanner, you can turn any of your existing photographs—whether prints or negatives—into digital image files with ease.

you can exercise over the appearance of the image, even using simple software, can also be extraordinarily refined.

One important feature that distinguishes image files from those produced by other computer applications is that most are in standard formats (*see pp. 92–3*) recognized by a very wide range of software. This include page- and graphic-design programs, web and presentation authoring, and even spreadsheets and databases. From this fact alone arises much of the versatility of the digital image. However,

raw (or RAW) formats produced by cameras may be specific to a manufacturer and recognized only by specialized raw-conversion software.

Sharing via the web

The more you discover about digital-image processes, the more their ease and convenience shine through. Beyond the simplicity with which we can now take and manipulate our pictures, there is also the ease of sharing them: modern software can fully automate the publication of your images as galleries on the web (*see pp. 196–9*).

Publish on . . .

The web

This is the main route for exhibiting your photographs. Not only will your work be available to as many people who visit your website, picture-sharing service, or hosted webpage, your work is on show 24 hours a day, every day. And you can edit what is shown at a moment's notice.

Output with . . .

Color printer

Desktop printers can now produce prints of the highest quality, yet prices are well within the reach of any computer owner. Even the early doubts about the longevity of the printed image are now banished.

Store on . . .

Recordable media

The ubiquitous CD and DVD are widely readable by modern desktop and laptop computers. Flash memory, such as USB drives, are good value for temporary storage. Portable hard-disc drives with large capacities are economical, too.

Picture composition

Much advice on picture composition tends to be both prescriptive ("place the subject at the intersection of thirds") and proscriptive ("don't put the subject in the center"), as if the adherence to a few rules can guarantee satisfactory composition. It may be better to think of any rules simply as a distillation of ideas about the structure of images that artists have, over many generations of experimentation, trial, and success, found useful in making pleasing pictures.

Any photographic composition can be said to work if the arrangement of the subject elements communicates effectively to the image's intended viewers. Often, the most effective way to ensure a striking composition is to look for the key ingredients of a scene and then organize your camera position and exposure controls to draw those elements out from the clutter of visual information that, if left cluttered, will ruin the photograph. Composition is therefore not only about how you frame the picture, but how you use aperture to control depth of field, how you focus to lead the viewer's attention, and how you expose to use light and shade to shape the image.

If you are new to photography, it may help to concentrate your attention on the scene's general structure, rather than thinking too hard about very specific details—these are sometimes of only superficial importance to the overall composition. Try squinting or half-closing your eyes when evaluating a scene; this helps eliminate details to reveal the scene's core structure.

Symmetry

Symmetrical compositions are said to signify solidity, stability, and strength; they are also effective for organizing images containing elaborate detail. Yet another strategy offered by a symmetrical presentation of subject elements is simplicity. In this portrait of a Turkana man, there was no other way to record the scene that would have worked as well. The figure was placed centrally because nothing in the image justified any other placement; likewise with the nearly central horizon. The subject's walking stick provides the essential counterpoint that prevents the image from appearing too contrived.

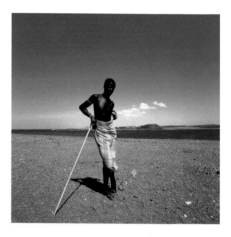

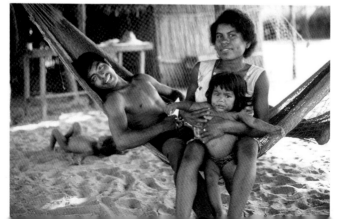

Radial

Radial compositions are those in which key elements spread out from the middle of the frame. This imparts a lively feeling, even if subjects are static. In this family portrait, taken in Mexico, the radial composition is consistent with the tension caused by the presence of a stranger (the photographer). The image suggests a modest wide-angle lens was used, but it was taken with a standard focal length.

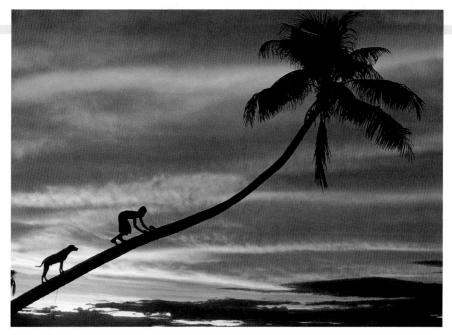

Diagonal

Diagonal lines lead the eye from one part of an image to another and impart far more energy than horizontals. In this example, it is not only the curve of the palm's trunk, but also the movement of the boy and his dog along it that encourage the viewer to scan the entire picture, sweeping naturally from the strongly backlit bottom left-hand corner to the top right of the frame.

Overlapping

When subject elements in a photograph overlap, not only does it indicate increasing depth perspective, but it also invites the viewer to observe subject contrasts. In the first instance, distance is indicated simply because one object can overlap another only if it is in front of it. In the second, the overlap forces two or more items, known to be separated by distance, to be perceived together, with the effect of making apparent any contrasts in shape, tone, or color. These dynamics are exploited in this low table view, aided by areas of bright and contrasting colors that fight for dominance.

The golden spiral, or "Rule of Thirds"

This image, overlaid with a golden spiral—a spiral based on the golden ratio—as well as with a grid dividing the picture area into thirds, shows that, as photographers, we almost instinctively compose to fit these harmonious proportions—the proportions that "look good."

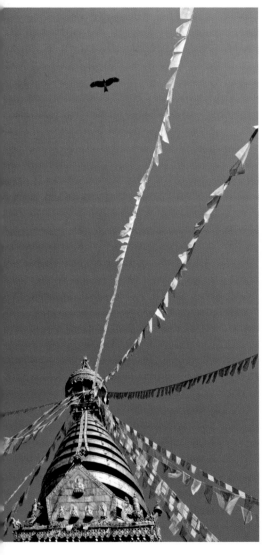

Tall crop

The opposite of a letterbox composition (*right*) is a tall and narrow crop, which emphasizes an upward-sweeping panorama—a view that can be taken in only by lifting the head and looking up. As with all crops based on a high aspect ratio, it usefully removes a lot of unwanted detail around the edges.

Letterbox composition

A wide and narrow letterbox framing perfectly suits some subjects, such as these prayer flags in Bhutan. Such a crop concentrates the attention on the sweep of colors and detail, cutting out unwanted— and visually irrelevant— material at the top and bottom of the image.

Picture composition continued

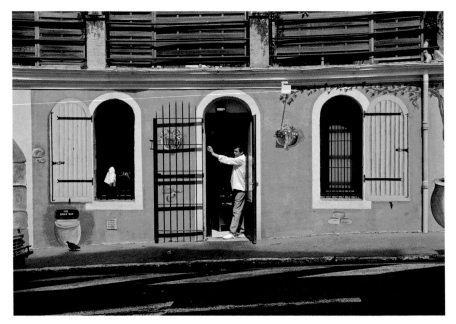

Framing

The frame within a frame is a painterly device often exploited in photography. Not only does it concentrate the viewer's attention on the subject, but it often also hints at the wider context of the subject's setting. The colors of the frame may also give clues about where the photograph is set. In this image,

taken in Cannes, France, multiple frames divide the image up into compartments, which circle around the figure of a bistro chef taking a break from his duties. Without the figure, the image would be too symmetrical and dull; but without the rhythmic framing, the figure would be rather static.

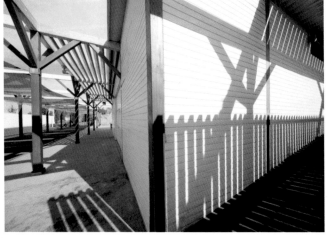

Geometric patterns

Geometric shapes, such as triangles and rectangles, lend themselves to photographic composition because of the way they interact with the rectangle of the picture frame. Here, in this corner of the great Ciudad de las Artes y las Ciencias in Valencia, Spain, shapes from narrow rectangles and acute triangles are all at work. In some parts they work harmoniously (the gaps between the slats); in others (the thin wedges created by diagonally crossing intersections), they create tension in the composition.

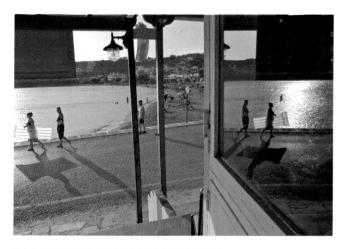

Symmetry

The glass of this window in Batsi, Andros, Greece, acts like a mirror to the beach scene, automatically giving a sense of symmetry to the image, but it is a partial symmetry. The subtle and not-so-subtle differences between the reality and the reflection give energy and tension to the image, as well as providing visual puzzles such as being able to see more of the sun in the reflection, but without the sky.

TRY THIS

Look for patterns whenever you have a camera handy. When you find an interesting example, take several shots, shifting your position slightly for each. Examine the pictures carefully and you may find that the shot you thought most promising does not produce the best result. Often, this is because our response to a scene is an entire experience, while photographs have to work within the proportions of the format.

Rhythmic elements

These regular columns of a courtyard in Sarzana, Italy, organize the haphazard groups of people, and together they create repeated lines and rectangles to form irregular bands of light and dark. These in turn form the rhythmic framework for the distant mountains that contrast with the diagonals of sunlight finding its way between the clusters of people.

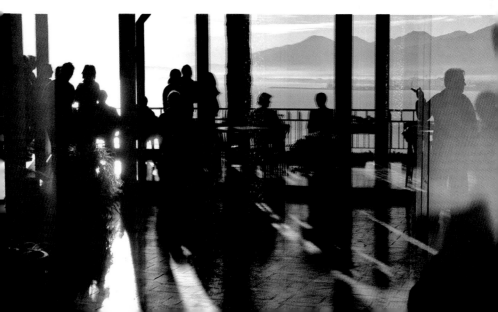

Focusing and depth of field

Depth of field is the space in front of and behind the plane of best focus, within which objects appear acceptably sharp (*see opposite*). Though accurate, this definition tells you nothing about the power that depth of field has in helping you communicate your visual ideas. You can, for example, use it to imply space, to suggest being inside the action, or to emphasize the separation between elements within the picture area.

Varying depth of field

Your chief control over depth of field is the lens aperture: as you set smaller apertures (using f/11 instead of f/8, for example), depth of field increases. This increase is greater the shorter the lens's focal length, so that the depth of field at f/11 on a 28 mm lens is greater than it would be at f/11 on a 300 mm lens. Depth of field also increases as the subject being focused on moves farther away from the camera. The corollary of this is that at close focusing distances, depth of field is very limited.

Using depth of field

An extensive depth of field (resulting from using a small lens aperture, a wide-angle lens, distant focusing, or a combination of these factors) is often used for the following types of subject:

- Landscapes, such as wide-angle, general views.
- Architecture, in which the foregrounds to buildings are important features.
- Interiors, including nearby furniture or other objects, and far windows and similar features.

As a by-product, smaller apertures tend to reduce lens flare and improve lens performance.

A shallow depth of field (resulting from a wide lens aperture, a long focal length lens, focusing close-up, or a combination of these) renders only a small portion of the image sharp, and is often used for:

- Portraiture, to help concentrate viewer attention.
- Reducing the distraction from elements that cannot be removed from the lens's field of view.
- Isolating a subject from the distracting visual clutter of its surroundings.

Lens focusing

Spreading light reflected from or emitted by every point of a subject radiates out, and those rays captured by the camera lens are projected onto the focal plane to produce an upside-down image. The subject appears sharp, however, only if these rays of light intersect precisely on the film plane (achieved by adjusting the lens's focus control). If not, the rays are recorded not as points, but rather as dots. If the image is reproduced small enough, then even dots may appear sharp, but as a subject's image diverges further from the film plane, so the dots recorded by the camera become larger and larger, until, at a certain point, the image appears out of focus—the dots have become large enough to be seen as blur.

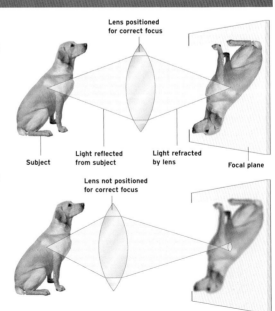

Lens positioned for correct focus

Subject

Light reflected from subject

Light refracted by lens

Focal plane

Lens not positioned for correct focus

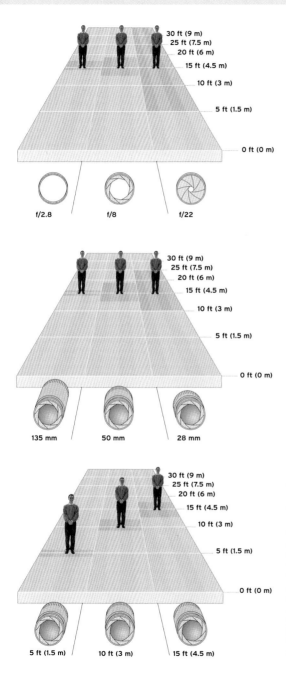

Effects of lens aperture

The main reason for changing lens aperture is to adjust camera exposure: a smaller aperture restricts the beam of light passing through the lens. However, the aperture also alters depth of field. As you set smaller apertures, the cone of light passing through the lens becomes slimmer and more needlelike. As a result, even when it is not perfectly focused, light from the subject is not as spread out as it would be if a larger aperture were used. Thus, more of the scene within the field of view appears sharp. In this illustration, lens focal length and focus distance remain the same, and depth of field at f/2.8 covers just the depth of a person, whereas at f/8 it increases to 6 ft (2 m) in extent. At f/22, depth of field extends from 5 ft (1.5 m) to infinity.

Effects of lens focal length

Variations in depth of field resulting from focal length alone are due to image magnification. With our figure at a constant distance from the camera, a long focal length (135 mm) will record him at a larger size than does a standard lens (50 mm), which, in turn, creates a larger image than the wide-angle (28 mm). To the eye, the figure is the same size, but on the sensor or film, the figure's size varies directly with focal length. Where details are rendered smaller in the image, it is more difficult to make out what is sharp and what is not. As a result, depth of field appears to increase. Conversely, longer focal length lenses magnify the image, so magnifying differences in focus. Thus, depth of field appears to be greatly reduced.

Effects of focus distance

Two effects contribute to the great reduction in depth of field as you focus closer and closer to the camera, even when there is no change in lens focal length or aperture. The main effect is due to the increased magnification of the image: as it looms larger in the viewfinder, small differences in the depth of the subject call for the lens to be focused at varying distances from the sensor or film. Notice that you must turn a lens more when it is focused on close-up subjects than when it is focused on distant ones. Another slight but important reason for the change in depth of field is that effective focal length increases slightly when the lens is set farther from the focal plane—in other words, when it is focused on subjects close-up.

Focusing and depth of field continued

Autofocusing

Two main methods of autofocus are used. In compact cameras, a beam of infrared (IR) light scans the scene when the shutter button is first pressed. The nearest and strongest IR reflections are read by a sensor, which calculates the subject distance and sets it on the camera a fraction of a second before the picture is taken.

The other main method is "passive." Part of the light from the subject is sampled and split up, but only when the lens is in focus do the parts of the image coincide (or are said to be "in phase"). The

crucial property of this system is that the phase differences vary, depending on whether the lens is focused in front of or behind the plane of best focus. Autofocus sensors analyze the pattern and can tell the lens in which direction to move in order to achieve best focus.

Though sophisticated, autofocus systems can be fooled. Beware of the following circumstances:
● The key autofocus sensor is in the center of the viewfinder image, so any off-center subjects may not be correctly focused. Aim the focusing area at your subject, "hold" the focus with a light pressure on the shutter-release button, and then return the viewfinder to the original view.
● When photographing through glass, reflections from the glass may confuse the IR sensor.
● Extremely bright objects in the focusing region—sparkling reflections on polished metal, say—could overload the sensor and mar accuracy.
● Photographing beyond objects that are close to the lens—say, through a bush or between the gaps in a fence—can confuse the autofocus system.
● Moving close-up subjects may be best kept in focus by setting a distance manually and then adjusting your position backward and forward in order to maintain focus.

Mimicking depth
While a narrow field of view usually yields a shallow depth of field, you can simulate a more generous zone of sharp focus linked with a narrow field of view by cropping a wide-angle image. Here, a 28-mm view has been cropped to that of a 200-mm lens, and the scene appears sharp from foreground to background.

Selective focus
A telephoto shot taken with the lens aperture wide open throws the girl in the foreground out of focus. One unwelcome consequence is that color from the background merges with the foreground, making color correction a tricky matter. It proved difficult to make a satisfactory duplicate of the original transparency, and the resulting scan also required a good deal of corrective work.

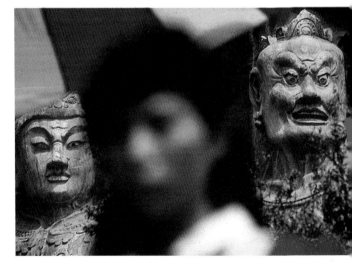

● With very fast-moving subjects, it may be better to focus on a set distance and then wait for the subject to reach that point before shooting.

Hyperfocal distance

The hyperfocal distance is the focus setting that provides maximum depth of field for any given aperture. It is the distance to the nearest point that is sharp when the lens is set at infinity and it is the nearest distance at which an object can be focused on while infinity appears sharp. The larger the aperture, the farther away this point is. With autofocus-only cameras, you cannot set the hyperfocal distance; however, with manual-focus cameras, you can set hyperfocal distance and then not worry about the clarity of any subject falling within the range of sharp focus.

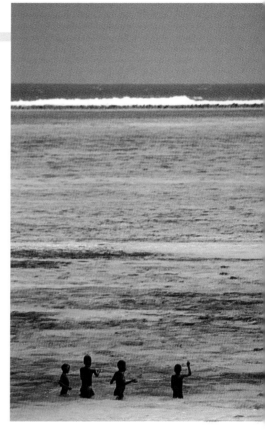

Off-center subjects
When the subjects are off-center, as here, you must not allow your camera to focus on the middle of the frame. To take this image, I simply focused on the boys, locked the setting, and recomposed the shot. Even in bright conditions and focusing at a great distance—330 ft (100 m)—depth of field is limited because of the very long focal length of the lens.

Right aperture
Medium-to-close-up pictures taken with a long lens will have a shallow depth of field unless a small aperture is set. In this shot, the charm of the scene would have been lost had unsharp subject elements dominated. The smallest aperture on this lens was set to give maximum sharpness, but the long shutter time then needed to compensate meant that a tripod was necessary to prevent camera shake.

Perceived depth of field

Acceptable sharpness varies according to how much blur a viewer is prepared accept. This, in turn, depends on how much detail a viewer can discern in the image, which, in turn, depends on the final size of the image (as seen on a screen or as a paper print). As a small print, an image may display great depth of field; however, as the image is progressively enlarged, it then becomes more and more obvious where the unsharpness begins, thereby making the depth of field appear increasingly more limited.

Composition and zooms

Zoom lenses let you change the magnification of an image without switching lenses. Zooms are designed to change the field of view of the lens while keeping the image in focus. When the field of view is widened (to take in more of the subject), the image must be reduced in order to fill the sensor or film area. This is the effect of using a short focal length lens or a wide-angle setting on a zoom. Conversely, when the field of view is narrowed (to take in less of the subject), the image must be magnified, again in order to fill the sensor or film area. This is the effect of using a long focal length lens or a zoom's telephoto setting.

Working with zooms

The best way to use a zoom is to set it to the focal length you feel will produce the approximate effect you are aiming for. This method of working encourages you to think about the scene before ever raising the camera to your eye to compose the shot. It also makes you think ahead of the picture-taking process, rather than zooming in and out of a scene searching for any setting that seems to work. This is not only rather aimless, it is also time-consuming and can lead to missed photographic opportunities.

A professional approach

Many professional photographers use zooms almost as if they were fixed focal length, or prime, lenses, leaving them set to a favorite focal length most of the time. They then use the zoom control only to make fine adjustments to the framing. Zooms really are at their best when used like this—cutting out or taking in a little more of a scene. With a prime lens, you have to move the camera backward or forward to achieve the same effect. Depending on the type of subject you are trying to record, you could leave the zoom toward the wide-angle or telephoto end of its range. On some digital cameras, however, zooms are stepped rather than continuously variable, so they cannot be used for making small adjustments.

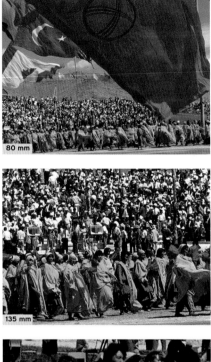

80 mm

135 mm

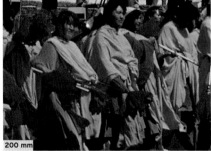

200 mm

Zooms for framing
Zoom lenses come into their own when you find it difficult or time-consuming to change your camera position, since they allow you to introduce variety into what would otherwise be similarly framed images. In this large outdoor performance, one shot was taken at 80 mm (*top*), one at 135 mm (*middle*), and the other at 200 mm (*above*), all from approximately the same camera position.

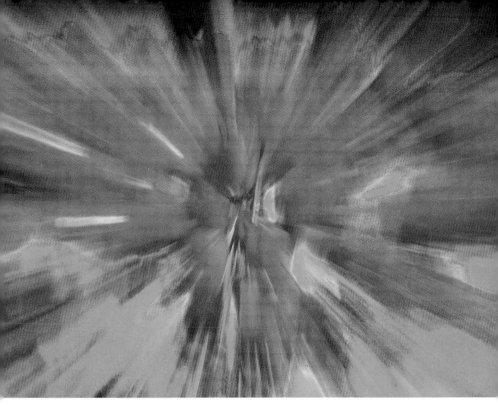

Zoom movement

Color and movement literally seem to explode out from this photograph of a simple tulip—an effect achieved by reducing the zoom lens's focal length during a long, manually timed exposure. And in order to emphasize the flower's blurred outlines, the image was also slightly defocused before the exposure was made.

Zooms for composition

Zooming from 80 mm (*above left*) to 200 mm (*above right*) produced an intriguing abstract image by allowing patterns of light and dark, color and non-color, to reveal themselves. But as the focal length increases, depth of field also diminishes (*pp. 18–21*), so select the lens apertures with care.

Extreme focal lengths

Some lenses have special capabilities—such as the ability to take ultra-wide-angle views or focus at very close subject distances—and these call for extra care when in use. And since they are often costly to buy, you need to know how to get the very best from them.

Ultra-wide-angles

Wide-angle lenses with a 35efl (equivalent focal length) of down to around 28 mm are easy to use, but when focal lengths become shorter than about 24 mm, successful results are less certain.

● To ensure that the image is evenly lit (all wide-angle lenses project significantly more light onto the center of the image than the edges), avoid using the widest apertures available.

● To keep accessories such as filters from intruding into the lens's field of view, never use more than one filter at a time; also make sure lens-hoods are designed for the focal length of the lens.

● With their extensive fields of view, ultra-wide-angles can catch a bright source of light, such as the sun, within the picture area. These highlights can cause flare or strong reflections within the lens barrel. Using smaller apertures help control this.

● Avoid having very recognizable shapes—a face, say, or a glass—near the edges of the frame. It will

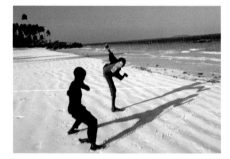

Problem horizons
In the hurry to record this scene on a beach on Zanzibar, the slight tilt of the camera, which went unnoticed while using the 17-mm setting on the lens, has produced an uncomfortable-looking horizon. Though far from a disaster, the picture would have benefited from a moment's extra thought before shooting.

appear obviously distorted if a small-sized image is then produced (*see below*).

● Line up wide-angle lenses very carefully with the horizon or some other prominent feature, since the broad sweep of view will exaggerate the slightest error in picture alignment.

● Avoid pointing the lens up or down unless you want to produce a distorted effect.

Wide-angle "distortion"
An ultra-wide-angle lens encompassed both the market vendor and her produce, but not only does she appear very distorted by being projected to the corner of the frame, so do the tomatoes in the bottom right-hand corner. If, however, you were to make a large print of this image and view it from close up, the apparent distortion would disappear.

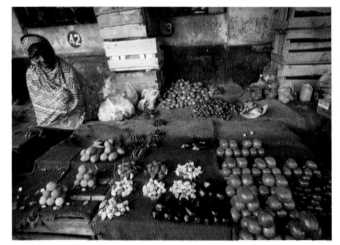

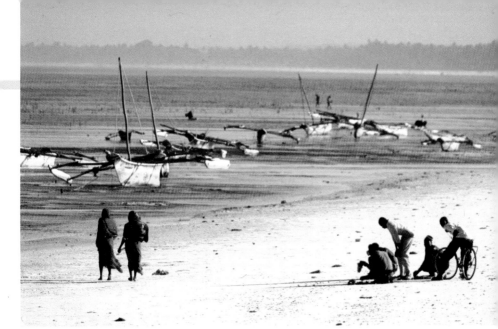

Long telephoto
In this version of the scene shown on the right, the zoom lens was set to 400 mm and a 1.4x extender was also used, giving an effective focal length setting of 560 mm.

● Avoid using the minimum aperture: you rarely need the depth of field produced, and image quality is likely to be degraded. However, selecting a small aperture may improve image quality when focusing on very close subjects.

Wide-ranging zooms

Zooms that offer a wide range of focal-length settings, such as 35efl of 28–300 mm or 50–350 mm, are attractive in theory but, in practice, may require special handling.

● Zooms with a wide range of focal lengths are far bulkier than their single-focal-length counterparts. A 28-mm lens used on the street is inconspicuous; a 28–300 mm zoom set at 28 mm is definitely not.

● The wide-angle setting is likely to show considerable light fall-off, with the corners of the image recorded darker than the middle, so avoid images that demand even lighting to be effective.

● Image distortion is always the price you pay for a wide range of focal lengths, so avoid photographing buildings and items with clearly defined sides and straight lines. There will be a

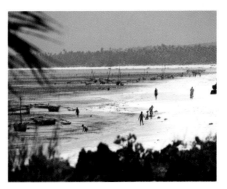

Short telephoto
This view shows a beach scene on Zanzibar as imaged by a moderate 100 mm telephoto setting. At this magnification, the lens shows the general scene but not any of the activity or recognizable subject details (*compare this with the top image*).

setting, usually around the middle of the range, where distortion is minimized; but even here, straight lines may appear very slightly wavy.

● As you set longer and longer focal lengths on a zoom lens, the maximum available aperture becomes smaller and smaller. This can reduce the scope you have for setting short shutter times, and the need for brighter shooting conditions increases as lens apertures become smaller.

Close-ups

In the past, true close-up photography required specialty equipment and fiddly accessories. However, this situation has entirely changed thanks to the introduction of digital cameras. These cameras work at close-up subject distances as if they were designed for the job.

Digital's ability to handle close-ups is due to two related factors. First, because the sensor chips are small, lenses for digital cameras need only to have short focal lengths. Second, short-focal-length lenses require little focusing movement in order to bring near subjects into focus. Another factor, applicable to digital cameras with zoom lenses, is that it is relatively easy to design lenses capable of close focusing by moving the internal groups of lens elements.

In addition to lens design, there is another feature common to digital cameras that also helps: the LCD screen. This provides you with a reliable way of framing close-ups with a high degree of accuracy, all without the complex viewing system that allows traditional SLRs to perform so well.

There will be occasions when you need to keep a good distance between yourself and the subject—a nervous dragonfly, perhaps, or a beehive. In such cases, first set the longest focal length on your zoom lens before focusing close up. In these situations, an SLR-type digital camera (one that accepts interchangeable lenses) is ideal, due to the inherent magnification given by the small sensor chip working in conjunction with lenses designed for normal film formats.

Simple subjects
Learning just what to include and what to leave out of a picture is a useful skill to master—not only is the image itself usually stronger for being simpler in visual content, as in the example shown here, but it is also often easier to use it for a range of purposes, such as compositing (*pp. 166–73*). Subject movement is always a problem with close-ups, especially plants outdoors, where they can be affected by even the slightest breeze. If you cannot effectively shield the plant from air currents, then set the shortest shutter time possible, consistent with accurate exposure, to freeze any subject movement.

Avoiding highlights
One of the secrets underlying good close-up photography is avoiding unwanted highlights intruding on the image. These usually appear as insignificant out-of-focus bright spots when you frame the shot, but in the final image they can appear far more prominent and be very distracting. To take this shot, I moved slowly around the subject, watching the LCD screen continually, and released the shutter only when the brightest area was positioned just as I wanted.

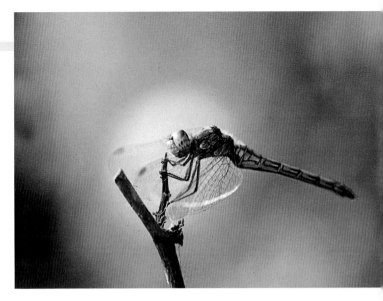

Long close-up
A long-focal-length lens with close-focusing ability allows you to get close to small, nervous subjects, such as this dragonfly, and so obtain a useful image size. In addition, the extremely shallow depth of field with such a lens throws even nearby image elements well out of focus. The central bright spot is in fact a flower.

Safe distance
It was dangerous to get too near this constrictor, so a close-focusing long lens was the best way to obtain good magnification in this case.

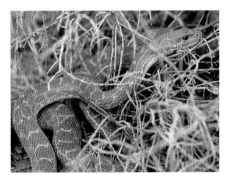

Normal close-up
With static or slow-moving subjects, a normal focal length lens used at its macro setting will suffice.

Digital depth of field

On one hand, the closer you approach your subject, the more rapidly depth of field diminishes, at any given lens aperture (see pp. 18–21). On the other, depth of field increases rapidly as focal length decreases. So the question is whether the increase in depth of field with the short focal lengths typical of digital cameras helps make close-up photography easier than with film-based equipment. The calculations are not straightforward, partly because in order for the shorter-focal-length lens to produce a given magnification, it must approach closer to the subject than a longer lens, which works

against the increase in depth of field. Another confusing factor is that digital cameras, with their regular array of relatively large pixels, cannot be treated in the same way as film-based cameras, whose images are based on a random collection of tiny grains of light-sensitive silver. With many digital cameras, you do not have the option of setting apertures at all, and, even when you do, the minimum aperture may be relatively large—say, f/8. Nonetheless, taking all these factors into account, depth of field often appears greater with digital photographic equipment than with film cameras.

Staying focused
Subjects viewed in close-up reveal their
graphic forms, but you then have a very
narrow depth of field. When stopping
down to increase this, make sure neither
camera nor plant moves during the shot.

Influencing perspective

You can exercise control over the perspective of a photograph by changing your camera position. This is because perspective is the view that you have of the subject from wherever it is you decide to shoot. Perspective, however, is not affected by any changes in lens focal length—it may appear to be so, but in fact, all focal length does is determine how much of the view you record.

Professional photographers know perspective has a powerful effect on an image, yet it is one of the easiest things to control. This is why when you watch professionals at work, you often see them constantly moving around the subject—sometimes bending down to the ground or climbing onto the nearest perch; approaching very close and moving farther away again. Taking a lead from this, your work could be transformed if you simply become more mobile, observing the world through the camera from a series of changing positions rather than a single, static viewpoint.

Bear in mind that with some subjects—still-lifes, for example, and interiors or portraits—the tiny change in perspective between observing the subject with your own eyes and seeing it through the camera lens, which is just a little lower than your eyes, can make a difference to the composition. This difference in perspective is far more pronounced if you are using a studio camera or waist-level finder on a medium-format camera.

Using zooms effectively

One way to approach changes in perspective is to appreciate the effect that lens focal length has on your photography. A short focal length gives a

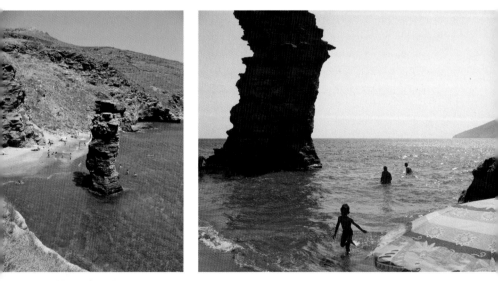

Alternative views
This wide-angle view (*above left*), shows an unremarkable snapshot of a vacation beach, in Andros, Greece. It is a simple image of the place, but it lacks an engaging interpretation or inventive viewpoint of the scene. Once on the beach, the temptation is to take in a wide shot that summarizes the whole scene. Instead, a low viewpoint that takes in the corner of a parasol gives a more intimate and involving feel: by using the parasol to balance the large rock, the picture is almost complete. Waiting for the right moment—a child runing into the foreground—brings the whole perspective to life.

perspective that allows you to approach a subject closely yet record much of the background. If you step back a little, you can take in much more of the scene, but then the generous depth of field of a wide-angle tends to make links between separate subject elements, since there is little, if any, difference in sharpness between them.

A long lens allows a more distant perspective. You can look closely at a face without being nearby. Long lenses tend to pull together disparate objects—in an urban scene viewed from a distance, buildings that are several blocks apart might appear to crowd in on top of each other. However, the shallow depth of field of a long lens used at close subject distances tends to separate out objects that may actually be close together by showing some sharp and others blurred.

Perspective effects

Wide-angle lenses
- Take in more background or foreground.
- Exaggerate the size of near subjects when used in close-up photography.
- Exaggerate any differences in distance or position between subjects.
- Give greater apparent depth of field and link the subject to its background.

Telephoto lenses
- Compress spatial separation.
- Magnify the main subject.
- Reduce depth of field to separate the subject from its background.

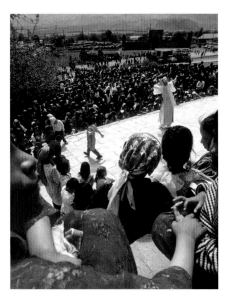

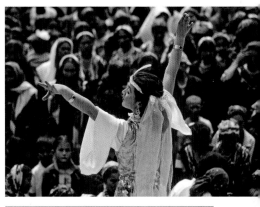

TRY THIS

Telephoto perspective
Overlooking the action there is a sense of the crush of people at this festival in mountainous Tajikistan (*above*). Two children holding hands complete the scene. The long-focal-length version (*above right*) focuses attention on the dancer, but excludes all sense of setting beyond the crowd watching the traditional performance.

For this exercise, leave your zoom lens at its shortest focal length setting. Look for pictures that work best with this focal length—ignore any others and don't be tempted to change the lens setting. This will help to sharpen your sense of what a wide-angle lens does. You may find yourself approaching subjects—including people—more closely than you would normally dare. The lens is making you get closer because you cannot use the zoom to make the move for you. Next, repeat the exercise with the lens at its longest focal length setting.

Changing viewpoints

Always be on the lookout for viewpoints that give a new slant to your work. Don't ignore the simple devices, such as shooting down at a building instead of up at it, or trying to see a street scene from a child's viewpoint rather than an adult's.

Your choice of viewpoint communicates subtle messages that say as much about you as they do your subject. Take a picture of someone from a distance, for example, and the image carries a sense that you, too, were distant from that person. If you photograph a scene of poverty from the viewpoint of a bystander, the picture will again have that distant look of having been taken by an aloof observer. Lively markets are popular photographic subjects, but what do they look like from a merchant's position? If you enjoy sports, shoot from within the action, not from the sidelines.

Practical points

Higher viewpoints enable you to reduce the amount of foreground and increase the area of background recorded by a lens. From a high vantage point, a street or river scene lies at a less acute angle than when seen from street or water level. This reduces the amount of depth of field required to show the scene in sharp focus.

However, from a low camera position, subjects may be glimpsed through a sea of grass or legs. And if you look upward from a low position, you see less background and more sky, making it easier to separate your subject from its surroundings.

Less can say more
At markets and similar types of locations, all the activity can be overwhelming—and the temptation is often to try to record the entire busy, colorful scene. However, if you look around you, there could be images at your feet showing much less but saying so much more. In Uzbekistan I noticed next to a fruit stand a lady who had nothing to sell but these few sad tulips.

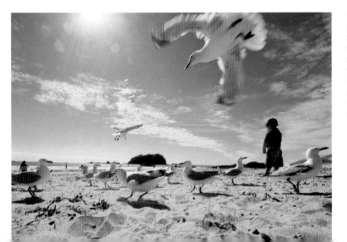

Child's-eye view
From almost ground level, the swooping gulls feel threatening and pull the viewer into the action. At the same time, looking upward gives the viewer a sense of open skies—this would be lost with the gaze directed downward.

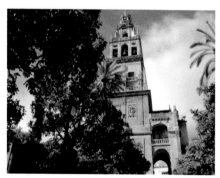

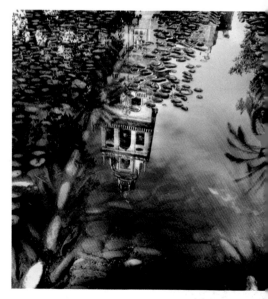

Changing viewpoint
This conventional view of the Mesquita of Cordoba, Spain (*above*), works well as a record shot, but it is not the product of careful observation. Looking down from the same shooting position, I noticed the tower of the building reflected in a puddle of water. Placing the camera nearly in the water, a wholly more intriguing viewpoint was revealed (*right*). An advantage of using a digital camera with an LCD screen is that awkward shooting positions are not the impossibility they would be with a film-based camera.

Quick fix Leaning buildings

Buildings and architectural features are always popular photographic subjects, but they can cause annoying problems of distortion.

Problem

Tall structures, such as buildings, lampposts, or trees, or even people standing close by and above you, appear to lean backward or look as if they are about to topple over.

Analysis

This distortion occurs if you point the camera up to take the picture. This results in your taking in too much of the foreground and not enough of the height of the subject.

Solution

● Stand farther back and keep the camera level—you will still take in too much of the foreground, but you can later crop the image.
● Use a wider-angle lens or zoom setting, but then remember to hold the camera precisely level—wide-angle lenses tend to exaggerate projection distortion.
● Take the picture anyway and try to correct the distortion by manipulating the image.
● Use a shift lens or a camera with movements. This equipment is specialized and expensive, but technically it is the best solution.
● Exaggerate the leaning or toppling effect to emphasize the height and bulk of the subject.

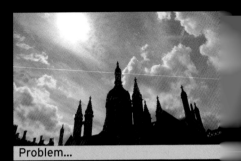

Problem...

Tilting the camera
An upward-looking view of the spires of Cambridge, England, makes the buildings lean alarmingly backward.

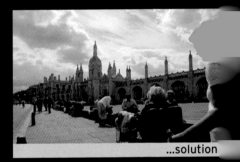

...solution

Using the foreground
By choosing the right camera position, you can keep the camera level and include foreground elements that add to the shot.

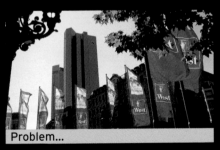

Problem...

Losing the foreground
To record the red flags against the contrasting blue of the building, there was no option but to point the camera upward, thus dismissing much of the foreground. As a result, the nearest

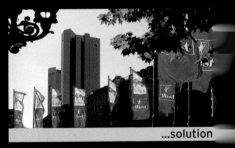

...solution

Alternative view
Keeping the camera level, a shift lens was used, set to maximum upward movement. This avoided the problem of converging verticals. Although this is the best solution to optimize image

Quick fix Facial distortion

Distorted facial features can be a problem with portraits. To make the subject's face as large as possible, the temptation is to move in too close.

Problem

Portraits of people taken close-up exaggerate certain facial features, such as noses, cheeks, or foreheads.

Analysis

The cause is a perspective distortion. When a print is viewed from too far away for the magnification of the print, the impression of perspective is not correctly formed (*see also p. 90*). This is why at the time you took the photograph, your subject's nose appeared fine, but in the print it looks disproportionately large.

Solution

- Use a longer lens setting—a 35efl of at least 80 mm is about right, so that for a normal-sized print viewed from a normal viewing distance, perspective looks correct.

- Use the longest end of your zoom lens. For many, this is a 35efl of 70 mm, which is just about enough.
- If you have to work close-up, try taking a profile instead of a full face.
- Avoid using wide-angle lenses close to a face, unless you want a distorted view.
- Don't fill the frame with a face at the time of shooting. Instead, rely on cropping at a later stage if you need the frame filled.
- Don't assume you will be able to correct facial distortions later on with image-manipulation software. It is hard to produce convincing results.
- If you have a digital camera with a swiveling lens, it is fun to include yourself in the picture by holding the camera at arm's length—but your facial features will then be so close they will look exaggerated.
- Make larger prints. With modern inkjet printers, it is easy to make letter-size images (substantially larger than the usual photographic snapshot), and at normal viewing distances they are far less prone to perspective distortion.

Profile
Taking portraits in profile avoids many of the problems associated with facial distortion in full-frontal shots. Make sure you focus carefully on the (visible) eye—other parts of the face may appear unsharp yet be acceptable to the viewer.

Full-frontal
To emphasize the friendly character of this man, several "rules" were broken: a wide-angle lens was used close-up; the shot was taken looking upward; and the face was placed off in one corner, thus exaggerating the distortion already present. But the total effect is amiable rather than unpleasant.

Color composition

Successful color photography uses color as a tool of composition. We try to work with colors as if they were distinct entities, separate from the things displaying them. Also, we try to work with an awareness of color relationships: colors close to each other on the color wheel (*see opposite*) contrast with and highlight each other, whereas colors next to each other offer more harmony, binding together what could be disparate elements in a composition.

Color and harmony

Although it is difficult to generalize about what are essentially subjective reactions to the use of particular colors, in general, if you include combinations of adjacent colors in an image you create a more harmonious effect. This is especially true if the colors are approximately equivalent to each other in brightness and saturation.

Color and mood

There is much to be said for learning to work with a carefully conceived and restrained palette of colors. A favorite trick of landscape photogra-phers at some times of the year, for example, is to select a camera viewpoint that creates a color scheme that is composed predominantly of browns and reds—the hues redolent of fall. By doing this, not only does a harmonious color composition result, all of the mood and atmosphere associated with the seasonal change from summer to winter are brought to bear within the image.

Depending on just how the photographer wants a picture to communicate with its intended audience, images that feature gardens as the prin-cipal subject might be dominated by colors such as various shades of green or blues and purples.

Monochromatic color

Another type of picture harmony results when the colors are all of a similar hue. The subtle tonal variations can impart a sense of quiet tranquility or reinforce the drama of the scene. Duotone or sepia-toned effects (*see pp. 140-3*) are monochromatic, as are views of the sea and sky containing a range of different blues. Sunsets are attractive because of their monochramatism.

Monochrome landscape

As the French painter Paul Cézanne taught us, every color of the rainbow can be seen in any scene if you look hard enough, especially in a landscape. However, the dominance of yellows and browns in this image encourages the viewer to admire the chiaroscuro and shape of the slopes without the distraction of color contrasts.

Emotional content

Even though all the main colors in this photograph are tonally very close, the image lacks impact when it is rendered in black and white. The emotional content of the warm reds, pinks, and purples is essential to the success of the study.

Blue on blue

Although the adjacent blues are what this picture is all about, an absence of contrast —provided here by the red label and the flesh tones— would have left the picture unbalanced and overstated.

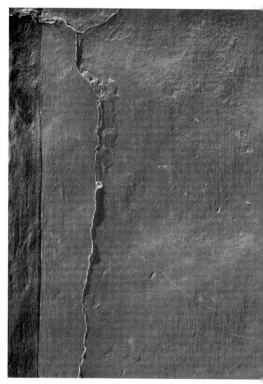

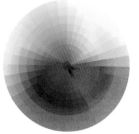

Color wheel

The color wheel displays combinations of hue and saturation: in the middle are the most saturated colors (those most intensely colored) while the perimeter shows the less saturated colors— those with more white. The colors are organized in the order familiar from the spectrum, with complementary colors opposite each other.

Red and purple

When I first noticed this painted wall, it appeared to have promise, but it was not until it was strongly lit by oblique sunlight that the picture really came together— the dominance of the red and the strongly graphic crack both being powerful visual elements. A little post-processing work served to heighten the colors and strengthen the shadows.

Pastel colors

Referring to pastels as watered-down versions of colors does them a disservice. Certainly, they are paler and less saturated than full-strength hues, but they are nevertheless a vital part of the photographic palette.

Evoking mood

Within the photographic image, pastels tend to generate a sense of calm and an atmosphere of softness. They are gentle and refined, whereas strong colors tend to be more strident; they are soothing as opposed to invigorating; subtle rather than obvious. Pastels, therefore, evoke emotional responses that are simply not possible where bright colors dominate. And, as a result, they are often chosen as the principal color theme in home interiors, especially where a calm, relaxed, or soothing environment is the aim.

Appropriate exposure

In portrait photography, the accurate exposure of pastel shades is often a crucial factor in the success

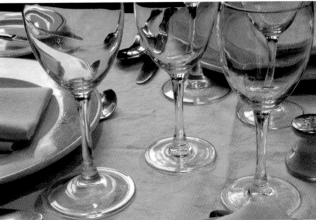

Creating harmony
The soft light and gentle colors, together with the smooth curves of the plates and glasses, have all combined in this image to create a sense of calm and repose. Anything other than pastel colors would disturb the composition and mood of this table setting. The scene was carefully exposed and a small aperture set to produce maximum depth of field.

Skin tones
The most natural way to articulate the softness and vulnerability of the naked human figure is with pastel colors illuminated by a gentle form of lighting. In this image, water has further softened subject details, while the wide-angle view has exaggerated her form. A slight reduction in color saturation was given in order to soften the original image even further.

of an image. Many skin tones, for example, are essentially desaturated hues—pinks being pale versions of reds, and East Asian skin tones being light versions of golds or yellow-browns.

Pictures that are composed predominantly of pastel colors are often associated with "high-key" imagery. An exposure reading taking in areas of dark shadow is likely to result in the camera controls being set to record shadow detail. This has the obvious effect of overexposing all the brighter parts of the scene, turning colors into pastel-like hues. This high-key technique can be effective in nature and landscape photography when you are trying to achieve a more interpretative, less descriptive effect.

However, if you are working with digital image files, you have the advantage of being able to tone down and lighten colors deliberately in order to create pastels from more strident hues (*see p. 154*). Another way to achieve a similar type of effect is to introduce pale colors into a black and white image (*see pp. 152–3*).

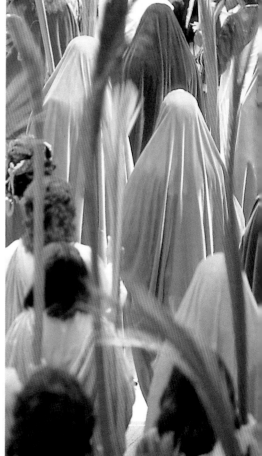

Color variety
A scene that utilizes pastel shades is not one in which all the colors have to be similar. In this selective view of a Scottish moor, a whole spectrum of different colors is on display, but the soft light has toned them all down so that they blend gently together to create a harmonious composition.

Color restraint
It is easy to be overwhelmed by strong colors and brilliant light. But there are times when a subtle color palette works far better—as in this near-abstract impression photographed during Holy Week in Mexico City. An overly strong color rendition, by using slight underexposure, would have recorded the bare heads as being too black, while the slight overexposure employed here has given a pastel effect and better detail in the shadow areas.

Strong color contrasts

Color contrasts result when you include hues within an image that are well separated from each other on the color wheel (*see p. 37*). While it is true that strongly colored picture elements may have initial visual impact, they are not all that easy to organize into successful images. Often, it is better to look for a simple color scheme as part of a clear compositional structure—too many subject elements can so easily lead to disjointed and chaotic pictures.

Digital results

Modern digital cameras are able to capture very vibrant colors that look compelling on your computer's monitor screen. Because of the way the screen projects color, these are, in fact, brighter and more saturated than those film can produce. However, one of the advantages of using computer technology is that the color range offered by film can be enhanced with image-manipulation software, giving you the opportunity, first to create, and then to exploit, an enormous range of vibrant colors.

Distracting composition
Combine strong colors with an unusual and an appealing subject, and you would think that you have all the important elements for a striking photograph (*above*). In fact, there is far too much going on in this picture for it to be a successful composition. The painting in the background distracts attention from the man— himself an artist, from Papua New Guinea—while the white edge on the right disturbs the composition. A severe crop, to concentrate attention on the face alone, would be necessary to save the image.

Lighting for color
The unbelievably strong colors seen in this image, taken on an isolated Scottish shoreline, are the result of shooting in the bright yet diffused light from an overcast sky, which has had the effect of making all the colors particularly intense. The palette of contrasting dark reds and blues not only looks good on screen, it also reproduces well on paper. This is because the particular range of colors in this image happen to be those that print well. A range containing, say, bright purples or sky blues would not be so successful.

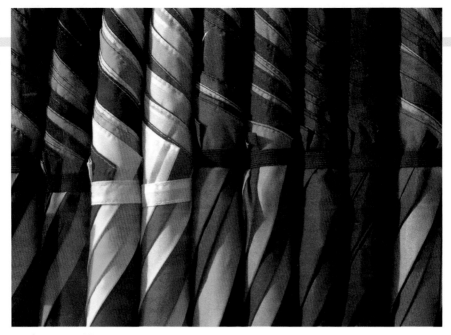

Simple composition

Bright colors are attractive in themselves, but they tend to be most effective when they are arranged in some type of pattern or sequence. This arrangement imposes a structure on them and thus suggests a meaning or order beyond the mere presence of the color itself. The main problem I encountered when taking this photograph of brightly colored umbrellas was avoiding the reflections from the store window in front of them.

Color gamut

The intensity of computer-enhanced colors gives them real appeal, but it is in this strength that problems lie. Strong colors on the page of a book or website will compete with any text that is included; they are also likely to conflict with any other softer image elements. In addition, you need to bear in mind that even if you can see intense, strong colors on the screen, you may not be able to reproduce them on paper. Purples, sky blue, oranges, and brilliant greens all reproduce poorly on paper, looking duller than they do on screen. This is because the color gamut, or range of reproducible colors, of print is smaller than that of the monitor.

Of the many ways to represent a range of colors, this diagram is the most widely accepted. The rounded triangle encloses all colors that can be perceived. Areas drawn within this, the visual gamut, represent the colors that can be accurately reproduced by specific devices. The triangle encloses the colors

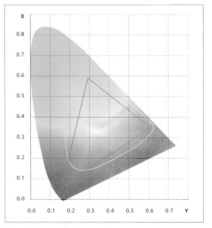

(the color gamut) of a typical RGB color monitor. The quadrilateral shows the colors reproduced by the four-color printing process. Notice how some printable colors cannot be reproduced on screen, and vice versa.

The appeal of rain
Rainy days are ideal for color shots because hues are more saturated due to low lighting contrasts (narrow luminance range). But you still need contrasts of color, as in this scene in Kolkata, India.

Exposure control

The process of determining the amount of light that is needed by the film or sensor for the required results is called exposure control. Unlike in film photography, many digital cameras can change sensitivities to maintain practical camera settings. For example, in low light, sensor sensitivity increases (just as faster film might be used in film-based photography) to allow you to set shorter shutter times or smaller apertures.

It is important to control exposure accurately and carefully, as it not only ensures that you obtain the best from whatever system you are using, but also saves you the time and effort of manipulating the image unnecessarily at a later stage.

Measuring systems

To determine exposure, the camera measures the light reflecting from a scene. The simplest system measures light from the entire field of view, treating all of it equally. This system is found in some handheld meters and some early SLR cameras.

Many cameras, including digital ones, use a center-weighted system, in which light from the entire field of view is registered, but more account is taken of that coming from the central portion of the image (often indicated on the focusing screen). This can be taken further, so that the light from most of the image is ignored, except that

from a central part. This can vary from a central 25 percent of the whole area to less than 5 percent. For critical work, this selective area, or spot-metering, system is the most accurate.

A far more elaborate exposure system divides the entire image area into a patchwork of zones, each of which is separately evaluated. This system, commonly referred to as evaluative or matrix metering, is extremely successful at delivering consistently accurate exposures over a wide range of unusual or demanding lighting conditions.

As good as they are, the exposure systems found in modern cameras are not perfect. There will be times when you have to give the automation a helping hand—usually when the lighting is most interesting or challenging. This is why it is so crucially important to understand exactly what constitutes "optimum exposure."

Optimized dynamics

Every photographic medium has a range over which it can make accurate records—beyond that, representation is less precise. This accuracy range is represented by a scale of grays on either side of the midtone—from dark tones with detail (say, dark hair with some individual strands distinguishable) to light tones showing

What is "correct"?

To the eye, this scene was brighter and less colorful than seen here. A technically correct exposure would have produced a lighter image—thus failing to record the sunset colors. Although it looks like this might challenge a basic exposure-measuring system, by placing the sun center frame you guarantee underexposure, resulting, as in this example, in a visually better image than a "correct" exposure would produce.

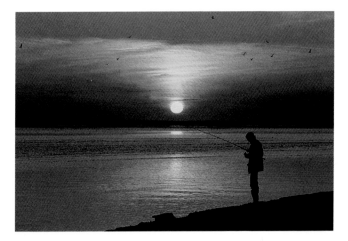

Narrow luminance range

Scenes that contain a narrow range of luminance and large areas of fairly even, regular tone do not represent a great problem for exposure-measuring systems, but you still need to proceed with care for optimum results. The original of this image was correctly exposed yet appeared too light because, pictorially, the scene acquires more impact from being darker, almost low-key. The adjustments that were made to darken the image also had the effect of increasing color saturation, which is another pictorial improvement.

Wide luminance range

The range of luminance in this scene is large—from the brilliant glare of the sky to deep foreground shadows. Exposure control must, therefore, be precise to make the most of the film's ability to record the scene. In these situations, the best exposure system is a spot meter, with the sensor positioned over a key tone—here, the brightly lit area of grass on the right of the frame. Evaluative metering may also produce the same result, but if you are using a film camera, you will not know until you develop the film.

texture (perhaps paper showing crinkles and fibers). If you locate your exposure so that the most important tone of your image falls in the middle of this range, the recording medium has the best possible chance of capturing a full range of tones.

Exposure control is, therefore, a process of choosing settings that ensure that the middle tone of an image falls within the middle part of the sensor's or film's recording range in order to make the most of the available dynamic range.

The easiest method for achieving precision in exposure control is to use a spot-metering system to obtain a reading from a carefully selected tone within a scene. This may be a person's face or, in a landscape, the sunlit portion of a valley wall.

Sensitivity patterns

Cameras use a variety of light-measuring systems, and the representations shown here illustrate two of the most common arrangements. With a center-weighted averaging system, most of the field of view is assessed by the meter, but preference is given to light coming from the middle of the frame. This produces the correct exposure in most situations. However, the optics of a light meter can be arranged so that all its sensitivity is concentrated into a small spot in the very middle of the field of view. This spot-metering system gives a precision of control, which, if used with care and knowledge, produces the best reliability.

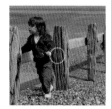

Metering systems

Center-weighted metering (*above left*) takes in all of the view but gives more weight, or emphasis, to the light level around the center of the image, tailing off to little response at the edge. So a bright light at the very edge of the image will have no effect on the reading. A spot-metering system (*above right*) reads solely from a clearly defined central area—usually just 2–3 percent of the total image area.

Exposure time

The shutter setting, determining the exposure time, is one of the fundamental controls of camera exposure. But it's much more interesting than that: with your choice of exposure time you can also control the extent of sharpness or blurring of your image.

Blurrings

When movement occurs during exposure, either in the subject or the camera, details are smeared or spread across the image, causing blurring of subject features. If the blur is too small to be seen, the image appears to be sharp.

Short exposure times catch moving subjects so their image cannot travel far across the capture surface, therefore the resulting blur is small—the image appears sharp. How short the exposure needs to be depends on the speed, direction of movement, and distance of the subject from the photographer. For instance, $\frac{1}{250}$ sec can catch a cyclist coming toward you, but $\frac{1}{1000}$ sec is needed if the cyclist is traveling across the frame. At a distance of 100 meters, a train traveling at 100 mph (160 kmph) is caught with $\frac{1}{500}$ sec, but at a distance of 1km, $\frac{1}{60}$ sec will be enough to capture a sharp image.

In contrast, deliberate blur can produce interesting results. When photographing from a fast-moving car or train, for example, even a short shutter time will not be able to prevent motion blur, especially of foreground objects. But you can introduce blur in any situation simply by setting a long shutter time—at least $\frac{1}{8}$ sec—and then deliberately moving the camera during the exposure. Another technique you can try is to blur the image by zooming the lens during a long exposure.

Moving camera
The blur produced by taking a photograph from a speeding car streaks and blends the rich evening light in a very evocative and painterly fashion thanks to small corrections from the image stabilizer in the lens. The scene looked darker than in the resulting image because movement during long exposures tends to cause overexposure.

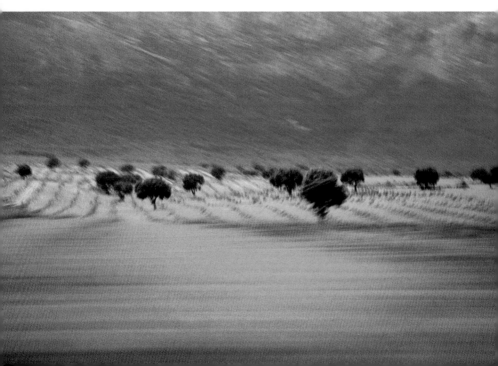

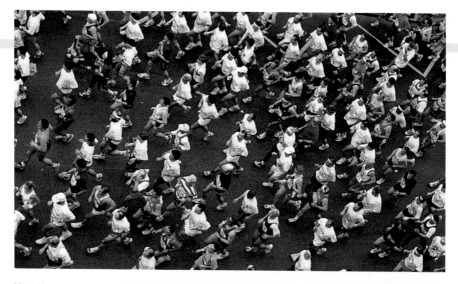

Marathon runners

Runners of the Paris Marathon are caught as a sharp image with an exposure time of $\frac{1}{180}$ sec. Normally a shorter exposure time of $\frac{1}{250}$ sec or less would be preferred to catch runners going across the field of view, but the overhead view helps reduce effects of blur. If the runners were moving toward the camera, around $\frac{1}{60}$ sec should capture a sharp image at the medium far distance seen here.

Gesture in low light

While photographing a pianist at rehearsal in the low light of a studio, brief exposure times are needed to catch fleeting gestures, but this is hard to reconcile with the low light. The solution is to use not only high-sensitivity capture, but to also deliberately underexpose to create a low-key image, thus allowing use of short exposure times.

Accessory flash

Digital cameras, almost without exception, are equipped with a built-in electronic flash. What makes the modern flash so universal is that it is both highly miniaturized and "intelligent." Most units, for example, deliver extremely accurate computer-controlled dosages of light that suit the amount of available, or ambient, light in the scene.

Making flash work for you

Whatever you might gain in terms of convenience by having a ready source of extra light built into the camera, you lose in terms of lighting subtlety. To make flash work for you, you need to exploit what limited control facilities your camera offers.

First, use the "slow-synch" mode if your camera offers it. This allows the ambient exposure to be relatively long, so that areas beyond the range of the flash can be recorded as well as possible, while the flash illuminates the foreground (*see below*). This not only softens the effect of the flash, it can also give mixed color temperatures—the cool color of the flash and the often warmer color of the ambient light—which can be eye-catching.

Second, try using a reflector on the shadow side of the subject. If angled correctly, it will pick up some light from the flash and bounce it into the shadows. Any light-colored material can be used as a reflector—a white sheet of paper, a white sheet, or a shirt. Professional photographers like to use a round, flexible reflector that can be twisted to a third of its full size. It is very compact, lightweight, and efficient, and it usually has two different surfaces—a gold side for warm-colored light and a matte side for softly diffused effects.

Third, an advanced option is to use slave flash. These are separate flash units equipped with sensors that trigger the flash when the master flash (built into or cabled directly to the camera) is detected. If you have a flash unit, then adding a slave unit is not expensive. However, you need to experiment with your camera to check if the synchronization of the multiple flash units is correct.

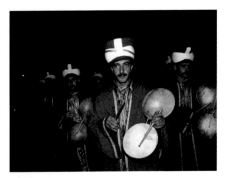

Flash limitations
Dusk in Istanbul, Turkey, and traditional musicians gather. The standard flash exposure used for this image lights only the foreground subjects, and the rapid light fall-off, characteristic of small light sources, fails to reach even a short distance behind the first musician. Adding to the problems, camera exposure is not long enough for the low ambient, or available, light levels prevailing at the time. As a consequence, the background has been rendered black. This type of result is seldom attractive, nor does it display any sound photographic technique.

Effective technique
When illumination is low, make the most of what light is available rather than relying on electronic flash. Here, exposure was set for the sky: this required a shutter of ¼ sec, giving rise to the blurred parts of the image. At the same time, the flash was brief enough to "freeze" the soldier in the foreground, so he appears sharp. Utilizing all ambient light ensures that the distant part of the scene is not wholly underexposed—some color can even be seen in the background building. Compare this with the image in which flash provided all the illumination (*above left*).

Using any setup with more than one flash means trying out different levels of flash output to discover the best results. Start by setting the slave to its lowest power output, bearing in mind that the task of this unit is to relieve subject shadows, not act as the main light. Some models of camera are designed for multiple-flash photography.

Flash synchronization

Because the pulse of light from electronic flash is extremely brief, even compared with the shortest shutter time, it is crucial that the shutter is fully open when the flash fires. Only then will the entire film area be exposed to the flash light reflected back from the subject. There is usually a limit to the shortest shutter time that synchronizes with the flash, often known as "x-synch." For most SLRs, this is between $\frac{1}{60}$ and $\frac{1}{250}$ sec. In some cameras, x-synch corresponds to the shortest available shutter time, which may be $\frac{1}{8,000}$ sec. To obtain this, however, you must use flash units made for that particular camera model.

Flash exposure

All flash exposures consist of two separate processes occurring simultaneously. While the shutter is open, or the light sensor is receptive, light from the overall scene—the ambient light—produces one exposure. This ambient exposure takes on the color of the prevailing light, it exposes the background if sufficient, and it is longer than that of the flash itself.

The second exposure is in addition to the ambient one. The burst of light from a flash is extremely brief, possibly less than $\frac{1}{10,000}$ sec (though studio flash may be as long as $\frac{1}{200}$ sec) and its color is determined by the characteristics of the flash tube (which can be filtered for special effects).

The fact that there are two exposures means that it is necessary to balance them in order to produce good results. But it also allows you to make creative use of the process by, for example, allowing the flash exposure to freeze subject movement, while the longer ambient exposure produces blurred results.

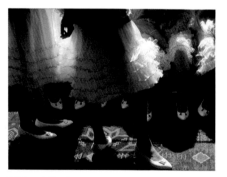

Without flash
Bright, contrasty sunshine streaming in through large windows behind the subjects—a troupe of young singers dressed in traditional costume from Kyrgyzstan—produced a strongly backlit effect. Without the use of flash, the shadows would appear very dark, but in this case a wall behind the camera position reflected back some light from the windows to relieve the contrast a little, and so retain some subject details.

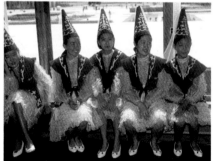

With flash
In this interpretation of the previous scene (*above left*), flash has been used. This produced enough light to fill most of the shadows. Now we can clearly see the girls' costumes, but note that shadows that still remain on the carpet. It is important to set the camera to expose the background correctly: since in this example it was very bright, a shutter time of $\frac{1}{250}$ sec was needed. The f/number dictated by the exposure meter was set on the lens, and the flash was set to underexpose by $1\frac{1}{2}$ stops. This ensured that the foreground was exposed by both the flash and by the available window light.

Quick fix Electronic flash

Modern electronic flash units are versatile and convenient light sources, ideal for use when light levels are low (and the subject is relatively nearby), or when image contrast is high and you want to add a little fill-in illumination to the shadow areas. However, due to the intensity of their output as well as their limited range and covering power, obtaining naturalistic lighting effects and correct exposure can be problematic.

Problem

Common types of problems that are encountered when using electronic flash include overexposed results—particularly of the foreground parts of the image—and underexposed results—particularly of the image background. In addition, general underexposure of long-distance subject matter is very common, as is uneven lighting, in which the corners or foreground are less bright than the center of the image.

Analysis

Modern electronic flash units have their own light-sensitive sensor to measure automatically the light output from the flash or the amount of light reflecting back from the subject and reaching the film or camera sensor. As a result, they are as prone to error as any camera exposure meter. Furthermore, the light produced by a flash unit falls off very rapidly with distance (*see above right and p. 48*).

Overexposed flash-illuminated pictures are usually caused by positioning the flash too close to the subject or when the subject is the only element in an otherwise largely empty space.

Flash underexposure is caused by the unit's having insufficient power to cover adequately the flash-to-subject distance. For example, no small flash unit can light an object that is more than about 30 ft (10 m) away, and even quite powerful flash units cannot adequately light an object that is more than about 100 ft (30 m) distant.

Uneven lighting is caused when the flash is unable to cover the angle of view of the lens—a problem most often experienced with wide-angles. And another problem occurs when an attached lens or lens accessory blocks the light from a camera-mounted flash.

Light fall-off
Light from a flash unit mounted on the camera falls off, or loses its effectiveness, very rapidly as distance increases. This is evident in this close-up image of a bride holding a posy of flowers. The subject's hands and the roses nearest the flash are brightly illuminated, but even just a little bit farther back, the image is visibly darker. This is evident if you look at the back edge of the wedding dress, for example. The effects of this light fall-off can be greatly minimized by using a light source that covers a larger area—hence the very different lighting effect you get when using bounced flash (*opposite*).

Solution

For close-up work, reduce the power of the flash if possible. When photographing distant subjects in the dark—landscapes, for example, or the stage at a concert—a flash is usually a waste of time and is best turned off. A better option is to use a long exposure and support the camera on a tripod or rest it on something stable, such as a wall or fence. With accessory flash units—not built-in types—you can place a diffuser over the flash window to help spread the light and prevent darkened co rs when using a wide-angle lens.

Mixed lighting

The result of balancing flash with an exposure sufficient to register the ambient light indoors delivers results like this. The lighting is soft but the color balance is warmed by the ambient light. Also, the background is bright enough for it to appear quite natural. If a greater exposure had been given to the background, there would have been an increased risk that subject movement would spoil the image.

Bounced flash

Direct flash used at this close distance would produce a harshly lit subject and a shadowy background. In this shot, the flash was aimed at the wall opposite the child. In effect, the light source then becomes the wall, which reflects back a wide spread of light. Not only does this soften the quality of the light, it also reduces the rapid light fall-off characteristic of a small-sized source of light. But bounced flash is possible only if you use an auxiliary flash unit. Note, however, that the background is rather darker than ideal—to overcome this, there must be sufficient ambient light to mix with the flash illumination to provide correct exposure overall (*above right*).

How to avoid the problem

The best way to obtain reliable results with flash is to experiment in different picture-taking situations. With a digital camera, you can make exposures at different settings in a variety of situations to learn the effects of flash without wasting any film. Some flash units feature a modeling light, which flashes briefly to show you the effect of the light—this is a useful preview, but it can consume a good deal of power and is likely to disturb your subject

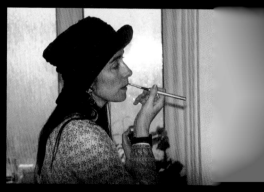

Uneven light

On-camera flash typically delivers these unsatisfactory results. The lighting is uneven, the shapes the flash has illuminated look flat, and there are hard, harsh reflections on all shiny surfaces. In addition, the flash has created unpleasant shadows (note the shadow of the lip-brush on the background woodwork). Always be aware of any flat surfaces positioned behind your subject when using flash from the camera position.

A compendium of ideas

2

Starting projects

A project gives you something to concentrate on, something on which you can focus your ideas or around which you can define a goal. Committing yourself to a specific project can give you a purpose and help you develop your observational and technical skills. In addition, a project provides you with a measure against which you can determine your progress as a photographer.

One of the most frequently asked questions is how you come up with project ideas—and a common mistake is to think that some concept of global interest is needed. In fact, the most mundane subjects can be just as rewarding and—even more important—achievable.

An action plan

● It could be that your skills as a photographer could be put to use by some local community group. So, instead of giving money, you could provide photographs–perhaps with the idea of holding a local exhibition to raise funds.

● If you try to do too much, too quickly, you are heading for disappointment. For example, you want to digitize all the pictures in your family albums. Fine; but don't try to complete the project in a month.

● You have to be realistic about the money involved in carrying through a project, but preoccupation with cost can freeze your enthusiasm, kill the sense of fun, and become, in itself, the cause of the waste of money.

● Nurturing a project idea is more about cooperation than coercion. You have to learn to work with the idiosyncrasies and character of the subject you have set your sights on. And doubts and misgivings are very common. If you find yourself inhibited or you are afraid to look silly, or if you think it's all been done before, then you may start to wonder what the point is. If so, then just bear in mind that you are doing this for yourself, for the fun of it. As long as you think it is worthwhile, why care what anyone else thinks?

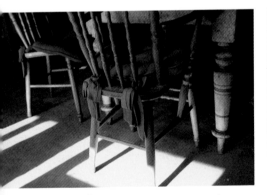

Illuminating domesticity
This is the type of domestic scene that could easily pass unnoticed at home, unless your concentration is sharpened by having a project in mind. Yet if you were to see the exact same scene on your travels, the simple fact that you were not in your familiar surroundings may make the light and balance of the complementary colors and the rhythm of the vertical or near-vertical lines immediately striking.

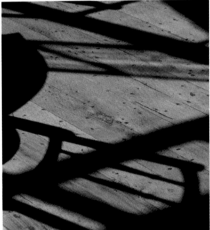

Shadows
Strong light casting deep, well-defined shadows and the warm colors of the floor make for an abstract image. To ensure that the lit area was properly exposed, I took a spot reading from the bright area of floor, entirely ignoring the shadows.

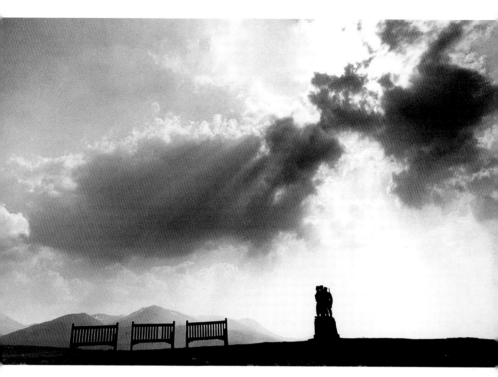

Juxtaposition

A monument to three wartime commandos in Scotland reflects the three benches erected for visitors to sit and enjoy the view.

A long wait in a bitingly cold wind was rewarded when a spectacular burst of sunlight broke through a gap in the cloud-laden sky.

Interior arrangements

The paraphernalia of a restaurant under construction produced a complex of lines and tones that caught my eye. The picture benefited from having the left-hand side slightly darkened to balance the darkness toward the top right of the image.

TRY THIS

Make a list of objects you are familiar with. These can be as simple and ordinary as you like—dinner plates, for example, or bus stops, drying clothes, or chairs. Do not prejudge the subject. If the idea comes to you, there is probably a good reason for it. Choose one subject and take some pictures on the theme: again, do not prejudge the results, just let the subject lead you. Be ready to be surprised. Don't think about what others will think of what you are doing. Don't worry about taking "great" pictures. Just respond to the subject—if it is not an obviously visual idea, then you might have to try a bit harder to make it work as an image. Don't abandon the subject just because it initially seems unpromising.

Abstract imagery

Photography has the power to isolate a fragment of a scene and turn it into art, or to freeze shapes that momentarily take on a meaning far removed from their original intention. Or chance juxtapositions can be given significance as a result of your perception and the way you decide to frame and photograph the scene.

Close-ups and lighting

The easiest approach to abstracts is the close-up, since it emphasizes the graphic and removes the context. To achieve this, it is usually best to shoot square-on to the subject, as this frees the content from such distractions as receding space or shape changes due to projection distortion.

Longer focal length settings help to concentrate the visual field, but be careful not to remove too much. It is advisable to take a variety of shots with differing compositions and from slightly different distances, as images used on screen or in print often have different demands made on them. For example, fine detail and texture are engrossing, but if the image is to be used small on a webpage, then a broad sweep may work better. And since you will usually be shooting straight onto flat or two-dimensional subjects, you do not need great depth of field (*see pp. 18–21*). This is useful, as it is often crucial to keep images sharp throughout.

Complicated abstract
Abstract images do not need to be simple in either execution or vision. Try working with reflections and differential focus (focusing through an object to something farther away). Here, in Udaipur, India, a complex of mirrors, colored glass, and highlights from window shutters battle for attention—and bemuse the viewer. Control of depth of field is critical: if too much of the image is very sharp, the dreamy abstract effect may be lost.

Found abstract
Here (*below*), the decaying roof surface at a busy train station must have been glanced at by thousands of commuters every day but seldom seen. Perhaps it is a simple expression of the process of aging, the origins of which can only be guessed.

Ecotourism

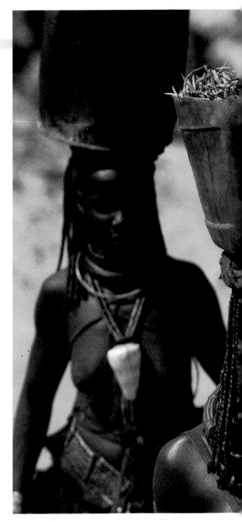

Every publicly funded animal reserve, national park, or nature preserve welcomes the type of activity that results in positive publicity of its aims. Thus, when you are a digital photographer, the technology at your command can turn you from a passive observer into an active contributor.

Aims and objectives

The likelihood is that you will have only limited time when you visit—a day probably, maybe two—so it is up to you to make the most of the opportunity. First, determine what the main attractions of the place are, and how you can best record them. Next, a little research beforehand will inform you of any recent developments that have taken place so you can decide whether or not they should be on your list of things to see. And don't neglect the people who work or live there—they may be rewarding subjects for your camera.

Digital photography usually wins over its film-based counterpart due to its versatility. You can use digital images in emails to illustrate a publicity campaign; for brochures within minutes of their being taken; and, of course, you can place them on a website publicizing the park or its work. In addition, many digital cameras allow you to include a sound bite from the person you have photographed.

However, a manual 35-mm camera may have the advantge over a digital type in extremely remote or testing locations, since they tend to be more robust and less dependent on batteries.

Candid shot
The Himba take great care with their appearance. Lost in conversation with other women of her tribe, this woman idly rearranges her intricate hairstyle, unaware of the camera's presence. Taken from relatively close-up, the very long focal length threw a great deal of the background out of focus.

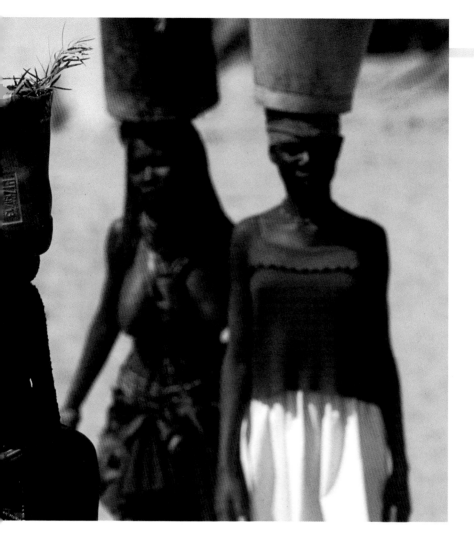

An outside eye

Mundane activity can appear exotic to outside eyes. For these women (*above*), a long walk is required just to fetch water. The day I took this shot there had been a lion attack on a cow near the village. In light of this, they decided it would be too dangerous to wait and make the trip at their preferred time of dusk.

Careful framing

The cool of dawn is the best time to milk the cows. An early start gave me a chance to combine portraiture with a record of an aspect of daily life. A wide-angle lens brought the subject elements together, but I took care not to place the woman's face too close to the edge of the frame, in order to avoid any distortion.

Ecotourism continued

Close framing
At the water hole, the girls of the village take a moment to relax and joke with each other. Framing the shot tightly cut out the glaring white light of the desert landscape.

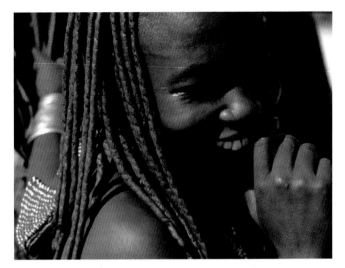

Lighting contrast
Long shadows from the distant hills darken the foreground while the sun turns the background a flaming orange.

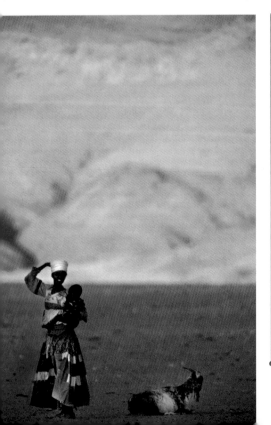

A professional approach

Even if the pictures you take are simply for your own enjoyment, a professional approach helps to ensure that you do not neglect to record some vital aspect of your visit or run out of film or memory cards.

- Bear in mind the basic story-telling elements of a picture story: the roads leading to and from the park help give your other images a context.
- Vary perspective and viewpoints as much as possible. Take close-ups as well as long views; wide-angle and telephoto shots.
- A choice of landscape- or portrait-format images gives you design flexibility if you ever want to produce publicity material.
- Take plenty of photographs whatever the conditions: you may be able improve the images (on the computer) even if the lighting or weather was less than perfect.
- If your digital camera can take short video sequences or voice recordings, don't neglect to use the facility.
- Take ample spare batteries and memory cards for a digital camera.

Close-up photography

Close-up photography used to require special equipment, but digital cameras have changed this. Not only is it common to be able to focus with the lens nearly touching the subject, the use of LCD screens giving a "through-the-lens" view allows all but the simplest models to focus close-up.

Points to consider

The main technical points to take into account when shooting close-up are:

● Depth of field is limited (*see pp. 18–21*), and it is all but impossible to include all of a subject within sharp focus. The best strategy is to focus critically on the most important part of the subject.

● Subject or camera movement is greatly magnified when working close-up. You will need to steady the camera and the subject to prevent blurred imagery. Flash, which delivers an extremely brief burst of light, can be used to reduce the effect of camera or subject movement.

● A reasonable working distance is needed with subjects such as birds or butterflies to avoid disturbing them. This requires the use of a long focal length—ideally, a 35efl of 180–200 mm.

● Automatic flash may be unable to respond quickly enough to light reflecting back from the subject, resulting in overexposure. To combat this, reduce flash exposure via the flash controls, set the flash to manual (*see right*), or cover the flash head with translucent material.

Close-up photography needs more care than when working at normal subject distances. To achieve the best results, you need a digital camera that allows apertures to be manually set and that has close-up focusing at the long end of the focal length range. Generally speaking, the cameras that feature these close-up-friendly facilities are good-quality digital SLRs.

Manual flash exposure

Using flash set to manual delivers the most accurate and reliable results when dealing with close-up subjects. You need to take four variables into account: the power of your flash; the working distance; the speed of your film (or sensitivity of your photosensor); and the effective lens aperture at the working distance. First, set your flash unit manually to low power— say, to ⅛ of maximum. Next, focus on an averagely reflective subject at a fixed distance from the camera—for example, 10 in (25 cm) away. Now make a series of exposures, changing the lens aperture each time, and carefully note all the settings used. Repeat this procedure at different subject distances and flash-output settings. Review the results on your LCD screen or after the film has been processed. You can then draw up a set of figures for different situations—such as ⅛ power at 10 in (25 cm) at a lens aperture of f/5.6, or ⅛ power at ⅓ in (1 cm) at f/8, and so on.

Safety first
Although this seal looks relaxed, I did not care to take the shot with an ordinary lens. In fact, I used a zoom set to 400 mm, and note how the shallow depth of field limits the zone of sharp focus. I decided that the snout and whiskers were the elements I wanted sharp and so focused specifically on them.

Close-up photography continued

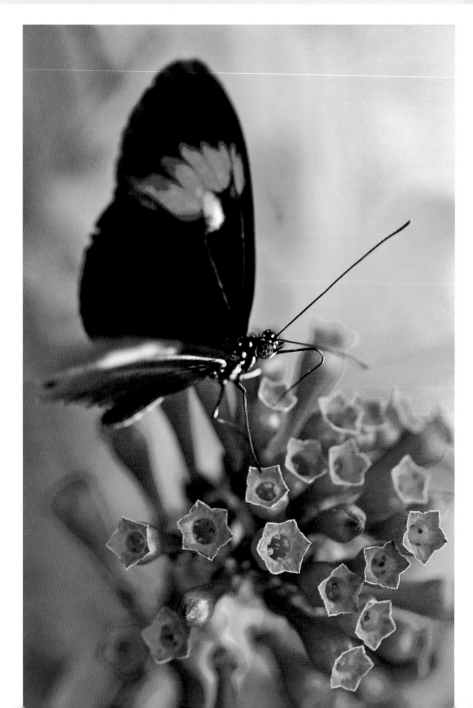

Approaching butterflies

Butterflies (*left*) have excellent vision and easily spot your approach. Using a long-focal-length lens will help—here the equivalent of 180 mm for 35 mm – because you obtain higher magnification from a greater working distance compared to a shorter focal length. Using an image-stabilized lens or camera helps ensure sharp images, but you always need to focus critically.

Natural history

The most common subject for close-ups is plant life. Here, it is the droplets of moisture clinging to the foliage that make the picture. By observing the subject from various positions, it was possible to see the reflected sparkles in the droplets change. But take care not to disturb the plants and disperse the water droplets by approaching too close.

Photomicrography

Extreme close-ups, as in this view of animal tissue (*right*), require a microscope. Modern, lightweight digital cameras are easy to link to laboratory microscopes as long as you have an adapter tube and mounting system, which are readily available from many camera stores.

Children

The photography of children falls into two main areas of interest—images of family and friends, or pictures taken when traveling abroad. We tend to photograph our own children, or children with whom we have some sort of relationship, in a very different way from children living in other cultures. The prime reason for this is that our approach to the "exotic" is one we are reluctant to apply to the familiar. For example, when overseas, the fact that a child is dirty or is wearing ragged clothing may be the very features that attract our photographic interest. We may be proud to show this imagery highlighting the different and unfamiliar to friends or colleagues, yet we would be reluctant to show our own children in anything but a favorable, "sanitized" light.

A change of attitude

So the challenge is clear: we must find a way to bring the two approaches together, to show more honesty in the photography of our own children while showing more respect in our representation of children from other cultures. For example, when you are traveling, you could try to learn about the games that children play: do they have rhyming games in Mongolia; do the children of the Philippines play "catch"; which version of soccer do they play on the beaches of Zanzibar? Another approach could be to show children from other cultures in roles that might be largely alien to our own—such as working in the fields or factories or active in religious observance.

In the end, by deepening our involvement, we increase our understanding and enjoyment of our subject, thereby giving our photography a most exciting and rewarding edge.

Selective view
Ostensibly, this is a study of contrasts—between the baby's hands and those of his grandmother; of colorful clothes against tanned skin— but this selective view also removes the viewer's gaze from the child's grubby face.

An even closer approach, to concentrate attention on, for example, the lower part of the image, might have been even more effective.

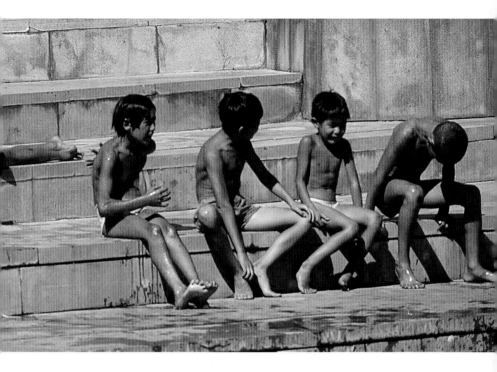

A candid approach

A large fountain in hot weather is irresistible to children anywhere in the world. The problem here was trying to photograph the boys without their realizing it— otherwise they would start playing to the camera. I mingled with the crowds, enjoying the sun, and waited for a suitable grouping and rare moment of relaxation. Then I raised my camera at the last moment and grabbed the shot.

Trust reveals personality

A child needs to trust you before you can enter his or her personal space. The close-up is the best way to record a sense of the child's personality and world. There is no need to capture the entire face: concentrate on the expressive eyes and mouth to create a concisely evocative image.

Fleeting moment
The young monks were on their way to prayer but were only too pleased to stop and pose for the camera for a few seconds: for this, autofocus and autoexposure gives the speed of response needed.

Children continued

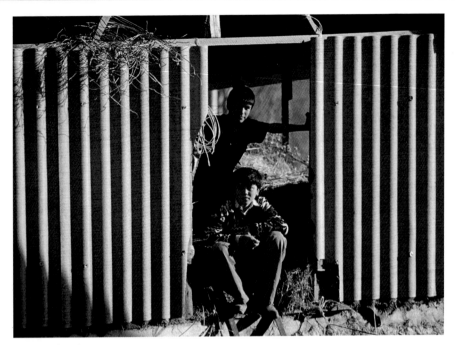

Suitable framing
Without the stark framing, this would be a well-lit, uninteresting image. But the frame not only helps the composition, it also gives us clues about where these boys live. With the hay just visible, this must be a farm. A second before shooting, the standing boy's face was lost in shadow but I could not focus and shoot quickly enough.

HINTS AND TIPS

Children can be a challenge in technical terms, as they are small, low down, and move quickly. They require stamina and fitness on the part of the photographer, as well as quick reflexes. You can help yourself by trying out these techniques:

● With very small children, work at a fixed distance: focus your lens manually to, say, 18 in (0.5 m) and keep your subjects in focus by leaning backward or forward as they move. Small children move very quickly but usually only over short distances. This method requires little effort and can be superior to relying on autofocus.

● When you first photograph a group of children, fire off a few shots in the first minute—they need to get used to the sound of the camera or light from the electronic flash, while you need to exploit their short attention span. Once they have heard the camera

working, they will soon lose interest and ignore you. If, however, you wait for them to settle before taking your first picture, they will be distracted by the noise.

● For professional photography of children, the best cameras to use are digital SLRs. These give you more flexibility than point and shoot digital cameras. You need the shortest possible shutter lag (the time interval between pressing the shutter and actually recording the picture) if you are not to miss out on the really spontaneous images, and rapid sequential fire is always a help.

● In low light, the best course of action is to use lenses with wide maximum apertures, such as f/1.4 or f/2. On modern cameras, unless you have a high-quality zoom lens, increase the ISO setting in preference to setting the lens's maximum aperture.

Landscapes

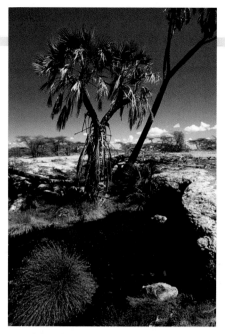

The natural landscape is one of the most accommodating yet challenging areas of photography. The land lets you photograph it from any angle, at any time, and in any weather, but the tough part is finding the ideal viewpoint in appropriate light.

Two essentials

The two essentials of landscape photography, are therefore: place, and light. When you arrive at a promising location, take your time to explore. You need to slow down completely—even put your camera away for a time. Then just walk around and look, walk a little more and look a little harder. One simple rule, or promise, to remember is that there is a picture to be found almost anywhere. All you have to do is look carefully.

At that point, you may decide that the light is not perfect: you may need the sun to come out, or the scene may be better under diffused light. The warm, rich light of the setting sun, casting long shadows, is often ideal—but not always. Your landscape photography will benefit from variety in lighting as well as location.

As a result, you may need to return at another time of the day—even another season of the year before the light on the scene is ideal. This is a large

Polarizing filter
The hallmarks of pictures made with a polarizing filter are deep blue skies and, if any water is visible, a lack of reflections, as shown in this landscape in Samburu, Kenya.

Foreground interest
An effective technique is to get close to foreground features. Here a spider's dew-laden web catches the morning sun, and so frames the landscape beyond.

Landscapes continued

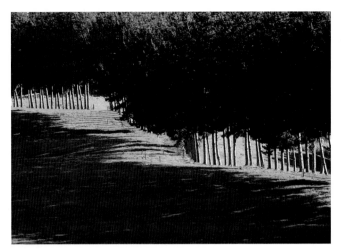

Leading the eye
A landscape photograph does not need to feature the sky or be shot with a wide-angle lens. This scene in New Zealand was taken with a zoom lens set to a 35efl of 600 mm in order to lead the eye to the masses of variegated greens and the patterns of tree trunks. It is a scene that could easily be turned into a painting.

Selective emphasis
The scene was simple enough and its promise was clear, but finding the right position to photograph this reservoir took many minutes thanks to restrictions on access. As the day was dull, there was little choice about lighting, so I had to shift my attention to shape and the balancing of tonal masses.

part of a landscape photographer's expertise: accepting the need to return, and knowing when to do so.

In the shorter term, however, on cloudy days it is often worth waiting for a break that lets the sun through. This often casts the whole scene in dramatically different tonalities. Conversely, it's always worth waiting to see how moving clouds change the mood of a scene.

Landscape cameras

Any camera in combination with any lens—from normal to extreme focal lengths—can be used to photograph landscapes. You do not always need wide-angle views. Try looking for distant details with a telephoto or home in on foreground interest with normal focal lengths.

Polarizing filters

A popular, some would say essential, accessory for landscapes is the polarizing filter. This is a neutrally dark glass filter on a rotating mount. When fixed on a lens pointing away from the sun, then rotated to an angle which varies with the situation, blue skies appear darker and shiny areas reveal their underlying color. This filter gives results that are impossible to fully reproduce with image manipulation. It is best used with an SLR, where you can see any changes through the viewfinder, and should be of the circular type.

Dawn mist

Landscape photography may seem leisurely, but often you have to act quickly. Driving out of Auckland airport, New Zealand, just after dawn, this mist-shrouded scene presented itself. I knew that it would evaporate quickly, so I jumped out of the car and raced back down the road to record it. Just seconds later, the rising sun masked the delicate hues in the sky and the mist thinned.

Pets

A common error in pet photography is to concentrate on an animal's face or depict it by itself, without any context. If you can detach yourself from the situation, evaluating it in terms of its visual interest, any resulting image is likely to be more successful. If, however, you produce images very personal to you, don't then be surprised if they fail to engage a wider audience.

What to look for

Broadening out this area of interest to include the study of relationships between people and their pets can make a fascinating subject for the camera. The challenge lies in finding original or illuminating approaches to the subject.

A straightforward portrait of a pet and its owner is rarely likely to be of interest to anyone but the owner and his or her family. However, through the careful choice of lighting and selecting the right moment to shoot you can produce an expressive image with wider appeal.

Pets are notoriously tricky subjects for the photographer to deal with. They certainly do not respect your wishes—in fact, it often seems that they know precisely what you don't want them to do, and then willfully do it. Above all, successful pet photography requires endless patience and quick reflexes.

Sociable cat
Harmony of tone and hue come together in this image with contrasts in texture and line. But it is only a friend's cat being sociable and wanting to sit between us. As a digital photographer, you can take as many shots as you like and simply discard the unsuccessful ones. You can tidy them up, too: here, the boards could be straightened a little and the object near the tip of the cat's tail could easily be removed.

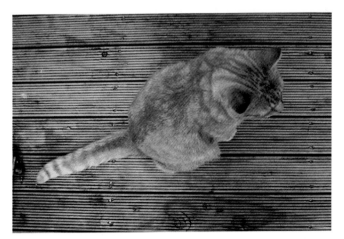

Quick reflexes
A cold, windswept walk on the beach may not seem to be the most promising subject for photography, but for a split second a picture opportunity presents itself— but you need to stay alert to record it. Here, the dogs appear to blend not only with the tones of the beach but they also seem to be responding to the contours of the landscape. The original color image was turned to black and white, then tints were added to suggest the natural colors.

Animal friend
A pet's favorite person is not only ideal for keeping the animal still, but, as in this example, she can be the subject of the portrait, too. In this image, all the colors are soft and muted, so there is nothing to conflict with the delicate shades of the guinea pig.

Professional service

Pet owners wanting professional portraits of their animals can provide a good source of work for the digital photographer. The advantage of working digitally is that you can not only offer unaltered, "straight" images, you can also easily supply any of the huge number of variations available via your image-manipulation software. Another advantage of digital technology is that you can shoot a number of images and then show them immediately to clients on a TV screen or computer monitor. This allows them to select the ones they want on the spot, thus saving you the time and expense of processing films and printing proof sheets.

Pets continued

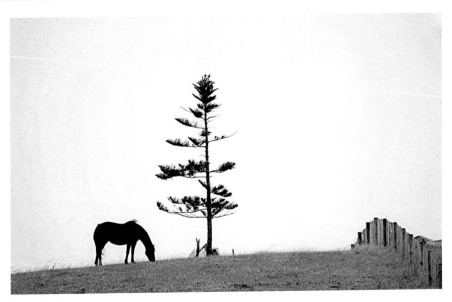

Project ideas
Exploring the relationship between this horse and its field could be a project in itself. Imagine this scene with blue sky or at sunset—already you have three very different images.

Simple shapes like this make excellent greetings cards or the clear area of sky of this version could also feature advertising copy.

HINTS AND TIPS

- Find out at which time of the day the animal is normally at its quietest. Consult the owner about when it is best to photograph the animal—it may be just after feeding time, for example. However, cold-blooded animals, such as snakes, frogs, and lizards, are quietest when the surrounding temperature is low—so dawn may be a good time.
- Find out what the animal likes. It may be calmed down by music or by being allowed to play first and let off steam. A hungry animal may be bad-tempered, but one that has been recently fed may be frisky and want to play. Again, consult the animal's owner.
- Is it likely to be startled by flash or the sound of the camera? Check with test firings of the flash at a distance before you approach within striking distance. Some animals may also be disturbed by the high-pitched noise of autofocus mechanisms—which you may not be able to hear—or by the sound of a motordrive.

- Always move smoothly and steadily and make no sudden noises. Avoid positioning yourself behind an animal, where it cannot see you.
- To keep your distance, use a longer focal length than usual. An extension tube (a ring of metal that sits between the lens and camera) or a close-up lens added to a long focal length lens enables you to focus much closer, but you will then have to work within a limited depth of field.
- Let the animal be handled by its favorite person: it will be calmer and less likely to behave erratically or in an unpredictable fashion.
- To keep the animal in focus as it moves around, try manual focusing. Keep the animal within the depth of field by changing your position as it moves, so keeping a constant distance between yourself and the subject. This is often easier and less tiring than constantly making small focusing adjustments.

Sports

Sports photographers were among the first to recognize the competitive edge digital technology could give them in the race to get pictures of dramatic sporting moments into newspapers and magazines. With no film to process, images could be transmitted down the phone line directly to the picture desk. Minutes after a home run is hit, the image can be with a picture editor on the other side of the world.

Digital photography also offers advantages for the more casual sports photographer. You may, for example, be asked to make prints of winners and team lineups for friends or relatives—an easy task for digital cameras and inkjet printers. Many sporting clubs have their own website to attract new members and to keep supporters informed of events, and images for these—from the Christmas party to the regional tournament—are always needed, and digital photography offers the easiest and least expensive way to provide them.

TRY THIS

Sports photography does not have to be confined to the sporting activity itself. A less-literal approach to the subject could lead you to document the fans— their faces and what they wear—or you could try making a record of behind-the-scenes activities—preparation for matches, the lives of the support staff, or what the event is like from a referee's perspective. By applying your imagination and knowledge of the sport, digital photography can open avenues of discovery about your favorite sport that might be closed to ordinary fans.

Behind the scenes
Photography of sporting activity can include not only the highlights of the action but it can also give some sense of the hours of instruction needed to learn a skill. Here, a sensei, or teacher, demonstrates an arm lock in the repertoire of Goju-ryu-style karate.

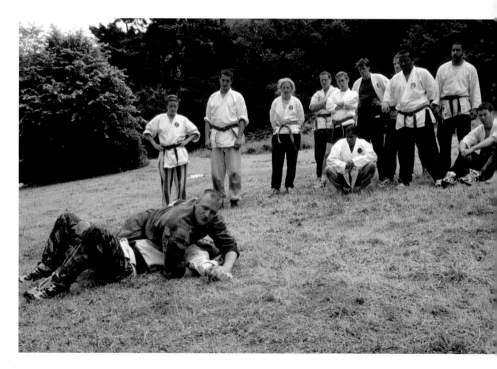

Sports continued

Concentration

One of the difficulties with sports is that with so much happening in the background it can be hard to concentrate on the foreground action. Here, a busy background did not intrude into the main subject—a karate student being tested for tension—due to the exposure difference that allowed the background to be underexposed. In addition, the use of a large aperture limited depth of field to the foreground figures.

Know your sport

The better you know a sport the better able you will be to anticipate the action—you have to be almost as alert as those involved in the free-style sparring taking place here. A blow can be delivered and retracted in a split second: not only do you have to respond, so does the camera—so you need to anticipate the action by small fractions of a second.

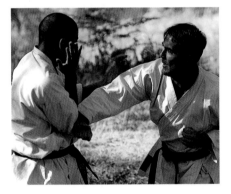

Shoot what you need

Here, during freestyle sparring, the attacker has succeeded in momentarily trapping the right hand of his opponent. Unfortunately, in the next instant, the duelists turned and obscured the action. One advantage of a digital camera is that you can shoot as many action sequences as you need and later discard those that are useless without worrying about wasted film.

Creative blur

Great sports photography is not just about showing the game. Only those who have taken part in a sport really know what it feels like, but we can use whatever photographic techniques that are available to us to show something of the spirit. A relatively long exposure—¼ sec—blurs the action, but it takes many attempts to find an image that balances blur with discernible shape.

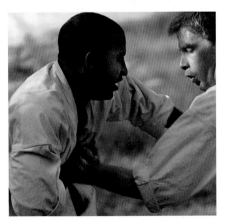

HINTS AND TIPS

The essence of the sports photograph lies in choosing the right moment to press the shutter. A split second represents the moment one tennis ace turns the tables on another or one misjudged tack separates the winner of the America's Cup from the also-rans. The strategy for sports photography is, therefore, constant vigilance to ensure you are at the right place at the right time.

● Allow for shutter lag: the time interval between pressing the shutter and actually capturing the image is usually at least ⅟₁₀ sec but can be as long as ¼ sec.

● Keep safety in mind. In covering powered sports there is always an element of risk for anyone involved— particularly photographers, who are often given vantage points that are close to the action. Don't place yourself at risk unnecessarily, and be guided by the track or event officials.

● Position yourself carefully. Try to view the event from a point at which you not only have a good view of the action, but also from where your target is not moving impossibly swiftly.

● "Know your sport" is the best advice. Use your expert knowledge to aid your photography. As a race track becomes worn down, for example, do the riders take a slightly different route around it? As the sun moves across the sky, do the players pass the ball from a different direction to avoid the glare? In dry conditions, do rally drivers take a corner faster than in the rain? Are you prepared for the changes?

Panoramas

The basic concept of a panorama is that the recorded image encompasses more of a scene than you could see at the time without having to turn your head from one side to the other. In fact, to obtain a true panoramic view, the camera's lens must swing its view from one side to the other.

Visual clues

The giveaway visual clue to a panorama is that there is necessarily some distortion—if the panorama is taken with the camera pointing slightly upward or downward, then the horizon, or any other horizontal line, appears curved. Alternatively, if the camera is held parallel with the ground, objects positioned near the camera—usually those at the middle of the image—appear significantly larger than any objects that are more distant from the camera.

Landscape view

The landscape is the natural subject area for the panorama, and it also presents the fewest technical problems. In addition, it can transform a dull day's photography into a breathtaking expanse of quiet tones and subtle shifts of color. Here, in Scotland, a still day creates a mirrorlike expanse of water to reflect the fringing mountain, thus adding interest to an otherwise blank part of the scene. This image consists of six adjacent shots, and it was created using Photoshop Elements.

Digital options

In recent times, the concept of panoramas has been enlarged (confusingly) to include wide-angle shots that have had their top and bottom portions trimmed or cropped into a letterbox shape. As a result, images have a very long aspect ratio—which means that the width is much greater than the depth of the image. These pseudo-panoramas do not show the curvature of horizon or exaggerated distortion of image scale of true panoramas.

The digital photographer has a choice. Pseudo-panoramas can be created simply by cropping any wide-angle image—all you have to do is ensure that the image has a sufficient reserve of detail to present credible sharpness after you have cropped it. Don't forget that a panorama can be oriented vertically as well as horizontally.

True panoramas are almost as easy to create digitally. First, you take a number of overlapping images of a scene from, say, right to left or from top to bottom. Then, back at the computer, you can join all these individual views together using readily available software such as Spin Panorama, PhotoStitch, or Photoshop Elements. These software packages produce a final, new panoramic image without altering your original image files in any way (*see pp. 182–3*).

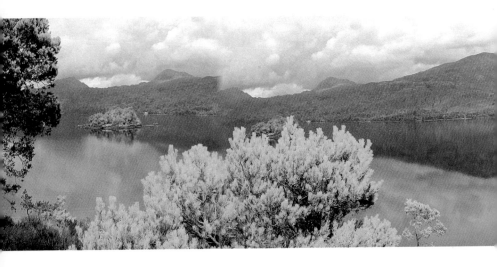

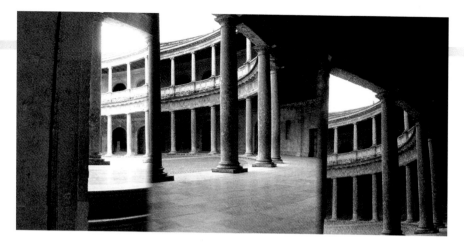

Unlikely subjects
You can experiment with component images (*left*) that deliberately do not match, in order to create a view of a scene with a rather puzzling perspective. The software may produce results you could not predict (*above*), which you can then crop to form a normal panoramic shape. While the final picture is by no means an accurate record of the building, in Granada, Spain, it may give the viewer more of the sense of the architecture—of the never-ending curves and columns. This image was created using the PhotoStitch application.

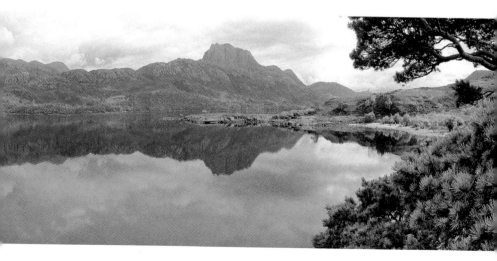

Panoramas continued

Canal scene

The distortions in scale that are caused by swinging the view from one side to another, so that near objects are reproduced as being much larger than distant ones, can produce spectacular results. In this view, taken under a railroad bridge crossing a canal in Leeds, England, one end is reproduced as if it is the entire width of the image, while the other end takes up only a small portion of the center. The mirror calm of the canal water helps to produce a strong sense of symmetry, which is in opposition to the powerful shape of the wildly distorted bridge.

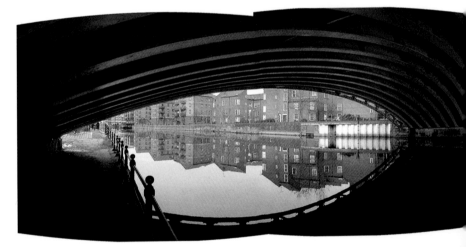

Rear nodal point

The image projected by a lens appears to come from a point in space: this is the rear nodal point. Rotate a lens horizontally around an axis through this point and features in the scene remain static even though the views change. A virtual reality head (see opposite) allows the axis of rotation to be set to that of the rear nodal point to give perfect overlaps between successive shots.

HINTS AND TIPS

In order to obtain the best-quality panoramic images, you might find the following suggestions helpful:

- Secure the camera on a tripod and level it carefully.
- Use a so-called "virtual reality head": this allows you to adjust the center of rotation of the camera so that the image does not move when you turn the camera. If you simply turn the camera for each shot, the edges of the images will not match properly.
- Set the camera to manual exposure and expose all the images using the same aperture and shutter speed settings. As far as you can, select an average exposure, one that will be suitable for the complete scene.

- Allow for an ample overlap between frames— at least a quarter of the image width to be safe.
- Set your lens's zoom to the middle of its range, between wide-angle and telephoto. This setting is likely to produce the most even illumination of the whole image field and also the least distortion.
- If possible, set the lens to a small (but not the smallest) aperture—say, f/11. Larger apertures result in unevenness of illumination, in which the image is fractionally darker away from the middle.
- Ensure that important detail—a distinctive building, for example—is in the middle of a shot, not an overlap.

Table setting
It can be fun to create panoramas of close-up views: here, a collection of views were blended together, playing with the pastel colors and repeated elliptical shapes (see also pp. 38–9).

Vacations

The challenge when photographing a vacation is to avoid the obvious while making a record of the events you may wish to remember in the years to come. Another challenge is to lift your images from the strictly personal—snaps that are of interest only to friends and family—to a level where they have a wider appeal.

Themes and subjects

One project idea that takes you away from the obvious monuments or museums could be something along the lines of street traders or local cuisine. Depending on your own interests, you might find that pictures of street food bring back the memories of a place far more vividly than, say, the facade of some neoclassical public building. And by working digitally, you have the ability to review an image as soon as you have taken it and decide whether or not another shot is needed.

Attitudes and approaches

It is simply good manners to take into account the sensitivities of the people in whose country you are traveling. It is their religion, customs, and attitudes to which you will be exposed, so treat your hosts' country with the same respect you would expect of tourists in your country. As a start, dress in a style that is appropriate to the cultural or social expectations of the country you are in. And don't insist on taking pictures of people if they wave you away or seem unhappy about it.

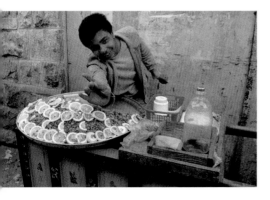

Local culture
Food shots can be colorful and memorable—food is an essential part of any vacation, and negotiating a purchase can be part of the fun. But don't record only the food or some artistic arrangement of produce—including the vendors in the shot increases the challenge and can give rise to more interesting and livelier pictures.

Changing emphasis
Even when the weather is less than perfect, the observant can always find picture opportunities. In this view of downtown Auckland, New Zealand, rain from a storm beats on the windows of an observation tower. It is usual to focus on the distant view, but by concentrating on the raindrops the scene shifts, and suddenly there is a picture to be made.

Securing your equipment

A potential problem on vacation is the tension that can exist between the vigilance necessary to take care of your equipment and the desire to relax and enjoy yourself. These points may help:

- In a hotel, make full use of any safe or security boxes that may be available. Sometimes these are provided in your room, sometimes at reception.
- Make sure you lock your luggage while you are out of your room.
- If you have to sleep during a long wait in a train or bus station or airport lounge, set a battery-powered alarm (that beeps if it is moved) on your bags.
- Stay in the best-quality accommodation you can afford—you are generally more at risk from theft in cheaper hotels or apartments.
- Use physical restraints (bolts or chains, if provided) to secure your door when you are in.
- Insure all your camera equipment and accessories before departure for their full replacement amount. Rates vary, so obtain two or three quotes.

Vacations continued

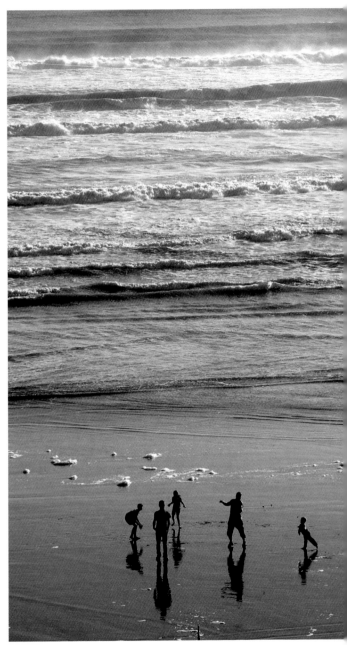

Ever ready
You may find interesting or strange images being created for you if you stay alert. When some villagers in Turkey borrowed my sunglasses, a child on his mother's arms wanted to try them on—and suddenly there was an image to be had (*above*). Tight framing left out the clues that would make the picture easier to read, making the image a little more intriguing.

Interpreting the ordinary
As the photographer, you may find yourself slightly apart as your search for pictures takes you away from the group. Here, walking up a hill from this beach in New Zealand rewarded me with a fine view of reflections of figures in the ebbing waters and wet sand.

Urban views

The urban environment sets challenges for the photographer that are similar to those encountered by landscape photographers (*see pp. 69–71*). There is, for example, the overriding need to find the ideal viewpoint, sifting through a multiplicity of visual experiences to arrive at that single one that stands for them all. Then there is the importance of timing and lighting. In addition, whether you are working in a town or in the country, you have to choose between the wide vistas or recording a more detailed view of your subject.

Technical considerations

Technically, there are differences between town and country photography. Pointing the lens a long way below or above the horizon in a landscape seldom causes obvious distortion effects, such as converging verticals, unless very upright trees are in view. In an urban setting, converging verticals are a constant challenge—whether to use them (easiest option), ignore them (seldom advisable), or correct them (requiring expensive equipment).

Depth of field is often a problem, too. While country views may stretch from the medium distance into infinity, and so easily fall within normal depths of field, town views often stretch from very close to very distant.

Points of law

In most developed countries you will encounter few problems photographing in major cities, but you may need to exercise some care when working in some other parts of the world. It may be illegal to photograph certain government buildings, and railroad stations and bridges may also be out of bounds. In addition, some buildings may be protected by copyright or design rights: this is unlikely to cause a problem unless you wish to make commercial use of your photographs.

London Eye
Shooting at night and using London's slowly turning ferris wheel, the London Eye, as my platform posed a challenge. The simple strategy in a situation such as this is to take as many pictures as possible and then review and edit them later.

Shooting at night

The tendency of all autoexposure systems is to overexpose urban nighttime shots. As a result, street lights become too bright and the essential "feel" of a night scene is lost. It is best to first turn off the flash, and then set your camera to manual and bracket a number of exposures, starting with a shutter speed of 1 sec. You will need to support your camera firmly, preferably on a tripod, to prevent camera shake. Note that digital cameras may produce "noisy" images with long exposures, in which blacks are degraded by lighter pixels. Some cameras offer a noise-reduction mode on long exposure, which you should turn on.

Urban views continued

Working around a subject
A simple exercise is to take an obvious landmark and then shoot as varied a set of views of it as possible. These images of the Sky Tower in Auckland, New Zealand, were all taken as I went about my business in that city. This shot (*above*), taken from a car, was very nearly missed—it is of such an ordinary scene, yet there is a rhythm in the multiple framing, a sense of a hidden story. In addition, its crisp colors make it a surprisingly rich picture. The passenger seat of a car makes a wonderful moving platform from which to work.

Supplementary flash
Noticing these flowers first, I went over to photograph them, only to find the tower unexpectedly in view. The flash on the camera illuminated the foreground flowers but not those a little farther away. The shadow visible on the bottom edge of the image was caused by the lens obstructing the light from the flash.

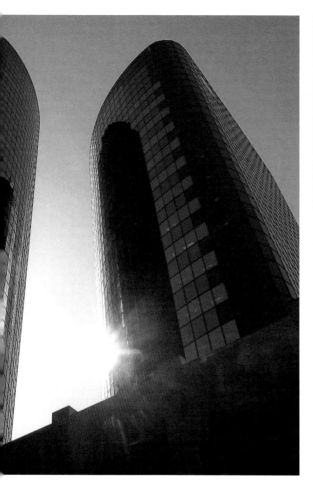

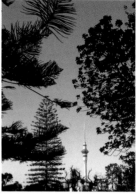

Silhouette lighting

The silhouettes of a variety of trees serve to frame the sleek, industrial lines of the distant tower (*above*). As the trees are represented by shape alone, they look very sharp—although depth of field in such views appears extensive, it is, in reality, an illusion of perception.

Converging lines

Generally, you would want to avoid pointing the camera steeply upward at buildings, as the strong convergence of normally parallel lines causes distortion. However, this can be exploited to create the sense of disorientation or of being loomed over. Its effectiveness is increased in this view by avoiding any alignment between the picture frame and the sides of any buildings.

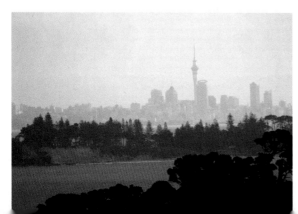

Distant view

The Sky Tower is visible even an hour's ride away by hydrofoil. A strong telephoto perspective—produced by the 35efl of a 560-mm lens—leaps over the distance and appears to compress the space between the intervening islands. The haze has desaturated colors to give a nearly neutral gray.

Zoos

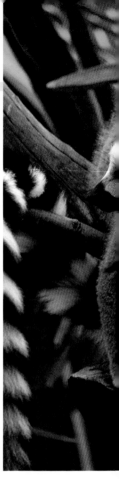

Zoos offer the best chance to get up close to wild animals. Modern zoos in major cities are becoming less like collections of cages and more like nature reserves for the study and preservation of wildlife. You can see well-fed animals in something like their natural habitat, although with much less room than is natural in which to roam or play.

A learning experience

For the photographer, zoos are useful places to practice some of the elements of wildlife photography before venturing into the field. You soon learn that you have to stay still and wait, sometimes for hours, for something to happen. Soon, you discover that if you set up at the right place at the right time, your wait for the right shot can be greatly reduced—and from this you learn the importance of knowing your animal and its habits.

You can approach animal photography in zoos in various ways: the images shown here mimic photography in the wild, with no signs of enclosures. An equally valid approach is to depict the captivity and the isolation of the animals by being empathetic through your photography.

The right moment
The ease of taking pictures of animals in zoos should not lull you into thinking it is easy to take effective images. As with animal photography in the wild, wait for the right moment, for a revealing insight in the animals' lives, or when the animals' features are clearly shown.

Subject sharpness
The depth of field available when you are focusing on a nearby subject with a long focal length lens is limited. The advice for people pictures applies to animals, too: if you focus on the eyes, then unsharpness elsewhere is acceptable. In this portrait of a red panda, the eyes and whiskers are sharp but little else, yet the image overall gives the impression of being extremely crisp.

HINTS AND TIPS

- Minimize the appearance of wire barriers when photographing by using your longest focal length settings and maximum aperture. Poke the lens between gaps in the barriers where possible, but avoid alarming animals who may attack you.
- Do not use flash in darkened enclosures: the animal may not react, but it may be alarmed—or even blinded.
- Some cameras use a "focus assist"—a beam of infrared light—to focus in the dark. Turn this off to avoid disturbing animals sensitive to infrared light.
- When shooting through glass, place yourself at an angle to avoid your own reflection and reflection from the flash, if used.
- When using flash through the bars of an enclosure, remember that the flash may cast unsightly shadows.

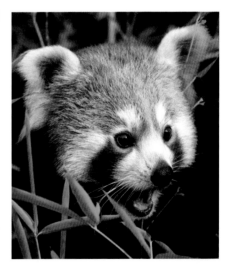

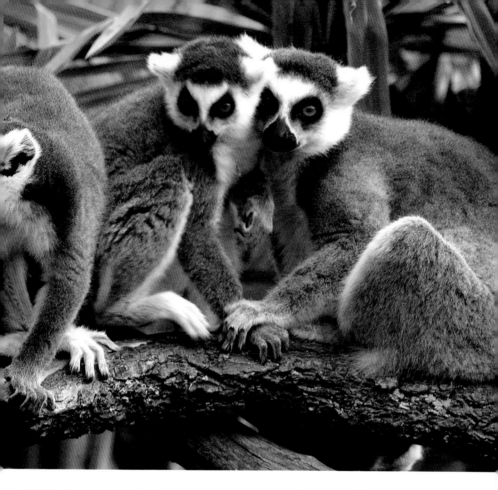

The truth behind the image

You could explore the field of unconventional portraits: views of animals you could never expect to see in the wild—such as this polar bear swimming, apparently soaking up the sunshine with some degree of pleasure. Beware, however, of the mistake of attributing human emotions to animals—it is widely accepted that polar bears are very distressed by captivity in zoos.

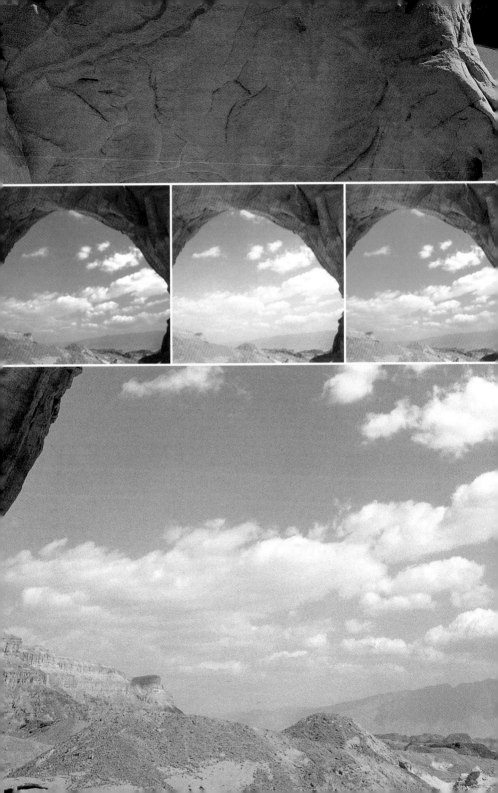

All about image manipulation

File formats

Most types of data file are produced by application software to be used specifically by that software, so there is only limited potential for interchange with other programs. However, image files are different, since they can be accessed and used by a range of programs. This is achieved by building them in widely recognized data-structures, or formats. The following are commonly supported.

TIFF

The best choice for images used in print reproduction, and widely adopted. A bit-mapped or raster image file format supporting 24-bit color per pixel, with such data as dimensions and color look-up tables stored as a "tag" added to the header of the data file. The variety of tag specifications gives rise to many types of TIFF. The format can be compressed losslessly using LZW compression. This reduces file size by about half on average. It is always safe to compress TIFF files. The suffix is .tif.

"Save as" screen shot

Whenever you save a digital picture file you need to make a decision about which format to save it in. The safest choice is TIFF, which is very commonly recognized, but specific picture needs, perhaps for publication on a website, for example, may demand that you use another type of format. You can use this dialogue box to change from one format to another. To preserve the original, save your new file under another name when choosing a different format.

JPEG

(Joint Photographic Expert Group; pronounced "jay-peg") A format named after its data-compression technique that can reduce file sizes to as little as 10 percent of the original. This is the best choice for photographs intended for use on the internet. JPEG files are saved to different levels of compression or quality. For general use, a middle setting (5 or 6) is sufficient, as it gives very good reductions in file size without noticeable loss in image quality. A high setting of 10–12 is appropriate for high-quality work—loss of quality is all but invisible. The suffix is .jpg. JPEG2000 uses entirely different compression technology for highly efficient compression but is not widely supported.

Photoshop

This is an application-native format that has become so widespread that it is now almost a standard. Photoshop supports color management, 48-bit color, and Photoshop layers. Many scanners will save directly to the Photoshop format, and the format used on other types of scanner may, in fact, be Photoshop, albeit under a different name. The suffix is .psd.

GIF

(Graphic Interchange Format) A compressed file format designed for use over the internet, comprising a standard set of 216 colors. It is best for images with graphics—those with larger areas of even color—but not for photographic images with smooth tone transitions. It can be compressed losslessly using LZW algorithms. The suffix is .gif.

PDF

(Portable Document Format) A format native to Adobe Acrobat based on PostScript. It preserves the document text, typography, graphics, images, and layout. There is no need to embed fonts. It can be read, but not edited, by Acrobat Reader. Very widely used and incorporated into Mac OS X. The suffix is .pdf.

PICT

(Macintosh Picture) A graphics format for Mac OS, it contains raster and vector information but is limited to 72 dpi, being designed for screen images. PICT2 supports color to 24-bit depth.

PNG

(Portable Network Graphics) A format for losslessly compressed web images. It supports indexed-color, grayscale, and true-color images (up to 48 bits per pixel), plus one alpha channel. It is intended as a replacement for GIF. The suffix is .png.

Raw format

Many digital cameras produce files in what is called, variously, RAW, Raw, or raw format, in addition to JPEG or TIFF files. Raw files save data directly from the analogue-to-digital converter at the camera sensor, so the data has not received any processing for white balance, levels, sharpness, nor any lossy compression. Each camera manufacturer, even individual models within a range, may produce raw files organized in different ways, leading to numerous raw formats. As a result, raw conversion software such as Adobe Lightroom, Apple Aperture, Adobe Camera Raw, DxO Optics, and Capture One must be updated regularly with new format data.

Raw files are favored for retaining maximum quality and flexibility during manipulation, but their variety and patchy documentation raise doubts for the long term. The DNG (Digital Negative) format has been proposed as an open standard for raw files by providing a open-source "wrapper" to contain the raw data.

JPEGs in detail

JPEG compression is efficient due to the fact that several distinct techniques are all brought to bear on the image file at the same time. Although it sounds complicated, thankfully, modern computers and digital cameras have no problem handling the calculations. The technique, known as "jay-pegging," consists of three steps.

1 The Discrete Cosine Transform (DCT) orders data in blocks measuring 8 x 8 pixels, which creates the characteristic "blocky" structure you can see in close-up (see right). Blocks are converted from the "spatial domain" to the "frequency domain," which is analogous to presenting a graph of, say, a continuous curve as histograms that plot the frequency of occurrence of each value. This step compresses data, loses no detail, and identifies data that may be removed.

2 Matrix multiplication reorders the data for "quantization." It is here that you choose the quality setting of an image, balancing, on the one hand, your desire for small-sized files against, on the other, the loss of image quality.

3 In the final stage of jay-pegging, the results of the last manipulation are finally coded, using yet more lossless compression techniques.

JPEG artifacts
This close-up view of a JPEG-compressed image shows the blocks of 64 pixels that are created by the compression feature. This can create false textures and obscure detail, but on areas of even tone, or where image detail is small and patterned, such artifacts are not normally visible—even with very high levels of compression. Note how the pixels within a block are more similar to each other than to those of an adjacent block.

The effect of these compressions is that JPEG files can be reduced by 70 percent (or, reduced to just 30 percent of their original size) with nearly invisible image degradation; you still have a usable image even with a reduction of 90 percent. However, this is not enough for some applications, and so a new technology, known as JPEG2000, based on another way of coding data, offers greater file compression with even less loss of detail.

Color management

After a decade of research and experimentation since the popular rise of digital photography, color technology is now able to get thousands of different screens, printers, and papers—as well as cameras —to work together to produce results with more or less reliable color. Now, the image captured by a camera may appear the same on the camera screen as on the computer monitor, and even the print from a desktop printer will look similar. Nevertheless, precise color matching is elusive, and the limitations of standard management systems such as ColorSync are now hindering progress.

First steps

Your monitor is central to color management. Not only do you view and manipulate your images there, but the monitor is also easily adjusted to meet a standard. That is the process of calibrating. Your computer operating system will allow you, through a control panel or System Preferences, to calibrate the screen using simple visual controls (see your system's Help section). See below for the basic settings required.

Calibration methods based on on-screen controls are inexpensive but rely on subjective judgments. The most objective method is hardware calibration, in which a color sensor is attached to the monitor and communicates with the video control: it requests standard colors to be displayed, then measures the actual color with the target. The differences are used to calibrate and characterize the monitor's color performance in the form of a profile.

Precautions

Whichever calibration method you use, observe the following precautions. Allow your monitor (even LCD types) to warm up for at least 30 minutes before attempting calibration. Remove any devices that may cause magnetic interference, such as a hard-disc drive or loudspeakers. Calibrate the monitor in the light you normally work in—ideally low enough to make it difficult to read a newspaper. Do not allow desklamps to shine on the screen.

Color profiles

The way one device handles color is defined by the differences between its own set of colors and that of the profile connection space, which is the set of colors that a "typical" human can see and distinguish. This information, called the ICC (International Color Consortium) profile, is embedded in the image and includes other data about the white point and how to handle out-of-gamut colors (see p. 41). When an image carries a

Calibration

Using the most accurate monitor calibrators or using on-screen targets will be of little help if the basic settings for gamma and white point are not carefully chosen to suit the end use of your images. If you supply to third parties such as stock agencies, magazines, or printers, consult them for their preferred monitor settings.

On-screen calibration

On-screen calibration offers prompts such as the above, showing steps for setting luminance response curves and the balance between the three colors. Settings are altered to match targets.

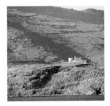

Linear gamma

With the screen set to Linear Gamma, the overall result is very bright, blacks are gray, and colors look washed out. Images adjusted on this screen would look too dark, saturated, and contrasty on normally adjusted screens.

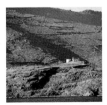

1.8 gamma

The 1.8 gamma was formerly the default setting in Apple Macs and the print industry. It is now regarded as too bright compared to the 2.2 gamma standard on Windows machines. A gamma of 2.0 may be set as a compromise.

color profile, a piece of equipment compliant with ICC profiles will "know" how to interpret the colors and adjust them, if necessary, for the output, whether it is display or print. There are different types of profile according to the device being used, but the key to color management is that every image you use should carry an appropriate profile. Adobe RGB (1998) is widely used for digital images. (*See also pp. 120–3.*)

Soft-proofing

Once your monitor is calibrated, you can use it to check how your images will look when printed; this is called soft-proofing. For this, the output profile must be the combination of printer and paper you will use. This profile can be set as the output space or applied to the viewed image directly. Applying an output profile usually makes the image look duller, but it should be a close match to the print.

Profile relationships

This diagram demonstrates how color characteristics of different devices can be translated to each other, using color profiles and a common color space.

Source profiles are seldom used because the majority of files are processed visually and are only of value with digital images in highly controlled environments, such as studios.

An image file may be embedded with a color profile so that it can be accurately reproduced when it enters a different working color space.

Working color space is your starting point. The sRGB color space is widely used for digital cameras and gives acceptable results. Another standard is Adobe RGB (1998), which gives better results for professional use.

Ink-jet profiles are perhaps the most troublesome for avid photographers. But produced accurately and used correctly, they can help maintain reliable, consistent results.

Monitor profiles are important because they help the computer system control the monitor, ensuring that colors are produced accurately.

CMYK output profiles are important for professional users and publishers of magazines and books, but they need not concern the majority of photographers.

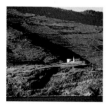

2.2 gamma
The standard on Windows machines, indicating a high level of correction to the monitor's output. Colors are rich, and blacks appear solid while retaining shadow detail but the image quality is a poor match for print quality.

D50 target white
Formerly widely accepted as the standard target white point for a monitor—that is, the monitor attempted to display white according to the definition for D50. The result appears to modern eyes to be creamy or yellowish.

D65 target white
As incandescent lights are used less and more prints are made on bright white paper, the D65 target white has become more widely adopted. It gives a cooler, bluer result than D50 and is a good choice for general digital photography.

9300 target white
Suitable for domestic TV and video, where the final viewing is on TV sets, this white point is generally too blue for digital photography. Using 9300 will result in images that look too red or yellow, and with flattened contrast.

Image management

The problem of managing images has grown exponentially since the beginnings of digital photography. From once taking a few dozen shots per day, photographers now commonly shoot hundreds of images daily: 1,500 images from a single wedding assignment is not unusual, and even a beach vacation can turn in 2,000 or more images. Work methods and specialty software have evolved to ensure the flood of images does not overwhelm the photographer.

Image work-flow

A little forward planning is the key to an efficient work-flow. You can organize your images by date, or assignment or by project—that is, a vacation or trip, or a favorite subject, such as "Urban views" or "Portraits." Within each assignment or project, you can create subfolders by date, by type of image, and so on. Folders on the computer are like their paper counterparts—they are awkward to handle if they get too full but inefficient if you have too many folders with very few items in them.

A good strategy is to organize your folder structure before you shoot, since that helps you to plan your photography and ensures efficiency later, when you want to locate your images. At the same time, plan your backup. Make sure you have sufficient space on another hard disc to create a backup copy as soon as you have downloaded your images.

File naming

Digital cameras automatically give file names to each image, adding a sequential serial number to each new image. Some cameras restart counting whenever you insert a new card. This easily leads to disaster because you can accidentally overwrite images. Always set your camera to series, or sequential, numbering.

When uploading images from your camera to the computer, you may use software (such as Apple Aperture, Adobe Lightroom, or Camera Bits Photo Mechanic) that changes the file name to something useful, like "Korthi_2010-08-31_123.jpg"—this tells us that it's image number 123 from Korthi, taken on August 31, 2010. Note that the underscores, dashes, and period used in this name are the only recommended marks; do not use marks such as an asterisk (*) or forward slash (/).

Metadata

The most important new contribution to managing images is the now-central role of metadata—data about the image that does not form the image, such as the location, the keywords, the caption, the copyright, and other information. The time to add metadata to your images is when you import them into your system: add the broad caption details, such as "Korthi, Andros Island, Cyclades, Greece," and the keywords: "Andros, Cyclades, olive, tree, terraces, agriculture, sunset." With some cameras, you may even add GPS (Global Positioning System) data to the image to locate it unambiguously.

As your collection grows, the keywords become an immensely powerful tool for locating images. For example, if you have traveled to Spain, Italy, and France over the years, a single search for the keyword "olive" will locate, within seconds, all your pictures of olives and olive trees.

Archiving

Always archive and back up your digital files. Some photographers delete the images they consider worthless before making archives, others reason that storage space is so low-cost that it is better not to risk losing images from a hasty decision to delete. There are many strategies. One way to archive your digital files is to copy them onto DVD or Blu-ray Disc, using a writer. Ensure you keep these backups in a location distant from your other copies of images. Another method is to use online, off-site services such as photo-sharing websites. These can work out to be much less costly than running your own hard-disc "farm" and have the added advantage that you can access your images via the internet from anywhere in the world, though speed of access may be reduced.

You may consider keeping archives of early working or work-in-progress files, not just the original and final files. These can create useful records for historical reasons—in case of litigation over copyright, for example. And sometimes ideas that do not fit one project may be useful for another, though you may not know it until months or years later.

Not only will you produce innumerable digital files in a short time, you may also produce lots of ink-jet prints. You should value all this work— after all, you will have put in a great deal of skill and time, so it makes sense to manage these assets properly. An essential part of good practice is to label or number all your work, and certainly the final prints. Make a note of the file name on the back of the print, as well as details such as the printer settings and paper type. Store your successful printouts in archival-quality boxes made from buffered, acid-free cardboard.

File lists
Image files can be shown in lists that display a thumbnail of the image together with all its associated metadata. Selecting one of the images allows the metadata to be edited. In software such as Apple Aperture (*shown here*) or Adobe Lightroom, image-enhancement controls are available alongside tools for organizing material for slide shows, web pages, or books.

Management software
One of the best ways to organize your images is by using management software. Applications worth considering include Adobe Lightroom, Apple Aperture, Extensis Portfolio, ACDSee, and Camerabits Photo Mechanic (*shown here*). Not only do all these programs help you to keep picture files organized, but they can also create "contact prints" and slide shows, as well as publishing picture collections to the web.

Opening files

The usual way to open a file is to double-click on it: place the cursor over the file's icon and quickly click the mouse twice. The computer's operating system then checks what type of file it is and launches a suitable software application. However, the computer's choice of application may not be yours. A preferred method is to start the application you wish to work with, then open the file from within it via File > Open. This also has a higher opening success rate.

Image sources

Images from specialized sources may need to be opened from within an application recommended by the manufacturer. In particular, raw files from cameras must be opened by software that recognizes the file type, in order for it to interpret the data correctly. If a raw file cannot be opened, you will need to update your software.

Internet downloads

Images from websites are usually in JPEG format (*see pp. 92–3*). If you expect to work on an image and then save it for extra treatment later on, it is good practice to perform a Save As on the file into Photoshop or TIFF format. Each time you make changes and save and close an image in JPEG, it is taken through the lossy-compression regime. This means that progressively, if subtly, the image quality is degraded.

Copyright and watermarks

Images from picture-agency discs, the web, or CDs and DVDs given away with magazines may show a "watermark"—such as the company's or photographer's name—printed across the image. This prevents piracy and asserts the owner's copyright. Images may also be invisibly marked: although there is no printing overlaying the images, they resist all but the most destructive changes to the files and suitable software can readily detect the invisible identification watermark. The bottom line is, if you are not sure whether you are infringing copyright in an image, do not use it.

Image degradation
This original portrait (*top left*) was saved several times with maximum JPEG compression (*top right*). Used small like this, the image is acceptable but, in fact, the original is far better, with smoother tones and more accurate color.

A close-up look at the original image (*above left*) shows continuous tones and unbroken lines, while the damage to the compressed version (*above right*) is obvious. A large print made from the JPEG image would simply not be acceptable.

"Choose Application" dialogue
On opening a file that has lost its association with a suitable software application, you will be asked by the system, via a dialogue box such as this, to locate an appropriate program. If your application does not appear, navigate to the folder in which you installed it.

Color mode

The image's color mode is crucial to the success and quality of manipulation. RGB is useful for the majority of image enhancements, but LAB is best for preserving color data to maintain image quality. The initial RGB capture underwater (*above*) was low-contrast and carried an overall green cast. If it is left in RGB, Auto Levels gives it a bright, colorful, but not accurate result (*above right*). In LAB mode, automatic Levels correction produces true-to-life colors with accurate tonality.

Adobe Photoshop

Could not open "IMG_5200.JPG" because an invalid SOS, DHT, DQT, or EOI JPEG marker is found before a JPEG SOI marker.

OK

"Could not open" warning

If you see this warning box on your screen, or one like it, do not worry. You should be able to open the file concerned from within an application. To do this, launch the application first and then try to open the file using the menu options provided.

Checking the image

- Check color mode and bit depth. Files from scanners may be recorded in LAB files. Most image-manipulation software works in 24-bit RGB color, and if the image is not in the correct mode, many adjustments are unavailable or give odd results.
- Check that the image is clean—that there are no dust spots or, if a scan, scratches or other marks. Increasing the contrast of the image and making it darker usually helps show up faint dust spots.
- Ensure the image has not had too much noise or grain removed.
- Assess image sharpness. If the image has been overly sharpened, further manipulation may cause visible edge artifacts.

- Is exposure accurate? If not, corrections may cause posterization or stepped tonal changes.
- Is the white balance accurate? If the file is not raw format, corrections may cause inaccurate colors and tones.
- Are the colors clear and accurate? If not, corrections may cause posterization, stepped tonal changes, or less accurate hues.
- Check there is no excess border to the image. It may upset calculations for automatic levels or other corrections.
- Check the file size. It should be adequate for your purposes but not much larger. If it is too small, you could work on it for hours only to find it is not suitable for the output size desired. If it is too large, you will waste time as all manipulations take longer than necessary to complete.

Cropping and rotation

Always check that scanned images are correctly oriented—in other words, that left-to-right in the original is still left-to-right after scanning. This is seldom a problem with images taken with digital cameras, but when scanning a film original it is easy to place the negative or transparency the wrong way around—emulsion side either up or down, depending on your scanner—so that the scanned results become "flipped." Getting this right is especially important if there is any writing or numbering in the image to prevent it reversing, as in a mirror image.

Image cropping

The creative importance of cropping, to remove extraneous subject detail, is as crucial in digital photography as it is when working with film. But there is a vital difference, for not only does digital cropping reduce picture content, it also reduces file size. Bear in mind, however, that you should not crop to a specific resolution until the final stages of image processing, as "interpolation" may then be required (*see pp. 114–5*). This reduces picture quality, usually by causing a slight softening of detail. Image cropping without a change of resolution does not require interpolation.

In general, though, at the very least you will want to remove the border caused by, for example, inaccurate cropping when making the scan. This

area of white or black not only takes up valuable machine memory, it can also greatly distort tonal calculations, such as Levels (*see pp. 104–5*). If a border to the image is needed, you can always add it at a later stage using a range of different applications (*see p. 118*).

Image rotation

The horizon in an image is normally expected to run parallel with the top and bottom edges of the image. Any slight mistakes in aiming the camera, which is not an uncommon error when you are working quickly or your concentration slips, can be corrected by rotating the image before printing. With film-based photography, this correction is carried out in the darkroom during the printing stage. But since it is a strictly manual process, you should not expect this type of correction to be an option available from the fully automatic printers found in minilabs.

In digital photography, however, rotation is a straightforward transformation, and in some software applications you can carry out the correction as part of the image-cropping process.

Note that any rotation that is not 90°, or a multiple of 90°, will need interpolation. Repeated rotation may cause image detail to blur, so it is best to decide exactly how much rotation is required, and then perform it all in a single step.

Fixed-size cropping

Some manipulation software, such as Photoshop, allows you to crop to a specific image size and to a specific output resolution—for example, 5 x 7 in (13 x 18 cm) at 225 dpi. This is useful since it combines two operations in one and is very convenient if you know the exact size of image needed— perhaps a picture for a newsletter. If so, enter the details in the boxes, together with the resolution. The crop area will then have the correct proportions, allowing you to adjust

the overall size and position of the image for the crop you require. Cropping to a fixed size is useful for working rapidly through a batch of scans.

| Width: 16.933 cm | Height: 12.7 cm | Resolution: 300 | pixels/inch | Front Image | Clear |

1000 px
1000 px 4:3
2000 px
2000 px 4:3
3000 px
3000 px 4:3
Crop Tool 600x400px 72dpi
Crop Tool 640 px x 480 px
Current Tool Only

Crop Options screen shot
By clicking on "Fixed Target Size" you can crop to a specific size and resolution. This is a convenient way to change not only the image size but also to change the resolution of your image.

Creative cropping

Cropping can help rescue an image that was not correctly framed or composed. By removing elements that are not required or are extraneous to what you intended, you can create a more visually coherent final image. Be aware that crops to one side of a wide-angle image may appear to distort perspective, since the center of the image will not correspond to the center of perspective. Cropping decreases the size of the image file and calls on the image's data reserves to maintain image quality.

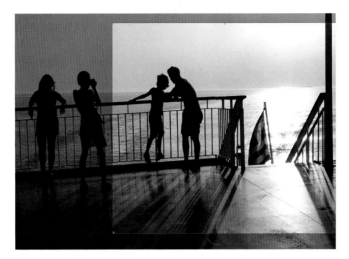

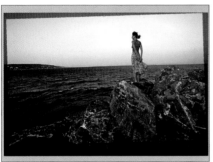

Sloping horizon

A snatched shot taken with a wide-angle lens left the horizon with a slight but noticeable tilt, disturbing the serenity of the image. But by rotating a crop it is possible to correct the horizon, although, as you can see from the masked-off area (*above left*), you do have to sacrifice the marginal areas of the image. Some software allows you to give a precise figure for the rotation; others require you to do it by eye. Some scanner software gives you the facility to rotate the image while scanning.

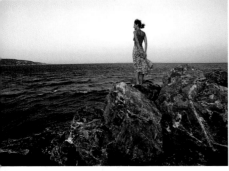

Saving as you go

Adopt the habit of saving your working file as you proceed: press Control + S (PC) or Command + S (Mac) at regular intervals. It is easy to forget in the heat of the creative moment that the image on the monitor is only virtual—it exists just as long as the computer is on and functioning properly. If your file is large and what you are doing is complicated, the risks that the copmuter will crash are increased (and the resulting loss of the work more grievous). A good rule to remember is that if your file is so large that making frequent saves is an inconvenient interruption, then you definitely should be doing it, inconvenient or not.

Quick fix Poor subject detail

Although in most picture-taking situations the aim is to produce the sharpest possible image, there are situations where blur is desirable.

Problem

Images lack overall "bite" and sharpness and subject detail is soft or low in contrast overall.

Analysis

Unsharp subject detail and low contrast can have many causes: a poor-quality lens; inaccurate focusing; subject movement; camera movement; dust or scratches on the lens; an intervening surface, such as a window; and overmagnification of the image.

Solution

One of the great advantages digital photography has over film-based photography is that unsharpness can, to varying extents, be reduced using image-processing techniques. The main one is unsharp masking (USM). This can be found on nearly all image-manipulation software: in Photoshop it is a filter; it is provided by plug-in software such as Extensis Intellihance; and the software drivers for many scanners also provide it. Some digital cameras also apply USM to images as they are being recorded (see pp. 110–11).

However, while USM can improve the appearance of an image, there are limits to how much subject information it can retrieve. In particular, unsharpness caused by movement usually shows little or no improvement with USM. At times, a simple increase in image contrast and color saturation can help to improve the appearance of image sharpness.

Turning the tables
Blurred, low-contrast images are not necessarily failures. This portrait was taken through a dusty, smeary window. The diffusion has not only softened all image contours, it has also reduced contrast and introduced some flare into the shadow areas. These are usually fatal image flaws, but if they appear in association with the right subject they can add a degree of character and atmosphere, rather than detract from picture content.

How to avoid the problem

● Keep the front surface of your lens and any lens filters clean. Replace scratched filters if necessary.

● Focus as precisely and carefully as possible.

● Release the shutter smoothly, in a single action. For longer handheld exposures, take the picture as you breathe out, just before you start to breathe in.

● For long exposures, use a tripod or support the camera on some sort of informal, stable support, such as a table, window ledge, wall, or a pile of books, to prevent camera movement.

● Experiment with your lens—some produce unsharp results when they are used very close-up, or at the extreme telephoto end of the zoom range.

Quick fix Poor subject color

If, despite your best efforts, subject color is disappointing, there is still a range of image-manipulation options to improve results.

Problem

Digital images are low in contrast, lack color brilliance, or are too dark. Problems most often occur in pictures taken in overcast or dull lighting conditions.

Analysis

Just like film-based cameras, digital cameras can get the exposure wrong. Digital "film" is, if anything, more difficult to expose correctly, and any slight error leads to poor subject color. Furthermore, high digital sensitivities are gained at the expense of poor color saturation; so, if the camera's sensitivity is increased to cope with low light levels, color results are, again, likely to be poor.

Overcast light tends to have a high blue content, and the resulting bluish color cast can give dull, cold images.

Solution

An easy solution is to open the image in your image-manipulation software and apply Auto Levels (*see pp. 104–5*). This ensures that your image uses the full range of color values available and makes some corrections to color casts. Although quick, this can overbrighten an image or make it too contrasty.

Some software, such as Digital Darkroom and Extensis Intellihance, will analyze an image and apply automatic enhancement to, for example, concentrate on increasing the color content or correcting a color cast.

The handiest single control is the universally available Saturation (*see pp. 116–7 and 120–3*).

Problem...

...solution

Manipulation options
The original scan (*top*) is not only dull, it is also not an accurate representation of the original scene. However, Auto Levels has generally

brightened up the image (*above*). Color saturation was increased using the Hue and Saturation control, and, finally, the USM filter was applied to help improve the definition of subject detail.

How to avoid the problem

● In bright, contrasty lighting conditions it may help to underexpose by a small amount: set the camera override to -½ of a stop or -⅓ of a stop, depending on what the controls permit.

● Avoid taking pictures in dull and dark conditions. However, bright but partly overcast days usually provide the best color saturation. On overcast days

consider using a warm-up filter (a very light orange or pink color) over the camera lens.

● Avoid setting the camera to very high sensitivities—for example, film-speed equivalents of ISO 800 or above. And avoid using high-speed color film of any type in a conventional camera if color accuracy is crucial.

Levels

The Levels control shows a representation, in the form of a histogram, of the distribution of tone values of an image. Levels offers several powerful options for changing global tone distribution. The easiest thing to do is to click on the Auto Level button. This, however, works effectively in very few cases. What it does is take the darkest pixel to maximum black and the brightest pixel to maximum white, and spreads everything else evenly between them. This, however, may change the overall density of the image.

Another control that may be available is Output Level. This sets the maximum black or white points that can be produced by, say, a printer. Generally, by setting the white point to at least 5 less than the maximum (in other words, to about 250) you prevent the highlight areas in your output image from appearing totally blank. Setting the black point to at least 5 more than the minimum (in other words, to about 5) you will help to avoid the shadow areas looking overly heavy in your output image.

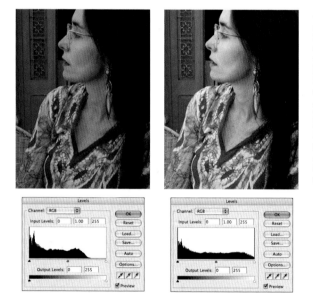

Auto Level
An underexposed image contains dark tones with few high-value ones (*far left*), confirmed in the Levels display (*bottom far left*). The gap on the right of the histogram indicates an absence of values lighter than three-quarter tone, with peak values falling in deep shadow. Applying Auto Level (*left*) spreads all available pixel values across the whole dynamic range. The new Levels display (*bottom left*) has a characteristic comblike structure, showing gaps in the color data. Auto Level not only brightens colors and increases contrast, it also causes a slight overall color shift.

How to read Levels

The Levels histogram gives an instant check on image quality—perhaps warning of a need to rescan.
- If all values across the range are filled with gentle peaks, the image is well exposed or well scanned.
- If the histogram shows mostly low values (weighted to the left), the image is overall low-key or dark; if values are mostly high (weighted to the right), the image is high-key or bright. These results are not necessarily undesirable.

- If you have a sharp peak toward one or other extreme, with few other values, you probably have an image that is over- or underexposed.
- If the histogram has several narrow vertical bars, the image is very deficient in color data or it is an indexed color file. Corrections may lead to unpredictable results.
- A comblike histogram indicates a poor image with many missing values and too many pixels of the same value. Such an image looks posterized (*see p. 268*).

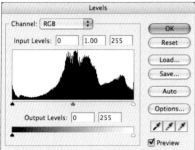

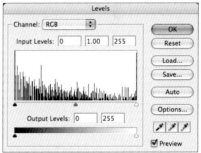

Well-distributed tones

As you can see from this Levels histogram, a bright, well-exposed image fills all the available range of pixels, with no gaps. Since the image contains many light tones,

there are more pixels lighter than midtone, so the peak of the histogram lies to the right of center. This image would tolerate a lot of manipulation thanks to the richness of color data it contains.

Deficient color data

An image with only a limited color range, such as this still-life composition, can be turned into a very small file by saving it as an indexed color file (*p. 130*). In fact, just 55 colors were sufficient to represent this scene with hardly any loss of subject information. However, the

comblike Levels histogram associated with it indicates just how sparse the available color data was. Any work on the image to alter its colors or tonality, or the application of filter effects that alter its color data, would certainly show up artifacts and produce unpredictable results.

Histogram display

The histogram for this image shows midtones dominated by yellow and blue with large amounts of red in mid- to light tones, consistent with the strong orange color of the shirt. This display is from the FotoStation application, which displays histograms for each RGB separation in the corresponding color.

Burning-in and dodging

Two techniques used in film-based and digital photography for manipulating the local density of an image are known as burning-in and dodging.

Controlling density

Burning-in increases the density in the area of the image being worked on, while dodging reduces it. Both techniques have the effect of changing the tonal reproduction of the original either to correct errors in the initial exposure or to create a visual effect. For example, the highlights and shadows of both film and digital images are low in contrast, and to counteract this you can burn in and dodge

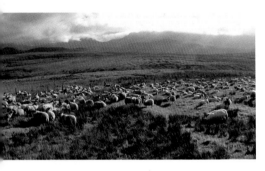

to bring out what shadow and highlight detail does exist by increasing local image contrast.

The same techniques can be used in order to reduce contrast—to darken highlight areas, for example—to bring them tonally closer to image midtones. An often-used application of this in conventional photography is burning in areas of sky when printing to darken them. Increasing the exposure of the sky (while shading, or dodging, the rest of the print) not only helps differentiate sky and cloud tonally, it also helps to match the sky tones to those of the foreground.

Digital techniques

In digital photography, burning-in and dodging are easily achieved using the tools available in all image-manipulation software. Working digitally, you can be as precise as you like—down to the individual pixel, if necessary. And the area treated can be between 1 and 100 percent of the image area, nominated by the Marquee or Lasso tool.

A drawback of working digitally, however, is that when manipulating large areas, results are often patchy and uneven, while working on large areas in the darkroom is easy.

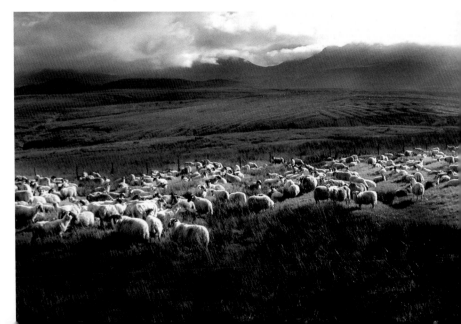

Working digitally, some applications allow you to set the tool for the shadows, midtones, or highlights alone. Carefully choosing the tonal range to be manipulated helps avoid telltale signs of clumsy burning-in and dodging. Corresponding techniques, available in Photoshop and some other professional software packages, are known as Color Dodge and Color Burn painting modes.

Color Dodge is not only able to brighten up the image, but also pushes up image contrast as you apply the "paint." In addition, if you set a color other than white, you simultaneously tint the areas being brightened. Color Burn has similar effects—darkening and increasing image contrast.

Correcting exposure

Taken on a bright winter afternoon, the camera's meter was fooled by the sudden appearance of the sun within the picture area, causing it to underexpose the scene (*above left*). This situation can be rescued using the Dodging tool set to work on the highlights areas alone. However, to produce the corrected image shown here (*above right*), the Paintbrush tool was chosen and set to Color Dodge. By using the brush in this mode, set to a mid-gray color and with lowered opacity (for example, 50 percent), you will obtain more rapid results with less tendency to burn out subject details. As an optional way of working, paint onto a new layer set to Color Dodge mode.

Correcting color balance

Looking at the original image (*above left*), the temptation to burn in the foreground and some of the background in order to "bring out" the sheep is irresistible. Brief applications of the Burn tool on the foreground (set to mid-tone at 10 percent) and background hills, plus the Dodge tool on the sheep (set to highlight at 5 percent) produced an image (*left*) that was very similar to the scene as it appeared at the actual time of shooting.

HINTS AND TIPS

- Apply dodging and burning-in techniques with a light touch. Start off by using a light pressure or a low strength of effect—say, 10 percent or less—and then build up to the strength the image requires.
- When burning in image highlights or bright areas, set the tool to burn in the shadows or midtones. Do not set it to burn in the highlights.
- When burning in midtones or shadows, set the tool at a very light pressure to burn in the highlights or midtones. Do not set it to burn in the shadows.
- When dodging midtones, set the tool at very light pressure to dodge the highlights or midtones. Do not set it to dodge the shadows.
- When dodging shadows, set the tool to dodge the highlights. Do not set it to dodge the shadows.
- Use soft-edged or feathered Brush tools to achieve more realistic tonal results.

Heightening contrast
Prayer flags in Bhutan are always a visual treat. Here, the flags were dodged to make them lighter, while the mountains and other dark areas were burned-in slightly to increase the contrast with the flags.

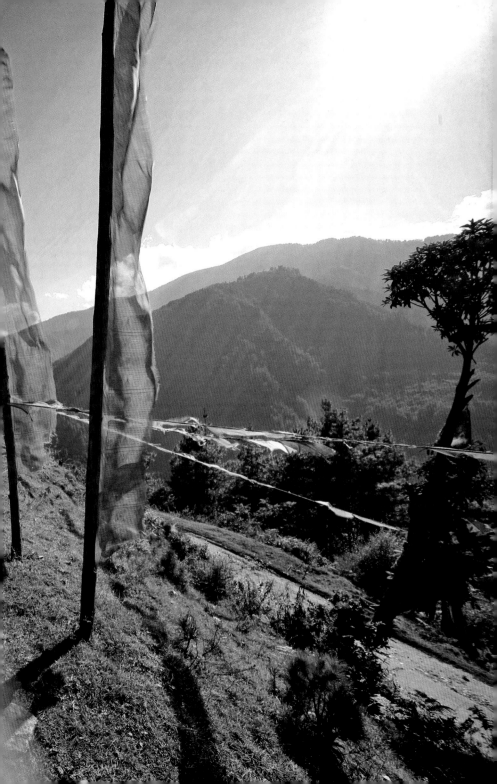

Sharpening

The ease with which modern image-manipulation software can make a soft image appear sharp is almost magical. Although software cannot add to the amount of information contained in an image, it can put whatever information is there to the best possible use. Edges, for example, can be given more clarity and definition by improving local contrast.

Digitally, sharpen effects are true filters, since they hold back some components and selectively let others through. A Sharpen filter is, in reality, a "high-pass" filter—it allows high-frequency image information to pass while holding back low-frequency information.

Unsharp Masking

The most versatile method of image sharpening is Unsharp Masking (USM). This takes a grid of pixels and increases edge definition without introducing too many artifacts. Unsharp Mask has three settings. In Photoshop, they are called Amount, Radius, and Threshold. Amount defines how much sharpening to apply; Radius defines the distance around each pixel to evaluate for a change; Threshold dictates how much change must occur to be acceptable and not be masked.

It is possible to overdo sharpening. In general, assess image sharpness at the actual pixel level, so that each pixel corresponds to a pixel on the monitor. Any other view is interpolated (*see pp. 114–5*) and edges are softened, or antialiased, making sharpness impossible to assess properly.

As a guide, for images intended for print, the screen image should look very slightly oversharpened, so artifacts (such as halos or bright fringes) are just visible. For on-screen use, sharpen images only until they look right on the screen.

Sharpening makes deep image changes that cannot easily be undone, so it is generally best to leave sharpening to last in any sequence of image manipulations, except for combining different layers. However, if you are working on a scan with many dust specks and other similar types of faults, you should expect the final sharpening to reveal more fine defects, so be prepared for another round of dust removal using cloning (*see pp. 112–3*).

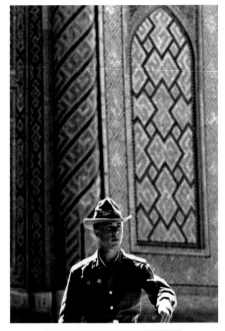

Undersharpening
In images containing large amounts of fine detail, such as this scene taken in Uzbekistan, applying a modest strength of USM filtering (55) and a large radius (22), with a threshold set at 11, does little for the image. There is some uplift in sharpness, but this is due more to an overall increase in contrast than to any other effect.

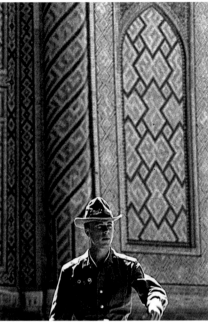

Oversharpening

The maximum strength setting used for this version results in oversharpening—it is still usable and is arguably a good setting if you intend to print on poor-quality paper. Strong sharpening also improves midtone macro-contrast, giving more sparkle and "bite" to the image. This can be more effective than using the contrast control.

Ideal setting

The best settings for images with fine detail is high strength with a small radius and a very low threshold: here, strength was 222, the radius was 2, and the threshold was kept at 0. Details are all well defined, and if large-size prints are wanted, details are crisper than those obtained with sharpening using a larger radius setting.

Dust and noise

Two factors are the "forever enemies" of image quality: dust and noise. Dust spots on the image result when material such as dust or pollen lands on the photosensor of a digital camera. Dust is a serious problem with dSLRs, since debris on the photosensing surface will be recorded on every image. Noise—usually seen as pixels markedly different to neighboring pixels and not caused by subject features—arises from the electronic properties of the photosensor of a digital camera or from electrical effects in the circuitry.

Noise control

The best way to avoid digital image noise is to use low ISO settings. When you have to use high settings, noise can be reduced only where it has a higher frequency than the image detail itself—in other words, if the specks are much smaller than the detail in the image. If the noise is similar in size to the detail, applying a filter will smudge or blur image information at the same time as suppressing the noise signals.

Changing the resolution of the image—either up or down—makes little or no contribution to reducing noise.

Digital filters such as Noise Ninja are effective, and all raw converters can reduce noise. DxO Optics stands out by reducing noise before applying the color filter array interpolation.

Dust-removal options

Many cameras incorporate mechanisms to reduce dust, using, for example, rapid vibration to shake off particles or antistatic coatings on the sensor to avoid attracting particles in the first place.

Certain digital SLR models offer dust-removal software: you photograph a plain surface, have the result analyzed by the software, which then creates a "mask" that can be applied to images to remove the dust. You may also have to help the camera directly by cleaning the sensor using ultra-soft micro-porous swabs or ultra-fine brushes that sweep up the dust and reduce static charges.

Dust on sensor
A 300 percent enlargement of the corner of a digital camera capture (*above*) shows a few faint specks of dust. They are blurred because they lie some distance above the sensor, which "sees" only their shadows. However, with manipulation the pale spots will become more visible.

Dust revealed
The full extent of the dust spots is revealed when we apply an adjustment layer to increase contrast and decrease exposure of the image (*left*). This presents the worst-case scenario and makes it easy to identify and eliminate the spots.

Dust removed
Use the Spot Healing Brush, Healing Brush or Clone Stamp tool to remove the dust spots. Set the brush to just slightly larger than the average spot, with a sharply defined brush edge, and sweep systematically in one direction.

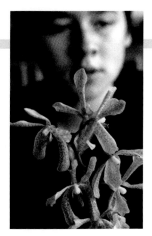

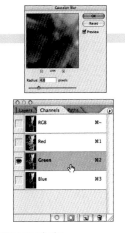

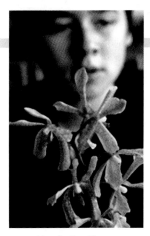

Noisy image
Poor noise-suppression circuitry and an exposure of ⅛ sec gave rise to this "noisy" image. Long exposures increase the chance of stray signals, which increase noise in an image.

Screen shots
Examining the different channels (*above*) showed that the noisiest was the green one. This was selected and Gaussian Blur applied (*top*). The radius setting was adjusted to balance blurring of the specks while retaining overall sharpness.

Smoother but softer
The resulting image offers smoother tones—especially skin tones—but the cost is visible in reduced sharpness of the orchids. You could select the red and blue channels to apply Unsharp Masking to improve the appearance of the flowers.

Manual dust removal

The key image-repair technique is to replace the dust with pixels that blend in with neighboring pixels. You may select the source for the pixels to cover the dust using the clone tool (*see pp. 176-7*) but this easily introduces artifacts. Alternatively, you apply a correction on the dust spot itself: the software "heals" the spot by sampling contiguous pixels around the spot then applying an algorithm that blends the local pixels with the dust. This tends to produce fewer artifacts but needs to be used with care where a spot is adjacent to a sharp boundary line.

Where several images carry the same spots, use software such as Aperture that can apply the same dust removal effect to many images at once.

Noise in detail
In this close-up view of an image, it is clear there is more noise, or random pixels (seen as specks and unevenness of tone), in the darker areas than in the brighter ones.

Compare the blue shadow area, for example, with the white plate. This is because noise in the photosensor is normally drowned out by higher signals, such as those generated by strong light.

HINTS AND TIPS

● Clone with the tool set to maximum pressure, or 100 percent—as lighter pressure produces a smudged or soft-looking clone.

● In even-toned areas, use a soft-edged or feathered Brush as the cloning tool. In areas with fine detail, use a sharp-edge Brush instead.

● You do not always have to eliminate specks of dust—reducing their size or contrast may be sufficient to disguise them.

● Work systematically from a cleaned area into areas with specks, or you may find yourself cloning dust specks, thereby compounding the problem.

● If cloning gives an overly smoothed look, introduce some noise to make it look more realistic. Select the area for treatment and then apply the Noise filter.

Image size and distortion

One of the most common manipulations is to change the output size of the image. There are three classes of change; the first two methods change size uniformly across the entire image, which does not change picture shape. You can change the output size of the image but keep the file size of the image the same: this is resize without resampling (or without changing the number of pixels). You can also resize with sampling, which changes the number of pixels in the image, in turn altering file size. Finally, the size change may be nonuniform— that is, you distort the image and change its shape.

Changing image size

In practice, you will likely set only a small range of sizes—from postcard to small poster, say. In general, you can increase the output size of your image by around 200 percent, but techniques such as spline-based or fractal interpolation can give enlargements of 1,000 percent of acceptable quality. Note that as print size increases, the assumption is that

viewing distance also increases. Files with higher resolution will support greater proportional enlargement than smaller files. All image manipulation can change image size, but specialized software such as Genuine Fractals or Photozoom, may do a better job.

Why distort?

You may distort an image to make it fit a specific area, for humorous effect or for visual impact. Images with irregular-shaped subjects are the best subjects, since the distortion is not too obvious.

The Transform tool can be used to solve a common photographic problem—projection distortion or key-stoning that occurs when the camera is not held square to a building or other geometrically regular subject. The digital solution to this problem is simple: a combination of cropping, allowing for losses at the corners if you have to rotate the image, followed by a controlled distortion of the entire image (*see p. 119*).

Destructive interpolation
The original landscape-format image of a flower and straplike leaves (*above*) was contracted on one axis only; so while depth remained the same, width was reduced to a third. This crams all the information into a narrow area and distorts the content of the image (*right*).

If, however, you decided to restore this image's original shape, it would not be as sharp as it originally was because the distortion is a destructive interpolation and involves the irretrievable loss of image information.

Comic effects

An image already distorted as a result of being shot from a very low camera angle has been taken to comic extremes to emphasize the subject's waving hand (*right*). Though sometimes amusing, such imagery needs to be used sparingly. The upper part of the image was widened by about 50 percent and the lower part was reduced by approximately the same amount. The resulting empty areas were then cropped off, as indicated by the white area on the screen (*above*).

What is interpolation?

Interpolation is a mathematical discipline vital to processes ranging from satellite surveys to machine vision (the recognition of license plates on speeding cars, for example). In digital photography, three methods of interpolation are used to alter image size. **"Nearest neighbor"** simply takes adjacent values and copies them for new pixels. This gives rough results with continuous-tone images, but it is the best way for bitmap line graphics (those with only black or white pixels).

"Bilinear interpolation" looks at the four pixels to the top, bottom, and sides of the central pixel and calculates new values by averaging the four. This method gives smoother-looking results.

"Bicubic interpolation" looks at all eight neighboring pixels and computes a weighted average to give the best results. However, this method requires more computing power.

Image Size

Pixel Dimensions: 7.00M

Width: 1396 pixels
Height: 1752 pixels

OK · Cancel · Auto...

Document Size:

Width: 4.653 inches
Height: 5.84 inches
Resolution: 300

☑ Scale Styles
☑ Constrain Proportions
☑ Resample Image:

Nearest Neighbor
Bilinear
Bicubic
Bicubic Smoother
✓ Bicubic Sharper

Image Size screen shot

If you have the professional image-manipulation software package Photoshop, you have the option of choosing your default interpolation method from the general application preferences menu, or you can override the default for each resizing operation using the Image Size dialog box (*above*).

Quick fix Image distractions

Unless there is a fundamental problem with your image, most minor distractions can be removed, or at least be minimized, using digital techniques.

Problem

While concentrating on your subject, it is easy not to notice distracting objects in the picture area. This could be something minor, such as a discarded food wrapper, but out-of-focus highlights can also be a problem.

Analysis

The small viewfinders of many cameras make it difficult to see much subject detail. Furthermore, though something is distant and looks out of focus, it may still be within the depth of field of your lens (see pp. 18–21). At other times, you simply cannot avoid including, say, telephone lines in the background of a scene.

Solution

You may not need to remove a distraction completely—simply reducing the difference between it and adjacent areas may be enough. The usual way to achieve this is with cloning—duplicating part of an image and placing it into another part (see pp. 176–9). For example, blue sky can be easily cloned onto wires crossing it, as long as you are careful to use areas that match in brightness and

hue. If you clone from as close to the distraction as possible, this should not be too much of a problem.

You could also try desaturating the background: select the main subject and invert the selection; or select the background and lower saturation using Color Saturation. You could also paint over the background using the Saturation or Sponge tool set to desaturate.

Another method is to blur the background. Select the main subject and invert the selection, or select the background directly, and apply a Blur filter. Select a narrow feather edge to retain sharpness in the subject's outline. Choose carefully or, when Blur is applied, the selected region will be left with a distinct margin. Try different settings, keeping in mind the image's output size—small images need more blur than large ones.

How to avoid the problem

Check the viewfinder image carefully before shooting. This is easier with an SLR camera, which is why most professionals use them. Long focal length lenses (or zoom settings) reduce depth of field and tend to blur backgrounds. And, if appropriate to the subject, use a lower viewpoint and look upward to increase the amount of non-distracting sky.

Problem...

Foreground distraction

An old man photographed in Greece shows me a picture of his sons. As he leans over the balcony, the clothespins in front of his chin prove impossible to avoid.

...solution

Cloning

Luckily, in this example there was enough of the man's skin tone visible to give a convincing reconstruction. To do this, the skin part of the image was used to clone areas of color over the adjacent distractions.

Problem...

Background distractions
In the chaos of a young child's room, it is neither possible nor desirable to remove all the distractions, but toning them down would help to emphasize the main subject.

Desaturated background
Applying Desaturate to the background, turn into gray, has helped separate the girl from th surrounding her. A large, soft-edged Brush to the printing mode was set to desaturation at

Problem...

Selective blur
Despite using a large aperture, a wide-angle lens setting still produced more depth of field than I wanted in this example (*above left*). To reduce the intrusive sharpness of the trees, I used the Gaussian Blur filter set to a radius of 9 pixels (*right*). First, I selected the figure with a feathering of 5 and then inverted this selection in order to apply the Gaussian Blur to the background alone (*above right*).

Quick fix Image framing

Don't allow your images to become unnecessarily constrained by the sides of the camera viewfinder or the regular borders of your printing paper. There are creative options available to you.

Problem

The precise and clear-cut rectangular outlines around images can not only become boring, but sometimes they are simply not appropriate—for example, on a website where the rest of the design is informal. What is needed is some sort of controlled way of introducing some variety to the way you frame your images.

Analysis

In the majority of situations, producing images with clean borders is the most appropriate method of presentation. But with the less-formal space of a webpage, a looser, vignetted frame might be a better option. On occasion, a picture frame can also be used to crop an image without actually losing any crucial subject matter.

Solution

Scan textures and shapes that you would like to use as frames and simply drop them onto the margins of your images. Many software applications offer simple frame types, which you can easily apply to any image and at any size. Special plug-ins, such as Extensis Photoframe, simplify the process of applying frames and provide you with numerous, customizable framing options.

How to avoid the problem

The need to create picture frames usually arises from the desire to improve an image that has not been ideally composed. Nobody thinks about picture frames when looking at a truly arresting photograph. Inspect your pictures carefully, checking the image right to the edges. Tilting the camera when shooting creates a different style of framing, or simply crop off image elements you don't need.

Framing option 1
The first option applies a geometric frame in which it partially reverses the underlying tones of the image. It is effective in hiding unwanted details in the top left of the image, but its outline is perhaps too hard in contrast with the soft lines of the subject's body.

Framing option 2
The simplest frame is often the best—here it is like looking through a cleared area of fogged glass. The color of the frame should be chosen to tone in with the image. However, you should also consider the background color: on this black page, the contrast is too high, whereas against a white page or an on-screen background, the nude figure would appear to float.

Framing option 3
Here, a painterly effect is combined with a frame that reverses both hue and tone (a Difference mode). By carefully adjusting the opacity of the frame, the colors were toned down to match that of the main image. Finally, the frame was rotated so that the main axis nude figure runs across the diagonal, leading the eye from the thigh to her just-revealed breast.

Quick fix Converging parallels

While the brain largely compensates for visual distortions—so, in effect, you see what you expect to see—the camera faithfully records them all.

Problem

Images showing subjects with prominent straight lines, such as the sides of a building, appear uncomfortable when printed or viewed on screen because the lines appear to converge. Regular shapes may also appear sheared or squashed (see also p. 34).

Analysis

The change in size of different parts of the image is due to changes of magnification—different parts of the recorded scene are being reproduced at different scales. This occurs because of changes in distance between the camera and various parts of the subject. For example, when you look through the viewfinder at a building from street level, its top is farther away than its base—a fact that is emphasized by pointing the camera upward to include the whole structure. As a result, the more distant parts appear to be smaller than the closer parts.

Solution

Select the whole image and, using the Distortion or Transformation tool, pull the image into shape. If there are changes in magnification in two planes, both will converge, and so you will need to compensate for both.

How to avoid the problem

● Choose your shooting position with care and try to compose the image in order to keep any lines that are centrally positioned as vertical as possible. In addition, look to maintain symmetry on either side of the middle of the picture.

● Rather than pointing the camera upward, to include the upper parts of a building or some other tall structure, look for an elevated shooting position. This way, you may be able to keep the camera parallel with the subject and so minimize differences in scale between various parts of the subject as they are recorded by the camera.

1 Verticals converge
Shooting from ground level with the camera angled upward caused the scene to appear to tilt backward.

2 Image manipulation
Stretching the lower left-hand corner of the image using the Distortion tool is the solution to this problem.

3 Verticals corrected
The corrected image looks better and corresponds more closely to the way the scene looked in reality.

White balance

The basis of accurate color reproduction is neutrality—an equal distribution of colors in the whites, grays, and blacks in the image to help ensure accuracy of hue. The white balance control on digital cameras helps ensure neutral colors on capture. But when we open the image, we may have to take the process further and adjust the brightness and saturation, which are other dimensions of accurate color.

What balance?

An image that is color balanced is one in which the illuminating light offers all hues in equal proportion—in other words, the illumination is white and not tinted with color. Color balance is not to be confused with color harmony (*see p. 36*). Thus, a scene can be full of blues or greens yet still be color balanced, while another scene that features a well-judged combination of secondary colors may look harmonious, but may not be color balanced at all.

The aim of color balancing is to produce an image that appears as if it were illuminated by white light; this is achieved by adjusting the white point. However, there are different standards for white light, and so there are different white points. For example, it would not look natural to correct an indoor scene lit by domestic lamps in order to make it look like daylight, so a warm-toned white point is called for instead.

Color Balance control

This control makes global changes to the standard primary or secondary hues in an image. In some software, you can restrict the changes to shadows, highlights, or mid-tones. This is useful for making quick changes to an image that has, for example, been affected by an overall color cast.

Warm white point
The original picture of a simple still-life (*above left*) has reproduced with the strong orange cast that is characteristic of images lit by domestic incandescent lamps. The corrected image (*above right*), was produced using Color Balance. It is still warm in tone because a fully corrected image would look cold and unnatural.

Dropper tools

A quick method of working when you wish to color-correct an image is by deciding which part of the picture you want to be neutral—that part you want to be seen as without any tint. Then find the midtone dropper, usually offered in the Color, Levels, or Curves controls in image-manipulation software. Select the dropper, then click on a point in your image that you know should be neutral. This process is made easier if you used a gray card in one of your images—all images shot under the same lighting as the gray card will require the same correction. Clicking on the point samples the color data and adjusts the whole image so that the sampled point is neutral: the dropper maps the color data of all the image pixels around the sampled point.

When working with raw files, the choice of color temperature (blue to red) and of tint (green to magenta) is yours. Usually, you choose color temperature and tint to ensure neutral (achromatic or colorless) colors are truly neutral.

Balancing channels

While the Curves control is most often used to adjust image tonality, by altering the Curves or Levels of the individual color channels, you apply a color balance to the high tones that is different from that of the shadows. This is helpful, for

Original image
This original image has not been corrected in any way, and it accurately reproduces the flat illumination of a solidly cloudy sky.

example, when shadows on a cloudless day are bluish but bright areas are yellowish from the sun. It is easiest to work by eye, adjusting until you see the result you wish for, but for best control you can analyze the color in neutrals and manually put in corrections to the curve. Working in CMYK, using Curves gives a great deal of control and the best results for print. The Color Balance control is essentially a simplified version of using the component RGB channels in Curves.

Channel mixing is effective where a small imbalance in the strengths of the component channels is the cause of color imbalance, due to, for example, using a colored filter or shooting through tinted glass.

The Hue/Saturation control can also be used, as it shifts the entire range of colors en masse. This can be useful when the color imbalance is due to strong coloring of the illuminating light.

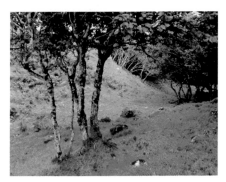

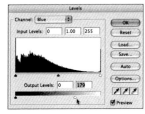

Color Balance control

Strong changes brought about via the Color Balance control, mainly by increasing yellow in the midtones— which is the lowest slider in the dialog box here— make the scene look as if it has been lit by an early evening sun.

Levels control

A golden tone has been introduced to the image here by forcefully lowering the blue channel in the Levels control— the middle slider beneath the histogram—thus allowing red and green to figure more strongly. Red and green additively produce yellow, and this color now dominates the highlights of the image.

Color adjustments

One of the most liberating effects of digital photography is its total control over color: you can control effects from the most subtle tints to the most outrageous color combinations.

Curves

Manipulating Curves, either all at once or as separate channels, is a potent way to make radical changes in color and tone. For best results, work in 16-bit color, as steep curve shapes demand the highest quality and quantity of image data.

Hue/Saturation

This control globally adjusts hues in the image, as well as the color saturation and, less usefully, the brightness. You may also select narrow ranges of colors to change, thus altering the overall color balance. Beware of making colors oversaturated, as they may not print out (*see pp. 41 and 188*).

Replace Color

This replaces one hue, within a "fuzziness" setting or wave-band, with another. Select the colors in the image you wish to change by sampling the

image with the Dropper tool, and then transform that part via the Hue/Saturation dialogue box (*see opposite*). By setting a small fuzziness factor—the top slider in the dialogue box—you select only those pixels very similar in color to the original; a large fuzziness setting selects relatively dissimilar pixels. It is best to accumulate small changes by repeatedly applying this control. Replace Color is good for strengthening colors that printers have trouble with (yellows and purples), or toning down colors they overdo (reds, for example).

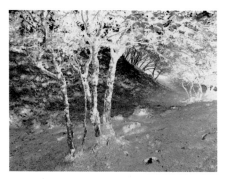

Color temperature

The color temperature of light has, in fact, nothing to do with temperature as we traditionally think of it; rather, color temperature is measured by correlating it to the color changes undergone by an object as it is heated. Experience tells us that cooler objects, such as candles or domestic lights, produce a reddish light, whereas hotter objects, such as tungsten lamps, produce more of a blue/white light.

The color temperature of light is measured in Kelvins, and a white that is relatively yellow in coloration might be around 6,000 K, while a white that is more blue in content might be, say, 9,500 K.

While color slide film must be balanced to a specific white point, digital cameras can vary their white point dynamically, according to changing needs of the situation.

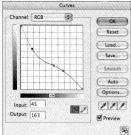

Curves control
A simple inversion of color and tone leaves dark shadows looking empty and blank. Manipulating tonal reproduction via the Curves dialog box, however, gives you more control, allowing you to put color into these otherwise empty deep shadows (the bright areas after inversion). In the

dialog box here you can see how the curve runs top left to bottom right—the reverse of usual—and the other adjustments that were made to improve density in the image's midtones.

Working in RGB

The most intuitive color mode to work in is RGB. It is easy to understand that any color is a mixture of different amounts of red, green, or blue, and that areas of an image where full amounts of all three colors are present give you white. The other modes, such as LAB and CMYK, have their uses, but it is best to avoid using them unless you have a specific effect in mind you want to achieve. When you are producing

image files to be printed out on paper, you may think you should supply your images as CMYK, since this is how they will be printed. However, unless you have the specific data or separation tables supplied by the processors, it is preferable to allow the printers to make the conversions themselves. In addition, CMYK files are larger than their RGB equivalents and thus are far less convenient to handle.

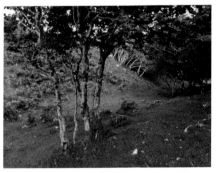

Hue/Saturation control

In this dialog box you can see that image hue has been changed to an extreme value, and this change has been supported by improvements in saturation and lightness in order to produce good tonal balance. Smaller changes in image hue may be effective

for adjusting color balance. Bear in mind that colors such as purples look brighter and deeper on a monitor than in print because of limitations in the printer's color gamut (*pp. 41 and 186–9*).

Replace Color control

Four passes of the Replace Color control were made to create an image that is now very different from that originally captured (*p. 121*). The dialog box here shows the location of the colors selected in the small preview window, and the controls are

the same as those found in the Hue and Saturation dialog box (*above left*), which allow you to bring about powerful changes of color. However, for Hue and Saturation to have an effect, the selected values must indeed have color. If they are gray, then only the lightness control makes any difference.

Quick fix Problem skies

A common problem with views taking in both sky and land is accommodating the exposure requirements of both—a correctly exposed sky leads to a dark foreground, or a correctly exposed foreground gives a featureless, burned-out sky.

Problem

Skies in pictures are too bright, with little or no detail and lacking color. This has the effect of disturbing the tonal balance of the image.

Analysis

The luminance range can be enormous outdoors. Even on an overcast day, the sky can be 7 stops brighter than the shadows. This greatly exceeds the capacity of all but the most advanced scanning backs.

Solution

If an area of sky is too light in a scan from a negative (black and white or color), it is best to make a darkroom print and burn the sky in manually (see pp. 106–7). Then you can scan this corrected print if further manipulations are required. Digital solutions will be of no help if the sky presents plain white pixels devoid of subject information. For small overbright areas, you can use the Burn-in tool, set to darken shadows or midtones, at very low pressure.

Don't set it to darken highlights or the result will be unattractive smudges of gray.

Another method is to add a layer, if your software allows, with the Layer mode set to Darken or Luminosity (which preserves colors better). You can then apply dark colors where you want the underlying image darker. The quickest method to cover large areas is to add a Gradient Fill—this is equivalent to using a graduated filter over the camera lens, but it is somewhat indiscriminate.

A more complicated method requires some planning. You take two identically framed images—one exposed for the shadows, the other for the highlights. This is best done in a computer, where it is a simple matter of superimposing the two images with a Gradient Mask.

How to avoid the problem

Graduated filters attached to the camera lens are as useful in digital as traditional photography— their greater density toward the top reduces exposure compared with the lower part of the filter, so helping to even out exposure differences between sky and foreground. It is worth bearing in mind that some exposure difference between the land and sky is visually very acceptable.

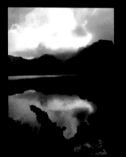

1 Gradient Fill
Areas of overbright highlight, as in the sky of this landscape, can be corrected using Gradient Fill. This mimics the effect of a graduated filter used on the camera lens.

2 Layers screen shot
First, a new layer was created and the Layer mode set to Darken. This darkens lighter pixels but not those already dark. A graduated dark blue was then applied to the top corners with medium opacity.

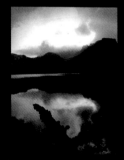

3 Final effect
This digital treatment does not increase graininess, as conventional burning-in would do, but note how local darkening lowers overall image brightness. Further adjustments to brighten the lake are possible.

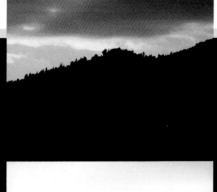

1 Masking overlays

The basis of this technique is to take two identically framed images—one exposed for the sky (*top*), the other exposed for the foreground (*above*)—and then composite them using a gradient or graduated mask to blend them smoothly. You need image-manipulation software that works with Layers and Masks (*pp. 168–75*). This is easy for digital photographers, but if you shoot on film, you can scan an original twice (once for highlights, once for shadows), ensuring that the two are the same size, and copy one over to the other.

2 Making a gradient mask

Next, using Layers control, you have to create a gradient mask, which allows you to blend one image smoothly into the other (*top*). Notice that this entire image is slightly transparent: in other words, the whole image is masked but there is heavier masking in the lower half, as you can see in the dialog box (*above*). The overall effect of applying this mask is that the lower image will show through the top layer.

3 Final effect

Blending the two exposures and the mask produces an image that is closer to the visual experience than either original shot. This is because our eyes adjust when viewing a scene, with the pupil opening slightly when we look at darker areas and closing slightly when focusing on bright areas. A camera cannot adjust like this (although certain professional digital cameras can partly compensate). Image-manipulation techniques can thus help overcome limitations of the camera.

Curves

The Curves control found in image-manipulation software may remind some photographers of the characteristic curves published for films. This is a graph that shows the density of sensitized material that will result from being exposed to specific intensities of light. In fact, there are similarities, but equally important are the differences. Both are effectively transfer functions: they describe how one variable (the input either of color value or of the amount of light) produces another variable (the output or density of silver in the image).

The principal difference is that when it comes to image-manipulation software, the curve is always a 45° line at the beginning. This shows that the output is exactly the same as the input. However, unlike the film curve, you can manipulate this directly by clicking on and dragging the curve or by redrawing the curve yourself. In this way, you force light tones to become dark, midtones to become light, and with all the other variations in between. In addition, you may change the curve of each color channel separately.

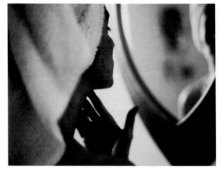

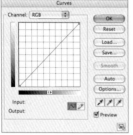

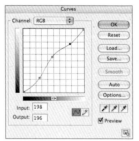

Original image and curve

Since the original negative was slightly underexposed, the image from the scan is tonally rather lifeless. You cannot tell anything about exposure by looking at the curve in the screen shot (*above*) because it describes how one tone is output as another. As nothing has been changed, when it first appears the line is a straight 45°, mapping black to black, midtone to midtone, and white to white. It is not like a film characteristic curve, which actually describes how film is responding to light and its processing.

Boosting the midtones

The bow-shaped curve displayed here subtly boosts the midtone range of the image, as you can see in the resulting image (*top*). But the price paid is evident in the quarter-tones, where details in the shadows and the details in the highlights are both slightly darkened. The result is an image with, overall, more tonal liveliness; note, too, that the outline of the subject's face has been clarified. With some image-manipulation software, you have the option of nudging the position of the curve by clicking on the section you want to move and then pressing the arrow keys up or down to alter its shape.

What the Curves control does

The Curves control is a very powerful tool indeed and can produce visual results that are impossible to achieve in any other way. By employing less extreme curves, you can improve tones in, for example, the shadow areas while leaving the midtones and highlights as they were originally recorded. And by altering curves separately by color channel, you have unprecedented control over an image's color balance. More importantly, the color changes brought about via the Curves control can be so smooth that the new colors blend seamlessly with those of the original.

In general, the subjects that react best to the application of extreme Curve settings are those with simple outlines and large, obvious features. You can try endless experiments with Curves, particularly if you start using different curve shapes in each channel. The following examples (*see pp. 128–9*) show the scope of applying simpler modifications to the master curve, thereby changing all channels at the same time.

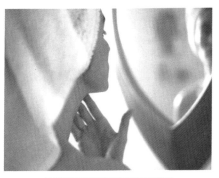

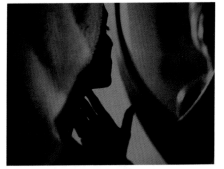

Emphasizing the highlights

The scan's flat, dynamic range suggests that it could make an effective high-key image by changing the curve to remove the black tones (the left-hand end of the curve in the screen shot is not on black but is raised to dark gray) and mapping many highlight tones to white (the top of the curve is level with the maximum for nearly a third of the tonal range). The result is that the input midtone is set to give highlights with detail. Very small changes to the curve can have a large effect on image, so if you want to adjust overall brightness, it is easier to commit to the curve and then use Levels to adjust brightness (pp. 104–5).

Emphasizing the shadows

The versatility of the original image is evident here, as now it can be seen working as an effective low-key picture. The mood of the picture is heavier and a little brooding, and it has lost its fashion-conscious atmosphere in favor of more filmic overtones. The curve shown in the screen shot has been adjusted not simply to darken the image overall (the right-hand end has been lowered to the midtone so that the brightest part of the picture is no brighter than normal midtone). In addition, the slight increase in the slope of the curve improves contrast at the lower midtone level to preserve some shadow detail. This is crucial, as too many blank areas would look unattractive.

Curves continued

Original image

The image you select for manipulating Curves does not have to be of the highest quality, but it should offer a simple shape or outline, such as this church. In addition, the range of colors can be limited—as you can see below, dramatic colors will be created when you apply Curves with unusual or extreme shapes.

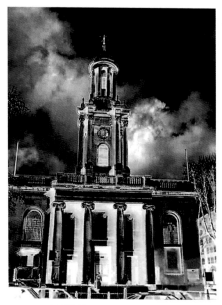

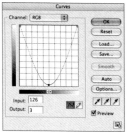

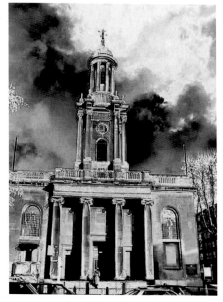

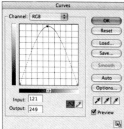

Reversing dark tones

A U-shaped curve reverses all tones darker than midtone and forces rapid changes to occur—an increase in image contrast, for example. The deep shadows in the church become light areas, giving a negative type of effect, but the clouds have darkened and greatly increased in color content. The effect of using this shape curve is similar to the darkroom Sabattier effect, when exposed film or paper is briefly reexposed to white light during development.

Reversing light tones

An arc-shaped curve reverses the original's lighter tones, giving the effect shown here. Although it looks unusual, it is not as strange as reversing dark tones (*left*). Note that the curve's peak does not reach the top of the range—the height of the arc was reduced to avoid creating overbright white areas. The color of the building changes as the red-green color in the normal image was removed by the reversal, allowing the blue range to make its mark.

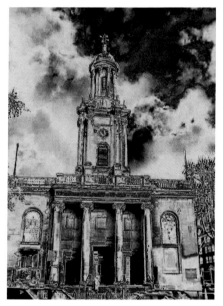

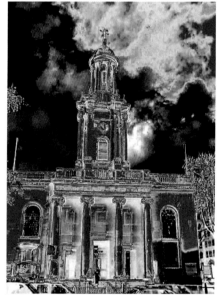

Tone/color reversal

Applying an M-shaped curve plays havoc with our normal understanding of what a color image should look like. Not only are the tones reversed as a result, but areas with dominant color whose tones have been reversed will also take on a color that is complementary to their own. And since parts of the tonal range are reversed and others are not, the result is a variegated spread of colors.

Using small files

When working on smaller image files, the results on the image of applying extreme curves become increasingly unpredictable due to gaps in the color data the software has to work with. When a W-shaped curve is applied, the picture becomes rather garish, an effect emphasized by the theatricality of the black sky. You can also see how some picture areas have sharply defined colors while others have smooth transitions, due to variations in the pixel structure of JPEGs (pp. 92–3).

Bit-depth and color

The bit-depth of an image file tells you its tonal resolution—that is, how finely it can distinguish or reproduce tones or shades. A bit-depth of 1 identifies just two tones—black or white; a bit depth of 2 can record four tones; and so on. The number of tones that can be recorded is 2 to the power of the bit-depth, so a typical bit-depth of 8 records 256 tones. When these are applied across the color channels, bit-depth measures the resolution of colors. Thus, 8 bits over three color channels—8 bits x 3 channels—gives 24 bits, the usual bit-depth of digital cameras. This means, in theory, that each color channel is divided into 256 equally spaced steps, which is the minimum requirement for good-quality reproduction.

Number of hues

The total number of hues available to a 24-bit RGB color space, if all combinations could be realized, is in the region of 16.8 million. In practice this is never fully realized, nor is it necessary. A typical high-quality monitor displays around 6 million hues, while a color print can manage fewer than 2 million, and the best digital prints reach a paltry 20,000 different hues at the most. However, the extra capacity is needed at the extreme ends of the tonal and color scale, where small changes require much coding to define, and data is also needed to ensure that subtle tonal transitions such as skin tones and gradations across a sky are smooth and not rendered aliased (also described as stepped or posterized).

Higher resolution

Increasingly, 24-bit is not measuring up to our expectations: tones are not smooth enough and there is insufficient data for dramatic changes in tone or color. This is why, when applying curves with very steep slopes, the image breaks up. Better-quality cameras can record images to a depth of 36 bits or more, but images may be down-sampled to 24-bit for processing. Even so, such images are better than if the images had been recorded in 24-bit. When working in raw format, you may be working in 16-bit space: if you wish to maintain the quality inherent, though not guaranteed, of 16-bit, process and save the file as 16-bit (48 bits RGB).

File size

Once the image is ready for use, you may find that surprisingly few colors are needed to reproduce it. A picture of a lion among sun-dried grass stems on a dusty plain, for example, uses only a few yellows and desaturated reds. Therefore, you may be able to use a small palette of colors and greatly reduce file size. This is particularly useful to remember when optimizing files for the web.

Some software allows images to be stored as "index color." This enables image colors to be mapped onto a limited palette of colors, the advantage being that the change from full 24-bit RGB to an index can reduce the file size by two-thirds or more. Reducing the color palette or bit-depth should be the last change to the image since the information you lose is irrecoverable.

Color bit-depth and image quality

When seen in full color (*left*), this image of colored pens is vibrant and rich, but the next image (*middle*), containing a mere 100 colors, is not significantly poorer in quality. Yet this index color image is only a third of the size of the full-color original. As the color palette is reduced still further, to just 20 colors (*right*), the image is dramatically inferior. However, since this change does not reduce file size any further, there is no point in limiting the color palette beyond what is necessary.

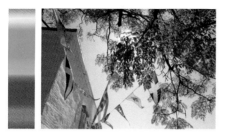

Original full depth
This image of a church in Greece was recorded as a 12-bit (36-bit RGB) raw image, then processed into an 8-bit file (24-bit RGB). It retains full subtlety of the skies and the transparency and colors of the bunting.

Two levels (tones)
With only two levels (tones) per color channel, a surprising amount of the original image is retained, with many shapes still well defined. But note the wall in shadow is completely black, and many of the sky tones are blank.

Four levels
With four levels, the sky tones are filled in but they are very patchy and with large jumps in tone and no accuracy of color, simply because the nearest available hue is used. Generally, colors are more saturated than in the original image.

24 levels
With 24 levels, the original image is almost fully reproduced, but the failures are in the sky: note that it remains much darker than in the original, and what was a light area in the lower part of the original is darker than the rest of the sky here.

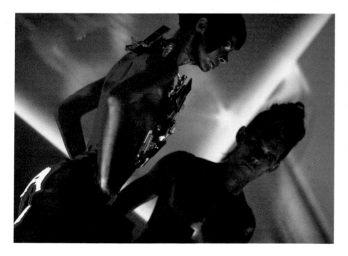

Limited palette, numerous colors
This image appears to use very few colors. However, the tonal variations of deep cyans, blues, and magentas are so subtle that at least 200 different hues are needed to describe the image without loss of quality. Nonetheless, an indexed color version of the file is a quarter of the size of the RGB version.

Color into black and white

Creating a black and white picture from a color original allows you to change the shot's emphasis. For example, a portrait may be marred by strongly colored objects in view, or your subjects may be wearing clashing colored clothing. Seen in black and white, the emphasis in these pictures is skewed more toward shape and form.

The translation process

A black and white image is not a direct translation of colors into grayscale (a range of neutral tones ranging from white to black) in which all colors are accurately represented—many films favor blues, for example, and record them as being lighter than greens.

When a digital camera or image-manipulation software translates a color image, it refers to a built-in table for the conversion. Professional software assumes you want to print the result and so makes the conversion according to a regimen appropriate for certain types of printing presses and papers. Other software simply turns the three color channels into gray values before combining them—generally giving dull, murky results.

There are, however, better ways of converting to black and white, depending on the software you have. But before you start experimenting, make sure you make a copy of your file and work on that rather than the original. Bear in mind that conversions to black and white loses color data that is impossible to reconstruct.

Before you print

After you have desaturated the image (*see box below*), and despite its gray appearance, it is still a color picture. So, unless it is to be printed on a four-color press, you should now convert it to grayscale to reduce its file size. If, however, the image is to be printed in a magazine or book, remember to reconvert it to color—either RGB or CMYK. Otherwise it will be printed solely with black ink, giving very poor reproduction.

Four-color black

In color reproduction, if all four inks (cyan, magenta, yellow, and black) are used, the result is a rich, deep black. It is not necessary to lay down full amounts of each ink to achieve this, but a mixture of all four inks (called four-color black) gives excellent results when reproducing photographs on the printed page. Varying the ratio of colors enables subtle shifts of image tone.

Desaturation

All image-manipulation software has a command that increases or decreases color saturation, or intensity. If you completely desaturate a color image, you remove the color data to give just a grayscale. However, despite appearances, it is still a color image and looks gray only because every pixel has its red, green, and blue information in balance. Because of this, the information is self-canceling and the color disappears. If, though, you select different colors to desaturate, you can change the balance of tones. Converting the image to grayscale at this point gives you a different result from a straight conversion, since the colors that you first desaturate become lighter than they otherwise would have been.

Saturation screen shot
With the color image open, you can access the Saturation control and drag the slider to minimum color. This gives a gray image with full color information. In some software you can desaturate the image using keystrokes instead (such as Shift+Option+U in Photoshop, for example).

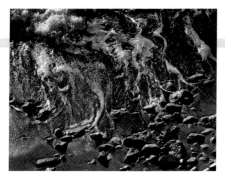

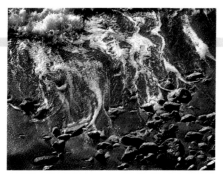

Color saturation

While the original color image is full of light and life, the colors could be seen as detracting from the core of the image—the contrasts of the textures of the water, sand, and stones. This is purely a subjective interpretation, as is often the case when making judgments about images.

Color desaturation

By removing all the colors using the Saturation control to give an image composed of grays, the essentials of the image emerge. The Burn and Dodge tools (*pp. 106–7*) were used to bring out tonal contrasts—darkening the lower portion of the picture with the Burn tool, while bringing out the sparkling water with the Dodge tool.

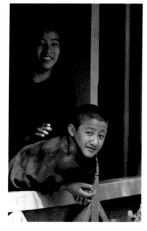

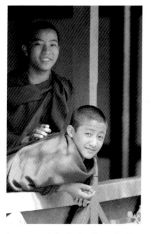

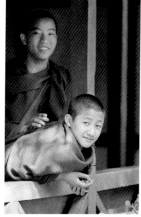

Overcoming distracting color

The strong reds and blues (*above left*) distract from the friendly faces of these young monks in Gangtok, Sikkim. However, a straight desaturation of the image gives us a tonally unbalanced result. Attempts to desaturate selectively by hue will founder because the faces are a pale version of the red habits. We need to compensate for the tonally unattractive product of desaturation (*middle*) by redistributing the tones to bring attention to the boys' faces. This involves reducing the white point to control the sunlit area in the foreground, plus a little burning-in to darken the light areas of the habit and the hand of the monk behind. Then, to bring some light into the faces (*right*), we use the Dodging tool set to Highlights.

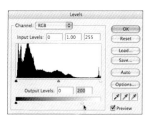

Levels screen shot

With the desaturated image open, move the white point slider in the Levels dialog box to force the brightest pixels to be about a fifth less bright: in other words, to have a value no greater than 200.

When color just won't do
The original image of this Chinese girl was brilliantly colored. However, by converting it to black and white, all distractions are removed and attention is focused into the girl's eyes.

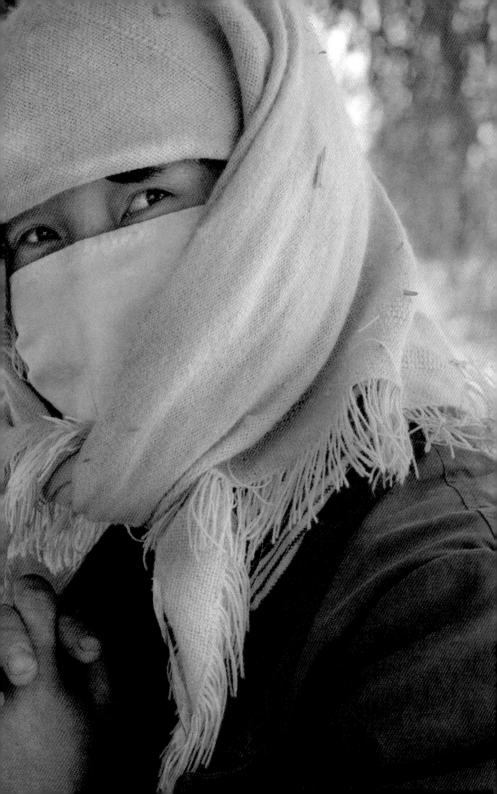

Color into black and white continued

Channel extraction

Since a color image consists of three grayscale channels, the easiest way to convert the color to grayscale is to choose, or extract, one of these and abandon the others. This process is known as "channel extraction," but it is available only as part of more professional software packages.

When you view the image normally on the monitor, all three color channels are superimposed on each other. However, if you look at them one channel at a time, your software may display the image as being all one color—perhaps as reds of different brightnesses, or as a range of gray tones, according to the software preferences you have set. If your software gives you the option, choose to view the channels as gray (by selecting this from the preferences or options menu). Then, simply by viewing each channel, you can choose

the one you like best. Now, when you convert to grayscale, the software should act on the selected channel alone, converting it to gray.

Some software may allow you to select two channels to convert to gray, thus allowing you a great deal of experimention with the image's appearance. In general, the channels that convert best are the green, especially from digital cameras, because the green channel is effectively the luminance channel, and the red, which often gives bright, eye-catching results.

Another method, available in Photoshop, is to use Split Channels to produce three separate images. With this, you save the image you like and abandon the others. Note, however, that this operation cannot be undone—the extracted file is a true grayscale, and is just a third the size of the original file.

Red-channel extraction

While the colors of the original image are sumptuous (*above left*), black and white seemed to offer more promise (*above right*). It is clear that the sky should be dark against the mane and cradling hand, so the green and blue channels (*right*) were of no help. Neither was the

lightness channel (*opposite*), since it distributes tonal information too evenly. The red channel, however, presented the blues as dark and the brown of the horse as light. So, with the red channel extracted, no extra work was needed.

Channels screen shot

If your software allows, select color channels one at a time to preview the effects of extraction. Turn off the color if the software shows channels in their corresponding colors.

Blue channel

Red channel

Comparing channels
RGB color images comprise three grayscale images. Here, the B channel is dark while the R is too light, but the green is well balanced, as it carries the detail. This is confirmed by the L channel in LAB mode (far right).

Green channel

LAB (with Lightness channel extracted)

LAB mode

When you convert an RGB color image image to LAB, or Lab, mode (a shortened form of L*a*b*), the L channel carries the lightness information that contains the main tonal details about the image. The a* channel values represent green when negative and magenta when positive; the b* represents blue when negative, yellow when positive. Using software, such as Photoshop, that displays channels, you can select the L channel individually and manipulate it with Levels or Curves without affecting color balance. With the L channel selected, you can now convert to grayscale and the software will use only the data in that channel. If your software gives you this option, you will come to appreciate the control you have over an image's final appearance, and results are also likely to be sharper and more free of noise than if you had extracted another of the channels to work on. The extracted file is a true grayscale, and so it is only a third of the size of the original color file.

LAB channels
In the Channels palette of Photoshop, you can select individual channels, as shown above. In this example, the screen will display a black-and-white image of the girl (*as above, center right*).

Color into black and white continued

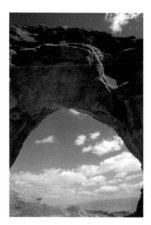

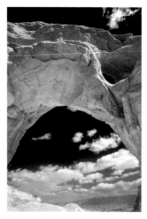

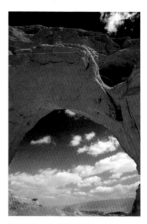

Original image
A simple conversion of this image could make colors look lifeless—a problem avoided by using the Channel Mixer control (*below*).

Working in RGB mode
In RGB, the blue channel was reduced, making the sky dark, and the red was increased to compensate. Results of using these settings are contrasty and dramatic, but the foreground is too bright.

Working in CMYK mode
With the original image translated into CMYK mode, results are noticeably softer than those achieved via the Channel Mixer in RGB mode.

Channel Mixer control

A colored filter used in black and white photography looks a certain color because it transmits only its own color waveband of light. Thus, a yellow filter looks yellow because it blocks non-yellow light. If you then use this filter to take a picture (making the appropriate exposure compensation), yellows in the resulting image are white and the other colors look relatively dark.

Lens filters are limited by the waveband transmissions built into each piece of glass, irrespective of the needs of the subject. But using the Channel Mixer tool you can, in effect, choose from an infinite range of filters until you find the ideal one for each subject.

Using this tool, you can now decide how to convert a color image to grayscale—making greens brighter in preference to reds, for example, or making blues dark relative to greens. Depending on your image software, you may also be able to work in RGB or CMYK (*see above*), the two methods producing different results.

Channel Mixer screen shot
With the control set to monochrome, the result is gray. If one channel is set to 100 percent, and the others at 0, you are effectively extracting that channel. This is more powerful than channel extraction (*pp. 136–7*).

If you set the control to Preview, you can see the image change as you alter the settings. For landscapes, increase the green channel by a large margin and correct overall density by decreasing the red and blue channels. Channel mixing is useful for ensuring that reds, which are dominant in color images, are rendered brighter than greens.

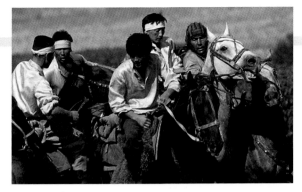

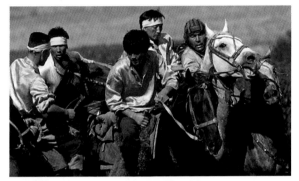

Separating tones

Starting with this color image (*top left*), a standard grayscale conversion gives acceptable results (*middle left*), but channel mixing separates out the tones more effectively, particular in shadow areas (*bottom left*). The settings required were complicated, and arrived at by trial and error (*screen shot above*). The work done reduces the need for further processing of the image, but if you wish to refine the results further, a channel-mixed image makes such techniques as burning-in and dodging (*pp. 106–7*) easier to apply, since, as you can see, the shadows on the shirts are far more open and susceptible to local density control.

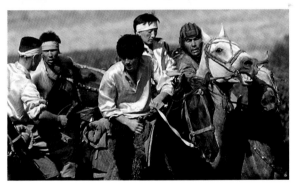

Duotones

Much of the art of traditional black and white printing lies in making the most of the limited tonal range inherent in printing paper. A common tactic is to imply a wider tonal range than really exists by making the print contrasty. This suggests that shadows are really deep, while highlights are truly bright. The success of this depends on the subtleties of tonal gradation between these extremes. A further technique is to tone the print, adding color to the neutral gray image areas.

Modern digital printers have opened up the possibilities for toning well beyond that possible in the darkroom. The range of hues is virtually unlimited—you can simulate all those that can be created with the four-color (or more) process.

Creating a duotone

Starting with an image, even a color one, first turn the file into a grayscale (*see pp. 132–9*) using, in Photoshop, the Image > Mode menu. This permanently deletes color information, so you need to work on a copy file. Similar results can be obtained in the Sepia Tone effect, a menu option in almost all image-manipulation applications.

Now that you have a grayscale image, you can enter the Duotone mode, where you have a choice of going it alone or loading one of the preset duotones. If you are not familiar with the process, use the Duotone Presets (usually found in the "Presets" folder of Photoshop). Double-click on any one to see the result.

Simple duotones
This view of Prague (*left*) has been rendered in tones reminiscent of a bygone era. After turning the image to grayscale, two inks were used for the duotone, neither of them black. This gave a light, low-contrast image characteristic of an old postcard.

Duotone Options screen shot
The curve for the blue ink (*above*) was lifted in the highlights in order to put a light bluish tone into the bright parts of the image and also to help increase the density of the shadow areas.

Clicking on the colored square in the dialog box (*see opposite*) changes the color of the second "ink." Bright red could give an effect of gold toning; dark brown, a sepia tone. This is a powerful feature—in an instant, you can vary the toning effects on any image without any of the mess and expense of mixing chemicals associated with the darkroom equivalent.

If you click on the lower of the graph symbols, a curve appears that tells you how the second ink is being used, and by manipulating the curve you can change its effect. You could, for example, choose to place a lot of the second ink in the highlights, in which case all the upper tones will be tinted. Or you may decide to create a wavy curve, in which case the result will be an image that looks somewhat posterized.

In Photoshop, you are able to choose to see Previews. This updates the image without changing the file, thereby allowing you to see and evaluate the effects in advance.

You need to bear in mind that a duotone is likely to be saved in the native file format (the software's own format). This means that to print it, you may first have to convert it into a standard RGB or CMYK TIFF file, so that the combination of black and colored inks you specified for the duotone can be simulated by the colored inks of the printer. This is the case whether you output on an inkjet printer or a four-color press.

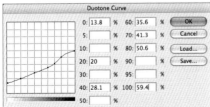

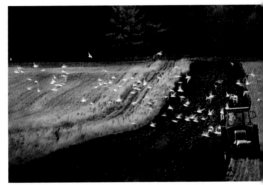

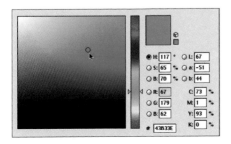

Retaining subject detail

In the original image (*above left*), there was so much atmosphere it was a pity to lose the color. But the resulting duotone, with a green second ink, offers its own charms (*above right*). To reduce overall contrast and allow the green ink (chosen via the Color Picker dialogue box, *bottom left*) to come through, it was necessary to reduce the black ink considerably—as shown by the Duotone Curve dialogue

box (*center left*). The low position of the end of the curve in the dialogue box (*center left*) indicates a low density of black, but the kinks in the curve were introduced to increase shadow contrast and retain subject detail. The lifted end of the curve shows that there are no real whites: the lightest part still retains 13.8 percent of ink, as shown in the top box labeled "0:" in the Duotone Curve dialogue box.

Tritones and quadtones

The addition of one or more inks to a duotone (*see pp. 140–1*) adds extra layers of subtlety to an image. Using most image-manipulation software, you will have tritone or quadtone boxes offering additional inks and curves for you to apply.

Bear in mind that with the extra inks offered, you can produce tinted highlights, or you can hint at colors in the shadows that are not present in the midtones, and in this way create more tonal separation. But there is no substitute for experimenting by applying different curves and colors, since this is the best way to learn how to use this powerful control. As a starting point, try using color contrasts by applying third and fourth inks in small amounts. Or, if you want a graphic-arts effect, try curves with sharp peaks.

One technical reason for using a quadtone is to help ensure accurate color reproduction. While not guaranteeing results, the chances of an accurate four-color black are greatly increased by specifying a quadtone in which the colors used are the standard cyan, magenta, yellow, and black of the printing process.

You can save curves and sets of colors and apply them to other grayscale images. When you find a combination that appeals to you, save it for future use in a library of your favorite settings.

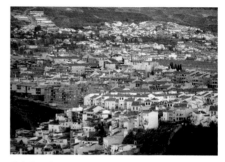

Original image
Starting with this view of the city of Granada, in southern Spain (*above*), I first made a copy file of the original to work on. Then, using the copy file, I removed all the color information to make a grayscale, before deciding on which inks to apply.

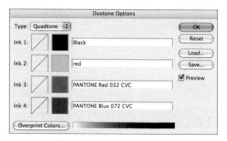

Quadtone
For this image, black has been assigned to the dark, featureless shadows, green to those shadows that still retain details, and blue to the lower and midtones. This is shown by the peaks in the graphs next to each color ink in the Duotone Options dialog box (*above right*). Adjusting the heights of the peaks changes the strength of the colors.

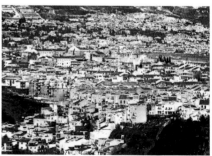

Tritone
Assigning different-colored inks to specific tonal densities in the image produces visual effects that are very difficult to achieve in any other way. In this tritone version of the scene, the fourth (blue) color has been switched off, and the result is a brighter, lighter image compared with the quadtone (*left*).

Sepia tones

With digital technology, you can bring about image changes with more control than is possible in a darkroom. A prime example of this is the digital equivalent of sepia toning—the low-contrast, nineteenth-century technique that gives warm, brown tones with no blacks or whites.

Old prints lack contrast due to the film's recording properties and the makeup of the print's emulsion. The softness is likely due to the lens, while the brown tone is down to the print's being treated with a thiocarbamide compound.

Many digital cameras produce "sepia-toning," if correctly set, and most image-manipulation applications will also give these effects with just a single command, though with little control. For greater control, first convert your grayscale image to RGB color mode. Once in RGB, desaturate the image. Use the Levels command (*see pp. 104–5*) to make the image lighter and grayer, and then remove the blacks and whites.

Now you can add color. The easiest way to do this is by using Color Balance (*see p. 120*) to increase the red and yellow. Or use the Variations command (if available) to add red, yellow, and possibly a little blue to produce a brown that you find suits the content of your image.

Another option is to work with a grayscale image in Duotone mode to add a brown or dark orange as the second ink. Using Photoshop, this provides the most subtle effects.

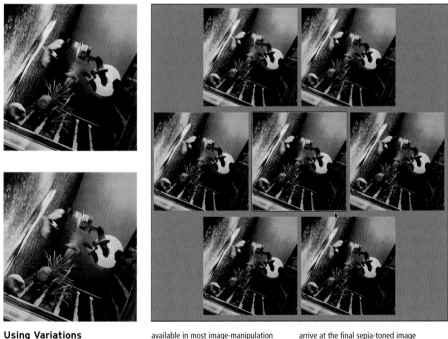

Using Variations
There are several ways to add overall color to the type of interior view shown here. Although subject content is strong, the black and white version (*top left*) lacks atmosphere. The multi-image Variations dialog box (*right*), an option available in most image-manipulation software packages, presents several versions of the toned original from which to choose. By clicking on one (*shown outlined in the dialog box above*), you turn it into the image of choice, and you can then compare it against the original. To arrive at the final sepia-toned image (*bottom far left*), the Levels control was used to reduce shadow density and so produce a flatter contrast.

Accentuating form
The original full-color image was turned into a tritone—using a blue tuned for lighter areas and red and black devoted to the darker tones—to bring out its simple, quasi-symmetrical composition.

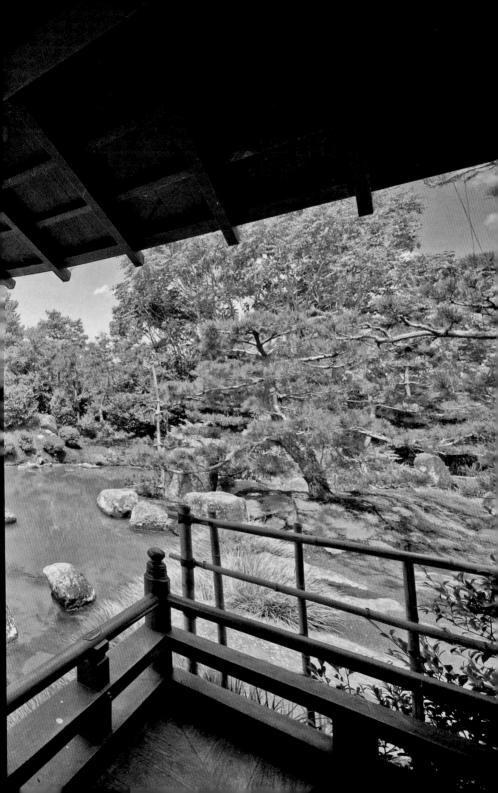

Sabattier effect

When a partially developed print is briefly reexposed to white light, some of the tone values are reversed. Although developed areas of the print are desensitized to light, partially undeveloped areas are still capable of being fogged. If these are then allowed to develop normally, they will darken. As the doctor and scientist who discovered this effect, Frenchman Armand Sabattier (1834–1910), described this process as "pseudo-solarization," it has become incorrectly known as "solarization"—which is, in fact, the reversal of image tones due to extreme overexposure.

Digital advantages

For the traditional darkroom worker, the Sabattier effect is notoriously time-consuming and difficult to control—it is all too easy to spend an entire morning making a dozen or more prints, none of which looks remotely like the one you are trying to create. Using digital image-manipulation techniques, however, this type of uncertainty is a thing of the past.

The first step is to make a copy of your original image to work on and convert that file to a grayscale (*see pp. 132–9*). Choose an image that has fairly simple outlines and bold shapes—images with fine or intricate details are not really suitable, since the tone reversal tends to confuse their appearance. You can also work with a desaturated color image if you wish.

There are several ways of simulating the Sabattier effect using Curves and Color Balance. Another method, if you have software that offers Layers and Modes (*see pp. 168–73*), is to duplicate the lower, original layer into a second layer. You then apply the Exclusion Layer mode, and adjust the tone of the image by altering the Curves or Levels for either layer.

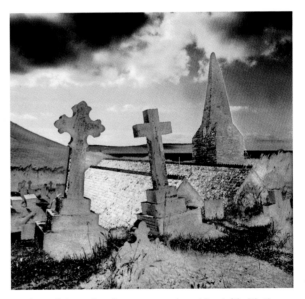

Working in black and white
Images with strong shapes (*top*) are ideal for the Sabattier treatment, since the changing tonal values only obscure images with fine detail. To obtain the partial reversal of tones shown here (*above*), a U-shaped curve was applied, which caused the shadows to lighten. The narrow halos on some shapes are a by-product of the Curves, and they are also reminiscent of the Sabattier effect induced in the darkroom, known as Mackie lines.

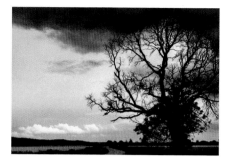

Working in color

Working digitally, you can take the Sabattier effect farther than is possible in the darkroom. By starting with a slightly colored image, you will end up with results displaying partially reversed hues. In this landscape, taken in Oxfordshire, England, the grayscale print was warmed using the Color Balance control to add yellow and red. On applying a U-shaped curve to this image, the highlights to midtones remained as they were, but the darker tones reversed— not only in tone but also in color, as you can see here (*right*). An arch-shaped curve would produce the opposite effects.

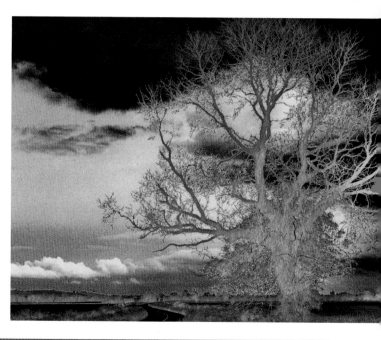

Using Curves

The most controllable and powerful way of working is to use the Curves control and draw a valley-shaped curve, with a more-or-less pronounced hollow in the middle (*top right*). By introducing small irregularities in the curve's shape you create surprising tonal changes— thus putting back into the process some of the unpredictability and charm of the original darkroom technique. The advantage of working with Curves is that you can save them and then apply them to any other image you wish. The Sabattier effect will also work with color images but, as with the tones, the colors become reversed as well. If you wish to avoid this, change the image to Lab mode (*see p. 137*), and then apply the "Sabattier" curve only to the L channel.

Gum dichromates

A gum dichromate is a flat colorization of a grayscale image; in the process, however, the tonal range tends to become compressed. Gum dichromates have had a popular following for most of the history of photography—they are relatively inexpensive and tolerant of processing variations, they are an accessible way to add color to black and white images, and the technique is a rapid route to effects that look painterly. However, the process is also rather messy and results unpredictable, and so most darkroom workers soon tire of it. Fortunately, once you know the look of a typical gum dichromate, you can easily reproduce it digitally without handling dyes and sticky substances.

A clean working method

The digital method is straightforward. Images with clean outlines and subjects without strong "memory colors"—flesh tones or green vegetables, for example, that everybody recognizes—are the easiest to work with. Start by selecting the areas you want to color using the Lasso or Magic Wand tool. Next, choose a color from the Palette or Color Picker and fill your selection using the Bucket or Fill tool with the Colorize mode set. Working this way ensures that colors are added to the existing pixels, rather than replacing them. The main point to bear in mind is that you should keep colors muted by choosing lighter, more pastel shades rather than deep, saturated hues—it is easy to create too many brilliant colors.

Another approach is to work in Layers, with a top layer filled with color and the mode set to Color or Colorize. This colors the entire image, so you will need to apply some masking (*see pp. 174–5*) to remove colors from certain areas. Another layer filled with a different color and different masks will apply colors to other parts of the image. If you want to lower the color effect overall, use the opacity setting. In fact, this method is the exact digital counterpart of the darkroom process.

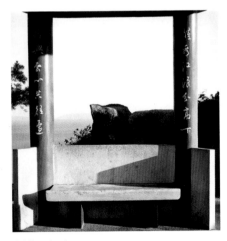

Adding texture

The original picture (*above left*) shows a place set aside for quiet contemplation in a cemetery in Hong Kong, and it has the clean, strong lines that work so well for dichromatic effects. Areas of the image were roughly selected and colored in to reproduce the inaccuracies that are typical of darkroom-produced dichromates.

After adjusting the colors, a texture was laid on the image to simulate the fibrous nature of a dichromate made the traditional way. The Texturizer filter of Photoshop was used twice at high settings, and then the Blur More filter was applied once in order to soften the texture a little.

Subtle covers

The colors of the room background, the bed itself, and the bed covers that were recorded in the original picture (*above left*) were each separately selected and then filled with the Colorize mode set. The resulting image, with its eye-catching blocks of pastel shades (*above right*) accurately imitates an old-style gum dichromate print.

Color and opacity

This negative print (*left*) was made from an instant black and white slide film (such as Polapan). It was scanned to RGB and areas roughly selected with the Lasso tool, set to a feather or blended edge of 22. Color was filled into each selection, using the Fill Layer mode set to Color. This colorizes the underlying layer at differing opacities. Different selections were filled with color and adjusted so that they balanced well to give the final image (*below*).

Split toning

Toning is a traditional darkroom technique—or workroom technique, as darkness is not essential for the process. Here, the image-forming silver in the processed print is replaced by other metals or compounds to produce a new image tone.

The exact tone resulting from this process depends, in part, on the chemical or metal used and, in part, on the size of the particles produced by the process. Some so-called toners simply divide up the silver particles into tinier fragments in order to produce their effect. Where there is variation in the size of particles, the image takes on variations in tone—from red to brown, for example, or from black to silvery gray. This variation in tone is known as split toning and is caused by the toning process proceeding at

Using the Color Balance control

Images with well-separated tones, such as this misty mountain view, respond best to split toning. To add blue to the blank, white highlights of the mist, an adjustment layer for Color Balance was created. The Highlight Ratio button was clicked and a lot of blue then added. Another adjustment layer was then created, but this time the tone balance was limited to the shadows. The Preserve Luminosity check-box was left unchecked in order to weaken the strong corrections given: the screen shot (*above*) shows that maximum yellow and red were set. Further refinement is possible in software packages such as Photoshop (*see right*).

Blending Options

This is part of the Blending Options box from Photoshop. The color bars show which pixels from the lower and which from the upper layer will show in the final image. With the sliders set as here, there is partial showthrough—allowing a smooth transition between the blended and unblended image areas. For this layer, the underlying area shows through the dark blue pixels. In addition, a wide partial blend was indicated for all channels, allowing much of the light blue to show over the dark, reddish tones.

different rates. These rates are dependent on the density of silver in the original image.

This, perhaps, gives you a clue about how the effect can be simulated digitally in the computer—by manipulating duotone or tritone curves (*see pp. 140–2*) you can lay two or more colors on the image, the effects of which will be taken up according to image density.

Another method is to use Color Balance (*see p. 120*), which is available in all image-manipulation software. This is easiest to effect in software that allows you to adjust the Color Balance control independently for highlights, midtones, and shadows. If your software does not allow this, you can achieve a similar effect with Curves, working in each color channel separately (*see pp. 126–9*).

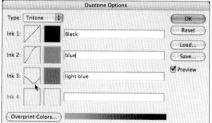

Using Tritone

The Tritone part of the Options dialog box for the final image shows a normal curve for the first, orange-brown, color. The second, blue, color is boosted to darken the midtones, while the third color, another blue, supports the first blue. Without the addition of this third color, the midtones would look a little too weak and lack visual impact.

Using Color Balance

The aim here was to highlight the similarity in shape between the tree reflected in the store window and the lamps within in the original image (*top left*). At first, two colors—brown and blue—were used, but it was hard to create sufficient contrast between the dark and light areas. To help overcome this problem, another blue was added to boost the dark areas, as shown in the Duotone Options dialog box (*above left*)—the blue plus brown giving deep purple. Color Balance (*above right*) was shifted to help shadow saturation, and the lamps were also dodged a little, to prevent them from being rendered too dark.

Hand-tinting

Hand-coloring in the digital domain is altogether a different proposition from painting directly onto prints. It allows you risk-free experimentation, no commitment to interim results, and freedom from the mess of paints. The core technique is to apply, using a suitable Brush tool, the desired color values to the grayscale values of the image, leaving unchanged the luminance value of the pixels. That is the job of the Color or Colorize mode.

Techniques

The best way to imitate the effect of painting is to use the Brush set to Color mode and then paint directly onto your image. Set a soft edge for the brush, or use one that applies its effects in irregular strokes, like a true brush. You should also set the pressure and the flow to low values, so that application of the brush produces a barely visible change in the image.

Another method is to create a new layer set to Color mode above the image, and paint into this. This makes it possible to erase any errors without damaging the underlying image. You will also find it easier to see where you paint if you use strong colors, and then reduce the opacity afterward. You may make extra layers

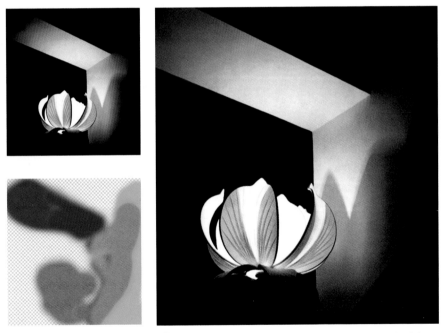

Color combinations
To suit the strong shapes of the original (*top*), equally strong colors were called for. You can work with any combination of colors, and it is worth experimenting—not only will some combinations look better, but some will also print more effectively than others. Bear in mind that

a blank area will not accept color if the Color or Blending mode is set to Colorize. To give white areas density, go to the Levels control and drag the white pointer to eliminate pure white pixels. Once the pixels have some density, they have the ability to pick up color. To give black areas color, reduce the amount of black,

again via Levels control. Although the "paint" is applied liberally (*above left*), note in the finished print (*above*) that color does not show up in the totally black areas.

to experiment with different strokes or even blend two or more layers.

Weak colors and pastel shades—that is, those of low saturation, with a lot of white—are often out-of-gamut for color printers and monitors (*see p. 41*), so you may need to bear in mind the limitations of the printed result while you work. As yet, the porcelainlike textured finish of a high-quality, hand-colored print is beyond the capabilities of ink-jet printers. The careful use of papers with tinted bases can help the effect, since the paper's background helps narrow the dynamic range and soften the image contrast.

Graphics tablet

The ideal tool for hand tinting is the graphics tablet, with its pen-shaped stylus. A standard mouse can position the cursor or brush with high precision and is useful if you need to leave the cursor in position, but with a graphics stylus you can vary the pressure with which you apply "paint," thereby affecting both the size of the brush and the flow of color. Some stylus designs also respond to the angle of the stylus. Another advantage of a stylus is that it is less tiring to use than a mouse. The downside is that a large graphics tablet requires far more desk space.

Painting and opacity

When tinting an image, you can apply the paint quite freely—as in this image (*above right*) of the painted layer that lies above the base image. However, for a realistic final effect, use a range of colors to give variety. The springtime foliage deep within an old wood (*above*) was emphasized by a lot of dodging (*pp. 106–7*) to lighten individual leaves. To introduce color, a new layer was created and its Blending mode set to Color, so only areas with density can pick up color (*above right*). The paint was then applied to this layer. Finally, the layer's opacity was reduced to 40 percent for the final image (*right*) to allow the foliage to show through the color overlay.

Tints from color originals

It is not necessary for color images to be strongly colored in order to have impact. You can, for example, use desaturated hues—those that contain more gray than actual color—to make more subtle color statements. In addition, selectively removing color from a composition can be a useful device for reducing the impact of unwanted distractions within a scene (*see pp. 116–7*).

For global reductions in color, you need only turn on the Color Saturation control, often linked with other color controls, such as Hue, in order to reduce saturation or increase gray. By selecting a defined area, you can limit desaturation effects to just that part of the image.

Working procedure

While working, it may be helpful to look away from the screen for each change, since the eye finds it difficult to assess continuous changes in color with any degree of accuracy. If you watch the changes occur, you may overshoot the point that you really want and then have to return to it. The resulting shuffling backward and forward can be confusing. Furthermore, a picture often looks as if it has "died on its feet" when you first remove the color if you do it suddenly—look at the image again after a second or two, and you may see it in a more objective light.

For extra control, all image-manipulation software has a Desaturation tool. This is a Brush tool, the effect of which is to remove all color evenly as it is "brushed" over the pixels. Work with quite large settings—but not 100 percent—in order to remove color quickly while still retaining some control and finesse.

Another way of obtaining tints of color from your original is to select by color or range of colors. If you increase the saturation of certain colors, leaving the others unchanged, and then desaturate globally, the highly saturated colors will retain more color than the rest of the image, which will appear gray in comparison.

Bear in mind that many pixels will contain some of the color you are working on, even if they appear to be of a different hue. Because of this, it may not be possible to be highly selective and work only over a narrow waveband. Photoshop allows you to make a narrow selection: you can use Replace Color as well as the waveband limiter in Hue/Saturation.

Global desaturation
To produce a selective desaturation of the original (*above left*), taken in Samarkand, Uzbekistan, the whole image was slightly desaturated, while ensuring that some color was retained in the apples and hands (*above right*). The process was paused so that the apples and hands could be selected, and then the selection was inverted, with a large feathering setting of 22. This was easier to do than selecting everything apart from the hands and apples. Desaturation was again applied, but this time just to the selected area.

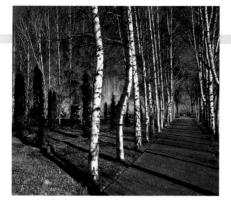

Selective color

The original shot of a park in Kyrgyzstan (*above left*) was too colorful for the mood I wanted to convey. In preparation for a selective desaturation based on colorband, I first increased the blues to maximum saturation in one action by selecting blues in the Saturation submenu. Then I opened Saturation again and boosted yellows (in order to retain some color in the leaves on the ground and the distant trees in the final image). The result of these two increases in saturation produced a rather gaudy interpretation (*above right*). Normally, a 40 percent global desaturation would remove practically all visible color, but when that was applied to the prepared image, the strengthened colors can still be seen, while others, such as greens, were removed (*right*).

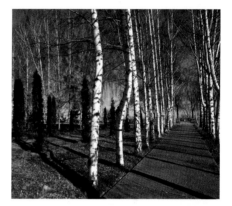

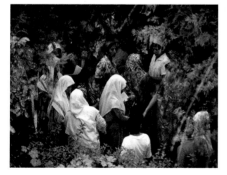

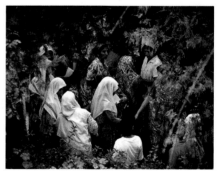

Partial desaturation

The best way to desaturate the original image here (*above left*) was to use the Desaturation tool (also known as Sponge in the Desaturation mode), as it allowed the effects to be built up gradually and for precise strokes to be applied. Although the intention was to desaturate the trees completely, in order to emphasize the glorious colors of the women's clothes, as the strokes were applied it became clear that just a partial removal and toning down of the green would be more effective (*above right*). The image was finished off with a little burning-in to tone down the white clothing.

Filter effects

One of the most alluring early advantages of digital photography was the ability to create fantastic visual effects at the touch of a button. These ranged from the visually dazzling to the faintly ridiculous. In time, it has become recognized that many special filter effects are solutions looking for visual problems. Filters are now, rightfully, part of a photographer's repertoire of techniques, but they are best reserved for a definite artistic objective. Therefore, it is important for a digital photographer to be familiar with the range of effects available in the software used.

Sharpness filters

The Sharpness filters are unlike other filters in that they are seldom used for special effects, but rather to enhance the visual quality of the image by bringing out detail. They work by examining the edges of image detail: sharpening filters increase the brightness differences or contrast at these boundaries: the Unsharp Mask (USM) filter is an important tool for increasing image sharpness (*see pp. 110–11*).

Behind the scenes

Image filters are groups of repeated mathematical operations. Some work by focusing on small parts of an image at a time; others need to "see" the entire image at once. For example, the USM filter looks at blocks of up to 200 pixels square at a time, while Render loads the entire image into memory. A simple filter effect to understand is Mosaic. The filter takes a group of pixels, according to the size you set, and calculates their average value by adding them all and dividing by the number of pixels. It then gives all the pixels in the group the same value, so the pixels appear greatly enlarged. The filter then moves to the next set of pixels and repeats the operation. Most Mosaic filters can work on small image segments at a time, but some need to operate on the entire image for each calculation. These latter types require a great deal of computer memory and calculating power. Add all of these operations together and you obtain the pixelated effect of the Mosaic filter.

Distortion and Pixelate filters

Distortion filters change the shape of the contents of an image—either overall or small portions of it—by changing the relative positions of pixels, thus retaining overall color and tone. These can be very tricky to control and need to be used with moderation. Blur effects are similar to distortion except, of course, image detail is lost because the pixel data becomes mixed together. Pixelate filters, clumping pixels of similar color values into cells, represent another order of distortion.

Ocean Ripple
This filter adds randomly spaced ripples to the surface of the image so that it appears to be underwater. To make the effect more realistic, you can add surface reflections to separate the "water" from the image below the surface.

Learning to use filters

- Practice on small files when experimenting with filter effects.
- Try the same filter on different styles of image to discover which filters work best on particular types of imagery.
- Filters often work best if applied to selected areas.
- Repeated applications of a filter can lead to unpredictable results.
- You usually need to adjust contrast and brightness after applying a filter.
- Reduce the image to its final size on screen to check the effect of filters.

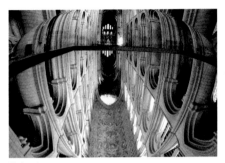

Polar Coordinates
This extreme distortion is achieved by turning cartesian coordinates into polar coordinates, where positions are defined by their angle from a reference. The "anamorphic" result can produce surprising forms.

Diffuse Glow
The effect of this filter is to render the image as though it were being viewed through a soft diffusion filter. The filter adds transparent white noise, with the glow fading from the center of the image or the center of a selection.

Crystallize
The image is divided into areas, the size of which can be adjusted, then colored with the average of the hues within the area, creating clumps of even color. With limited color palettes, the effect can produce attractive abstracts.

Spherize
This imitates barrel, or pin-cushion, distortion, according to the setting. However, the effect is constrained by the canvas size, so to apply it over the entire image, you must first increase the canvas size, apply the filter, then crop.

Diffuse Glow repeated
A filter can be applied twice to an image for a cumulative effect. If the original effect is too weak, a second application can greatly improve it. Adjustments with Levels or Curves may still be needed, as here, to lighten the shadows.

Mosaic
This classic pixelate filter clumps the average colors together into squares of user-adjustable size. It appears to distort because the image boundaries are shifted when colors fill the large "pixels." This can be used to disguise image detail in a selection.

Filter effects continued

Artistic and Brush Strokes

Artistic filters in Photoshop, similarly to the artist brush effects in Corel Painter, simulate or replicate artists' materials. Effects such as colored pencils, charcoal drawing, or painting with dry or loaded brush strokes are available. They work by using the image information and combining it with local distortion effects programmed to mimic real artists' materials. Like the Artistic filters, the Brush Strokes filters give a painterly look using different brush- and ink-stroke effects, and the Sketch filters give similar effects but in monochrome.

Colored Pencil
In order to simulate a drawing made with colored pencils, the boundaries of the main subject are given a rough crosshatch appearance, and the solid background color shows through the smoother areas with a texture resembling rough paper.

Sprayed Strokes
This filter quickly reduces an image to its essential shape. The user can set the direction of the strokes, making it very versatile, but it often works best with low-contrast images. Here, the settings were: Stroke Length 6, Spray Radius 24, Left Diagonal.

Cutout
This filter quickly simplifies the image colors and shapes into blocks of uniform color based on averages taken over broad areas. Here, Levels were set to 5, with Edge Simplicity set to a medium 6, and Edge Fidelity to 2.

Paint Daubs—Wide Sharp
Brush Size set to the maximum of 50 and Sharpness set to the minimum of 0 gives this edge-corrected blur, where the outlines of the image are recognized and their sharpness is preserved, but other details are blurred out.

Paint Daubs—Sparkle
Much more than mere daubing of paint, this filter adds false contour lines partially related to the underlying luminosity. It gives pleasing effects when the Brush Tips is set to Sparkle. Here, the settings were: Brush Size 26, Sharpness 32.

Poster Edges

Giving a passably good imitation of comic-book or cartoon illustration, this filter exaggerates any texture and also outlines the edges of the image. For this result, Edge Thickness was set to 6, Edge Intensity to 5, and Posterization to 1.

Chalk & Charcoal

This filter readily produces images that are very convincing in texture and tonality. It works well even with detailed originals. The Charcoal Area was set to a medium 8, the Chalk Area to a high 15, and the Stroke Pressure to the minimum of 0.

Bas Relief

This filter raises a relief pattern on the image according to luminosity values. It can be very useful when combined with the original image, using Layers. Here, the Detail was set to 13, Smoothness to 3, with the Light coming from the left.

Chrome

This filter applies a Liquify to the image, guided by local luminosity, so the areas with the greatest number of ripples are those with sharp luminosity gradients. Here, Detail was set to 3, and Smoothness to the maximum of 10.

Neon Glow

Effective for adding glowing edges to objects, this filter is useful for colorizing an image while softening its look. In Photoshop, the glow color can be selected from the Color Picker that is presented in the Filter Gallery.

Charcoal plus Difference mode

This image shows the result of applying the Charcoal filter to the original image, then merging it with a copy of the original, using the blend mode (see p. 171) set to Difference. (See also Multiplying effects, p. 161.)

Filter effects continued

Render, Stylize, and Texture

Render and Stylize filters simulate lighting effects in a scene, while Texture filters appear to raise the surface of an image to give it depth or an organic feel. All the filters in these families make heavy demands on the computer, and you may find large files take longer than usual to render. After using filters such as Find Edges and Trace Contour, which highlight edges, you can apply the Invert command to outline the edges of an image with colored lines or to outline the edges of a grayscale image with white lines.

Craquelure
This filter combines a texture change that replicates the cracks of an old oil painting with a little lighting effect. The image results from setting a low Spacing of 15, an average Crack Depth of 6, and a high setting for Crack Brightness, at 9.

Emboss
The Emboss filter can be effective for dramatic transformations of geometric shapes, its gray mask being helpful for further effects. Here, strong settings were used for all parameters: Angle -49°, Height 43 pixels, Amount 98%.

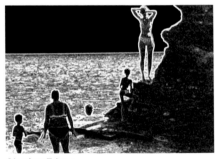

Glowing Edges
While Glowing Edges is most obvious on large-scale boundaries, such as around the rock, it also works on small-scale boundaries, dramatically changing the sea's color. Here, the settings used were: Edge Width 3, Edge Brightness 17, and Smoothness 4.

Solarize
This filter reverses tones and colors at the same time. It usually causes a drop in overall contrast and saturation because we prefer our images slightly darker than midtone. After application, it is usual to return contrast and saturation to normal levels.

Find Edges
Filters that define edges work at all scales of the image, so while their effect is predictable with large-scale boundaries, the surprises come with high-frequency, small-scale detail. Here, the sea is textured, while the figures are clearly outlined.

Difference Clouds

Used alone, the Clouds filter randomizes luminance data to completely obscure image detail. The Difference Clouds filter combines Clouds with the Difference blend mode in one step. The results are unpredictable and often surprisingly good.

Extrude

The Extrude filter is worth exploring for the strange effects it produces. You can define the type and size of extrusions and whether their depth is dependent or random. For this, Pyramids were chosen at a Size of 30 pixels, Depth of 30, and Random.

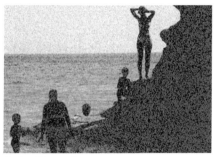

Grain–Clumped

The Grain filter offers many different effects, or Grain Types, of which perhaps the most useful is Clumped. It appears similar to film grain and is a passable substitute. (For true film-grain simulation, use specific software such as DxO FilmPack.)

Stained Glass

This filter is useful for defining the scale of important detail, and it also simplifies the color scheme. Adjust the size of the cells until they retain key subject detail. Here, the settings were: Cell Size 10, Border Thickness 4, and Light Intensity 3.

Texturizer–Canvas

Another very useful filter is Texturizer. In Photoshop it offers four different textures, plus controls over the scale and relief, as well as the direction of lighting. The Canvas texture gives a good simulation of printing on canvas surfaces.

Multiplying effects

To increase further the potential of filters:

- Apply filters to individual layers or several layers to build up the effects, altering blend modes as you go.
- Apply a sequence of different filters, then use the History Brush to blend the results.
- Apply filters to individual color channels with different settings for each.
- Apply the same filter effect to unrelated images to help make them belong together.
- Create filter effects using Smart Filter to keep the filter effect editable for future alterations.
- Use masks or selections on layers to blend effects.

High dynamic range

Dynamic range refers to the difference or ratio between the highest and lowest energy levels in a system. In digital photography, the dynamic range of a scene is the difference between the lightest or brightest part and the darkest or shadow part—essentially its scene luminance range. What makes the range high or not is relative to the recording device we use. High dynamic range means, in practice, that the scene's range of brightness is too large to record all the details we want, given the equipment being used.

Typical dynamic ranges

The practical measure for dynamic range is the number of exposure stops between the darkest area with detail to the lightest area with detail. By this measure, color prints show, at the very best, information for about seven stops from darkest to lightest. Color transparency film records only four stops. Compact digital cameras perform about the same as color print, but dSLR cameras can record ten or more stops of information.

HDR imaging

One way to consider a scene whose dynamic range exceeds the recording capacity of our equipment is that the bright parts need one camera exposure setting, while the darker parts need another. An image that captures a full range of tones can be made by blending two or more different exposures: at least one optimized for the lower midtones and one for the upper high tones.

Highlight/Shadow effect
The use of controls that bring out shadow and highlight details can simulate the appearance of HDR; indeed, they work by compressing an image's tonal range. The effect usually looks unnatural and is further marred by halos around the subject.

Today, we have progressed from exposure blending to more sophisticated versions of blending—often calling themselves HDR, together with a technique called tone mapping. Together, HDR techniques can overcome a camera's dynamic range limitations. HDR compresses the dynamic range in the scene to fit into your image.

How to HDR

To create HDR sequences, you must make bracketing shots with minimal or zero movement between them.
1. Set ISO 200, or ISO 400 and the exposure mode to Aperture Priority.
2. Set series exposures: three or more shots per second.
3. Turn on image stabilization, if available.
4. Set the camera to bracket exposures by 1 stop if the sun is to one side, or 2 stops if you are facing the Sun.
5. With the camera supported or steady, make the

bracketing exposures. You may also record a single image in raw, create two or more variants at different exposures, and merge these to HDR, but the results are inferior to true variations in exposure.
6. Open the images in software such as Photomatix or Photoshop (File > Automate > Merge to HDR), and blend your images. For superior results, shoot at lower sensitivities, record in raw, make seven bracketing exposures, and use a tripod.

Limits to blending

A raw image of an unlit room taking in the sunny view outside can be darkened to bring color to the window (*top left*), while another version may be lightened to bring out detail in the flowers (*above left*). Blending the images using Blend Options (*see p. 150*) partially succeeds (*above*), but transitional midtone areas, such as those around the window, are not well blended.

Merge to HDR

This shot of two friends chatting by the sea originally came out as a silhouette, with poor details in the shadows. I wanted to retain some feeling for the silhouette, but extract shadow detail, too. From the raw file I made some versions that darkened the bright light on the sea, and some that opened up the shadows. In Merge to HDR, the best result was from the Exposure and Gamma option. A little adjustment in Levels improved the overall contrast (*see below*).

In Photoshop, Merge to HDR offers four different algorithms for combining images: the "best" option depends on the characteristics of your image. In most cases, Exposure and Gamma is the most useful, and it offers fine-tuning controls that are not available in the other methods. Local Adaptations produces highly graphic results and offers radius-based fine-tuning.

Original image

Underexposed 1 stop

Overexposed 1 stop

Underexposed 2 stops

Equalize Histogram

Exposure and Gamma

Highlight Compression

Local Adaptations

Selecting pixels

There are two methods of localizing the action of an image-manipulation effect. The direct way is to use a tool that applies the effect to a limited area, such as the Dodge tool or any Brush. The other method is first to select an area or certain pixels within the image, then apply the effect. This ensures that only the selected pixels will be affected.

Making a selection

When you need to select parts of an image, there are two options. You can select every pixel contained within an area that you define by using, say, the Lasso or Marquee tool. These pixels can be of any value or color. In this case, the pixels are said to be contiguous. Or you can select pixels from across the image that are the same as or similar to a color you specify, using tools such as the Magic Wand or Color Range control. Since there may be gaps between these areas, this type of selection is

called noncontiguous. Magic Wand can be set to Contiguous to select only pixels that are touching each other or are similar in color or tone.

An important option is the ability to partially select a pixel near the edge of a selection. This is called "feathering." It creates a gradual transition across the boundary from pixels that are fully selected through those that are partially selected to those that are unselected, thus smoothing out the effect you apply. A feathering of 0 means that the transition will be abrupt; more than 1 pixel will give a more gradual transition. Note that the effect of increased feathering is to smooth out any sharp angles in the selection.

Selections and masks

The result of selecting a local, defined set of pixels for the changes to work on is related to that of masking (*see pp. 174–5*), but there are important differences. First, a selection is a temporary mask—it disappears as soon as you click outside a selected area (some programs allow you to save a selection, to reapply later or to use on another image). Second, in software with Layers, the selection applies to any layer that is active. Third, you can copy and move selected pixels—something that cannot be done with a mask.

Original image
This view of a church in New Zealand shows the original image. I wanted to make the windows lighter in order to reduce the contrast with the bright exterior.

Making a selection
Using Photoshop's Lasso, with a feathering width set to 11 pixels, I selected the dark glass within the window frames. To start a new area to be selected, hold down the the Control key (for PCs) or Command key (for Macs)—the selected area is defined by moving dashes, known as "marching ants." When the Levels command is invoked, settings are applied only to the selections.

Final effect
In some circumstances, the somewhat uneven result of using the Lasso selection can produce more realism than a perfectly clean selection would give. The dark areas remaining toward the bottom of the right-hand windows correspond to the area omitted from the selection in the previous image (*above left*).

● Learn about the different ways of making a selection. Some are obvious, such as the Lasso or Marquee tool, but your software may have other less-obvious methods, such as Color Range in Photoshop, which selects a band of colors according to the sample you choose.

● Use feathered selections unless you are confident you do not need to blur the boundaries. A moderate width of around 10 pixels is a good start for most images. But adjust the feathering to suit the task—for a vignetted effect, use very wide feathering, but if you are trying to separate an object from its background, then very little feathering produces the cleanest results. Set the feathering before making a selection.

● Note that the feathering of a selection tends to smooth out the outline: sudden changes in the direction of the boundary are rounded off. For example, a wide feathering setting to a rectangular selection will give it radiused corners.

● The selected area is marked by a graphic device called "marching ants"—a broken line that looks like a column of ants trekking across your monitor screen: it can be very distracting. On many applications you can turn this off or hide it without losing the selection: it is worth learning how to hide the "ants."

● In most software, after you have made an initial selection, you can add to or subtract from it by using the selection tool and holding down an appropriate key. Learning the method provided by your software will save you the time and effort of having to start the selection process all over again every time you want to make a change.

● Examine your selection at high magnification for any fragments left with unnatural-looking edges. Clean these up using an Eraser or Blur tool.

● Making selections is easier to control with a graphics tablet than with a mouse.

Original image
The brilliant red leaves of this Japanese maple seem to invite being separated out from their background. However, any selection methods based on outlining with a tool would obviously demand a maddening amount of painstaking effort. You could use the Magic Wand tool, but a control such as the Color Range (*right*) is far more powerful and adaptable.

Color Range screen shot
In its implementation in Photoshop, you can add to the colors selected via the Eyedropper tool by using the plus sign; or by clicking the Eyedropper tool with a minus sign (beneath the "Save" button), however, you can refine the colors selected. The Fuzziness slider also controls the range of colors selected: a medium-high setting, such as that shown, ensures that you take in pixels at the edge of the leaves, which will not be fully red.

Manipulated image
Having set the parameters in the Color Range dialog box (*above left*), clicking "OK" selects the colors—in this case, just the red leaves. By inverting the selection, you then erase all but the red leaves, leaving you with a result like that shown here. Such an image can be stored in your library to be composited into another image or used as a lively background in another composition.

Quick fix Removing backgrounds

One of the most common image-manipulation tasks is to eliminate a background. There are two main methods: one is to remove the background directly by erasing it (time-consuming); the other is to hide it under a mask.

Problem

The main problem is how to separate a foreground object from its background while retaining fine edge detail, such as hair, or maintain the transparency of a wine glass and retain shadows and blurred edges.

Analysis

Almost all edges in images are slightly soft or fuzzy—it is more the transitions in color and brightness that define edges. If a transition is more sudden and more obvious than other transitions in the locality, it is seen as an edge. If you select the foreground in such a way as to make all its edges sharp and well defined, it will appear artificial and "cut out." However, much depends on the final size of the foreground: if it is to be used small and hidden by a lot of other detail, you can afford a little inaccuracy in the selection. If not, you must work more carefully.

Solution

Make selections with edge transitions that are appropriate to the subject being extracted. The usual selection methods—Lasso or Magic Wand—are sufficient most of the time, but complicated subjects will need special tools, such as Corel KnockOut, Extensis Mask Professional, or the Extract Image command in Photoshop.

How to avoid the problem

With objects you expect to separate out, it is best to work with a plain backdrop. However, while a white or black background is preferable to a varied one, even better is a colored ground. The aim is to choose a color that does not appear anywhere on the subject—if your subject is blond, has tanned skin, and is wearing yellow, a blue backdrop is perfect. Also, avoid using rimlighting, since this imparts a light-colored fringe to the subject. In addition, avoid subject-movement blur and try to keep an extended depth of field so that any detail, such as hair behind the subject's head, is not soft or fuzzy.

Low tolerance
With simple tasks, such as removing the sky from this image, the Magic Wand or similar tool, which selects pixels according to their color and is available in almost all image-manipulation software, is quick to use. It has just one control—the tolerance—which allows you to set the range of colors to be selected. If you set too low a tolerance (here the setting was 22) you obtain a result in which only a part of the sky is selected, seen by the "marching ants" occupying just the right-hand portion of the sky and small, isolated groups.

Removing the sky
Adjusting the tolerance setting in small, incremental steps allows you to see when you have captured just the right area to be removed. Then, pressing "OK" removes your selection. The edges of the selection may be hard to see in a small image, but are clearly visible on a large monitor screen.

High tolerance
If you set too high a tolerance, you will capture parts of the building where it meets the sky. Here, notice the result of setting a large feathering (111 pixels) to the selection—pixels a long way to either side of a target pixel are chosen. As a result, the selection is smoothed out and the boundary is very fuzzy.

Original image
This original image of a young Afghan girl, who is also expert carpet weaver, shows her taking to the floor to ce. Unfortunately, the distracting background does add to the image as a whole.

2 Defining fore- and background
Using Corel KnockOut, I first drew inside the girl's outline to define the foreground and then outside her outline to define the background. The region between the two outlines comprises the transition area that allows soft boundaries to be smoothly masked.

Making the mask
Using the information from the previous step, a mask eated. The mask outlines the foreground while hiding background: the black shows the hidden area and the e where the image will be allowed to show through.

4 Knocking out the background
Now, while the mask hides part of the image on its own layer, it does not affect images on another layer (*below left*). Therefore, if you place an image behind the mask, you will see that image appear.

Layers screen shot
The Layers dialog box shows the little girl and associated mask lying over the introduced image. use the mask was produced by extracting the girl, riginal background is gone, waiting for a new round image to be introduced.

6 Masked combination
The background was lightened to tone in with the colors of the girl. The mask has preserved the softness of the girl's outline, and now she appears to be dancing in front of the wall-hanging. An extra refinement would be to soften the background so that it appears less sharp.

Layer blend modes

The "layers" metaphor is fundamental to many software applications, such as desktop publishing, video animation, and digital photography. The idea is that images are "laid" on top of each other, though the order is interchangeable. Think of layers as a stack of acetate sheets with images; where the layer is transparent, you see through to the one below. However, not all software layers have the same resolution, start with the same number of channels, or have the same image mode. The final image depends on how layers blend or merge when "flattened," or combined, for final output. Before then, however, they allow you to make changes without altering the original data, while each remains independent of the others.

Color as layers

A key point to remember is that the basic color image is composed of red, green, and blue layers—normally called channels. In essence, the terms "layers" and "channels" are interchangeable. Masks, too, are channels, since they work with a layer to affect the appearance of an underlying layer.

By analogy, if you see a face through a layer of misted glass, it looks soft or diffused. Now, if you clean off part of the glass, the portion of face lying directly under the cleaned-off area becomes clearly visible, without being obscured as under other parts of the glass. So the glass is a layer over the underlying layer—the face—and by doing something to part of it, but not all, you have applied a mask, which is in effect another layer.

Using layers

The main use for layers (also known as "objects" or "floaters" in some applications) is to arrange composite images—those made up of two or more separately obtained images. You can place images on top of one another, varying the order in which they lie; duplicate smaller images and place them around the canvas to create a new image; or change the size of individual components or distort them at will. At the same time, the ways in which one layer interacts or blends with the underlying layer—known as the blend modes—can also be altered. Finally, you can control the transparency or opacity of the layers, too—from high opacity for full effect (or low transparency), to barely visible, when you set a high transparency (or low opacity).

Original 1
The dreamy spires of Cambridge, England, offer the clean clarity of shape and line that are ideal for work with superimposing images. The actively clouded sky also adds variety without too much detail. Prior to use, the image had its colors strengthened by increasing saturation, and the towers were straightened so that they did not lean backward.

Original 2
The outline of wintry trees in France provides fascinatingly complicated silhouettes for the image worker. Taken on an overcast day, the sky was too even to be interesting for this exercise, so a rainbow-colored gradient was applied across the whole image. Finally, colors were strengthened and the outline of the trees sharpened to improve their graphic impact.

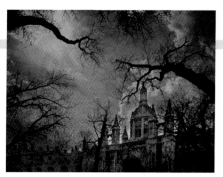

Normal

The Normal blend is often ignored, but it is a proper blending mode—provided you lower the opacity of the top layer below 100 percent, the lower layer then becomes progressively more visible. Here, the top layer at 50 percent shows a useful blend is possible—one that cannot be replicated by other blend modes—and it does not matter which is the topmost image.

Multiply

This mode is the digital equivalent of sandwiching two color slides—densities multiply and the image darkens. Here, the upper layer was reduced to 60 percent opacity to prevent turning the trees black. Multiply mode can be used to recover images that are too light (overexposed slides or underexposed negatives). Duplicate the image into another layer, and set this new layer to Multiply.

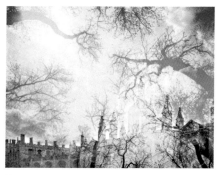

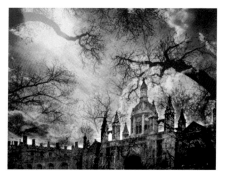

Screen

Adding together the lightness of corresponding pixels is like projecting one slide from a projector onto the projected image of another slide—the result is always a lighter image. By reducing the opacity of the top layer, you control image darkness. This mode is useful for lightening an overly dark image (the opposite of Multiply). Simply duplicate the image onto another layer and set the top to Screen, then adjust opacity.

Overlay

This mode is able to mix colors evenly from both layers, and is very responsive to changes in opacity. It works by screening light areas in the upper layer onto the lower and by multiplying dark areas of the upper layer onto the lower, which is the opposite effect of Hard Light (*p. 170*). At lowered opacities, its effect is similar to that of the Normal blend but with more intense colors. It is useful for adding textures to an image.

Layer blend modes continued

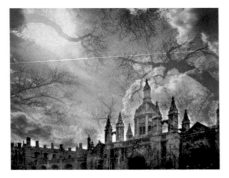

Soft Light

Soft Light blending darkens or lightens image colors, depending on the blend color. The effect is similar to shining a diffused spotlight on the image. Now, painting with pure black or white produces a distinctly darker or lighter area but does not result in pure black or white. This is a very effective way of making local tonal adjustments. It is a softer and generally more useful version of the Hard Light blending mode.

Hard Light

This mode is similar to Soft Light: it darkens image color if the blend layer is dark, and lightens it if the blend is light, but with greater contrast. It simulates the contrasty projection of the image onto another image. It is generally less useful than Soft Light but can prove valuable for increasing local contrast—particularly if applied as a painted color at very low pressures and lowered opacity.

Blending modes

Interactions between layers are tricky to learn, since their precise effect depends on the value of a pixel on the source (or blend, or upper) layer compared with the corresponding pixel on the destination (or lower) layer. The most often-used method is simply to try them out one by one (hold the shift key down and press "+" or "-" to step through the menu) until the effect looks attractive. This can distract from your initial vision by offering effects you had not thought of—but that is part of the fun of working with powerful software. With experience, you will get to know the Blend modes that are most pleasing and plan your images with them in mind.

One key point to remember is that the effectiveness of a mode may depend to a great extent on the opacity set on the source layer—sometimes a small change in opacity turns a garish result into one that is visually persuasive. So if you find an effect that does not look quite right, change the opacity to see what effect this has.

Of the many blend modes available in such software as Adobe Photoshop or Corel Painter, some of the most useful are:

- **Soft Light** This offers a useful approach for making tonal adjustments (*see above*).
- **Color** Adds color to the receiving layer without changing its brightness or luminance—useful for coloring in grayscale images.
- **Difference** This produces dramatic effects by reversing tones and colors.
- **Color Burn/Dodge** Useful for greatly increasing contrast and color saturation or, at lower opacities, making global changes in tone and exposure (*see opposite*).

Normal
Dissolve

Darken
Multiply
Color Burn
Linear Burn

Lighten
Screen
Color Dodge
Linear Dodge

Overlay
Soft Light
Hard Light
Vivid Light
Linear Light
Pin Light

Difference
Exclusion

Interaction modes

The different ways in which layers can interact also apply to other situations, such as painting, fading a command, and cloning. Experience with different effects helps you to previsualize results.

Color Dodge

At first glance, Color Dodge appears like Screen mode (*p. 169*) in that it brightens the image, but its effect is more dramatic. Black in the upper layer has no effect on the receiving layer, but all other colors will tint the underlying colors as well as increasing color saturation and brightness. This mode is useful when you want to create strong, graphic results. Note that when you change the order of the images, you get markedly different effects.

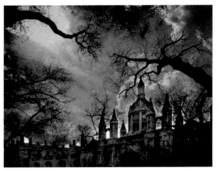

Color Burn

This blend mode produces very strong effects as it increases color saturation and contrast. At the same time, it produces darkened images by replacing lighter underlying pixels with darker top pixels. Be aware that both Color Burn and Color Dodge modes often produce colors that are so extreme they cannot be printed—in other words, they are out-of-gamut for printers (*see p. 41*).

Darken

The Darken mode applies only darker pixels from the top layer to the bottom layer. Here, the black branches of the trees overshadow anything that lies under them, showing the importance of using clear but interesting shapes. This mode does not strongly change colors. If, for example, there is no difference between the corresponding pixels on the top and bottom layers, there is no change—so this mode cannot be used to darken an image (*but see Multiply, p. 169*).

Difference

The Difference mode is one of the most useful for giving dramatic and usable effects, since it reverses tones and colors at the same time—the greater the difference between corresponding pixels, the brighter the result will be. Notice how the dark forms of the trees are rendered in the negative, while the blues of the sky turn to magenta. Therefore, where top and bottom pixels are identical, the result is black, and if one is white and the other black, the result is white.

Layer blend modes continued

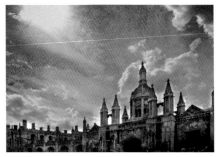

Exclusion

A softer version of Difference mode (*p. 171*), Exclusion returns gray to pixels with medium-strong colors, rather than strengthening the colors. A useful variant is to duplicate the top layer and apply Exclusion to the duplicate layer—now topmost. This creates something similar to the Sabattier effect (*pp. 146–7*).

Hue

In this mode the colors of the top layer are combined with the saturation and brightness (luminosity) values of the lower layer. The result can be a strong toning effect, as seen here, or it can be weak, depending on the images used. It is worth comparing the effect of this mode with that of the Color mode (*below*).

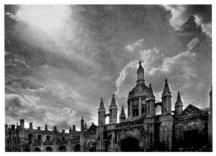

Saturation

Here, the saturation of the underlying layer is changed to that of the corresponding pixel in the top, or source, layer. Where saturation is high, the lower image returns a richer color. It is useful where you wish to define a shape using richer or weaker colors: create a top layer with the shape you want and change saturation only within the shape, then apply Saturation mode.

Color

Both hue and saturation of the upper layer are transferred to the lower layer, while the luminosity of the receiving layer is retained. This mode simulates the hand-tinting effect of black and white prints. Note that the receiving layer does not have to be turned to a grayscale image for this mode to be effective. Compare this with Hue mode (*above*).

Luminosity

This blend mode is a variant of Hue and Color: this time, the luminosity of the top layer is retained while the color and saturation of the underlying layer are applied. It is always worth trying the layers in different orders when working with these modes, particularly with this group consisting of Hue, Color, and Luminosity. In this image, reducing the opacity of the top layer produces a soft, appealing image, in contrast to the more high-contrast result when both layers are left at full strength.

Vivid Light
This both burns and dodges: lighter blend colors decrease contrast and lighten the receiving layer (dodges), while darker ones increase contrast and darken the lower color.

Pin Light
Blend colors lighten or darken the underlying layer according to the blend color and underlying color. The results are tricky to predict, but visually appealing effects are often produced.

Linear Burn
The receiving colors are darkened to match the blend color. This burns or darkens the image without increase in contrast. The strong darkening effect is best tempered through opacity control.

Linear Light
Similar to Vivid Light, this burns or dodges in response to the blend color by changing brightness. Its effect is to increase contrast— as darker colors are darkened, lighter ones are lightened.

Linear Dodge
Similar to Color Dodge (*p. 171*), this blend mode brightens the base or receiving layer to match that of the blend layer, thus blends with black produce no change. It is an effective way of brightening an image to a high-key effect but has a tendency to produce too much blank white.

Lighten
This mode chooses the lighter of the two colors being blended as the result of the combination. This blend tends to flatten or reduce contrast, but it is effective for producing pastel tones. Images that originally have subtle tones respond very well to this mode.

Masks

Masks allow you to isolate areas of an image from color changes or filter effects applied to the rest of the image. Unlike real-life masks, digital types are very versatile: you can, for example, alter a mask's opacity so that its effects taper off, allowing you to see more or less clearly through it. Using image-manipulation software, you can alter a mask until you are satisfied with it and then save it for reuse. When you do so, you create what are known as "alpha channels," which can be converted back to selections. Technically, masks are 8-bit grayscale channels—just like the channels representing the colors—so you can edit them using the usual array of painting and editing tools.

If your software does not offer masks, don't worry—it is possible to carry out a good deal of work by the use of selections. But remember that selections are inclusive—they show what will be included in a change; masks work the opposite way, by excluding pixels from an applied effect.

Software takes two approaches to creating masks. First is Photoshop's Quick-mask, which gives direct control and allows you to see the effect of any transitional zones. Or, you can create a selection that is turned into a mask. This is quick, but transitional zones cannot be assessed.

Quick-mask

In Photoshop and Photoshop Elements, you hit the Q key to enter Quick-mask mode. You then paint on the layer and hit Q again to exit, but in the process, you turn the painted area into a selection. You can also invert your selection (select the pixels you did not first select)—sometimes it is easier to select an area such as bright sky behind a silhouette by selecting the silhouette and then inverting the selection. You then turn the selection into a mask by adding a layer mask.

The layer mask makes all the underlying pixels disappear, unless you tell it to leave some alone. When applying a layer mask, you can choose to mask the selected area or mask all but the selected area. The advantage of Quick-mask is that it is often easier to judge the effect of the painted area than it is to make many selections. It also means that an accidental click of the mouse outside a selection does not cancel your work—it simply adds to the mask. Use Quick-masking when you have many elements to mask out at once.

Turning selections into masks

Some methods of selecting pixels have already been discussed (*see pp. 164–5*). If you need a

Using Quick-mask

1 Bottom layer
Quick-mask, or any method where you "paint" the mask, is best when you are not attempting to enclose a clearly defined shape, such as a person's silhouette. It is best first to place the image that will be revealed under the mask—in this example, it is an Islamic painting.

2 Creating the mask
Next, the mask is applied to the main leaves in this negative image. The red color shows where the freehand masking will be created. When it is turned into a mask, this is the area that will allow the base image to show through.

sharp-edged selection whose scale you can change without losing crispness of line, then you need to create a clipping path.

Although almost anything you can do with masks can be done with selections, it is convenient to turn a selection into a mask, since it is then easier to store and reuse—even for other images. It is good practice to turn any selection you make into a mask (just in case you wish to reuse it), particularly if it took a long time to create.

Alpha channels

Alpha channels are selections stored as masks in the form of grayscale images. The convention is that fully selected areas appear white, nonselected areas are shown black, while partially selected areas appear as proportionate shades of gray. In effect, an alpha channel is just like a color channel, but instead of providing color, it hides some pixels and allows others to be visible. An alpha channel can be turned into a selection by "loading" the selection for that channel. The term "alpha" refers to a variable in an equation defining the blending of one layer with another.

Limiting filter effects
Here (*top*), the mask has been applied to "protect" the child's face from the effect of the Stylize/Extrude filter. Note that when you turn the painted area into the selection, the mask would be applied only to that selection, so you have to invert the selection to take in everything but the face. When the filter was applied (*above*), it worked only on the pixels that were not protected.

3 Quick-mask Layers screen shot
This dialog box shows that the painting forms the bottom layer (but not the background, since masks cannot be applied to the background). The top layer consists of the grass and, to the right, the mask is also shown.

4 Final effect
You can move the underlying image around until you are happy with the results—in other words, when the most effective areas are showing through within the areas defined by the masking.

Cloning techniques

Cloning is the process of copying, repeating, or duplicating pixels from one part of an image, or taking pixels from another image, and placing them on another part of the image. First, you sample, or select, an area that is to be the source of the clone; second, you apply that selected area where it is needed. This is a basic tool in image manipulation, and you will find yourself constantly turning to it whenever you need, say, to replace a dust speck in the sky of an image with an adjacent bit of sky, or remove stray hairs from a face by cloning nearby skin texture over them.

This is only the start, however. Such cloning makes an exact copy of the pixels, but you can go much farther. Some applications, such as Corel Painter, allow you to invert, distort, and otherwise transform the cloned image compared with the source you took it from.

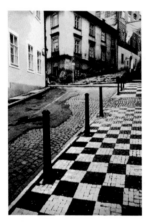

Original image
An unsightly tarred area of road left by repairs marred this street scene in Prague. All it will take is a little cloning to bring about a transformation.

History palette
The screen shot of the History palette shows the individual cloning steps that were necessary to bring about the required transformation.

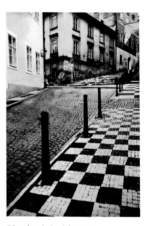

Manipulated image
The result is not perfect—it has none of the careful radial pattern of the original—but it is far preferable to the original image. It was finished off by applying an Unsharp Masking filter plus a few tonal adjustments.

HINTS AND TIPS

The following points may help you avoid some of the more obvious cloning pitfalls:

● Clone with the tool set to maximum (100 percent). Less than this will produce a soft-looking clone.

● In areas with even tones, use a soft-edged or feathered Brush as the cloning tool; in areas of fine detail, use a sharp-edged Brush.

● Work systematically, perhaps from left to right, from a cleaned area into areas with specks—or else you may be cloning dust specks themselves.

● If your cloning produces an unnaturally smooth-looking area, you may need to introduce some noise to make it look more natural: select the area to be worked on and then apply the Noise filter.

● You can reduce the tendency of cloning to produce smooth areas by reducing the spacing setting. Most digital Brushes are set so that they apply "paint" in overlapping dabs—typically, each dab is separated by a quarter of the diameter of the brush. Your software may allow you to change settings to that of zero spacing.

● If you expect to apply extreme tonal changes to an image using, say, Curves settings, apply the Curves before cloning. Extreme tonalities can reveal cloning by showing boundaries between cloned and uncloned areas.

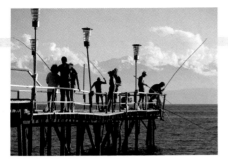

Original image

Suppose you wished to remove the lamp on the far left of this image to show an uninterrupted area of sky. You could use the cloning tool to do this, but it would be a lot of work and there would be a danger of leaving the sky's tones unnaturally smoothed-out in appearance.

1 Marquee tool

The Marquee tool was set to a feather of 10 pixels (to blur its border) and placed near the lamp to be removed to ensure a smooth transition in sky tones.

2 Removing the lamp

By applying the Marquee tool, you can see here how the cloned area of sky is replacing the lamp. Further cloning of sky was needed in order to smooth out differences in tone and make the new sky area look completely natural.

3 Looking at details

The final removal of the lamp was done with a smaller Marquee area, with its feather set to zero (as sharp as possible). Finally, the lamp behind the one removed was restored by carefully cloning from visible parts of the lamp.

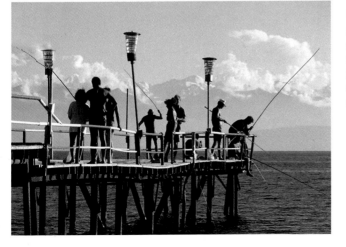

4 Cleaned-up result

As a finishing touch, a small area of cloud was cloned over the top of the lamp and its lid was darkened to match the others left on the pier.

Cloning techniques continued

Special cloning

In addition to the corrective type of cloning seen on pp. 176–7, it is possible to take the process further and use it creatively.

In most software, there are two main ways of applying a clone. The basic method is what is now known as nonaligned, or normal: the first area you sample is inserted to each new spot the Brush tool is applied to. The other cloning method keeps a constant spatial relationship between the point sampled and the first place the sample is applied to—in other words, an offset is maintained so that the clone is aligned to the source point.

However, software such as Corel Painter offers as many as nine other ways of aligning the clone to the source. You can distort, shear, rotate, mirror, scale up or down, and so on. The procedure is more complicated than with normal cloning because you need to define the original scale and position prior to applying the clone. You first set the reference points in the source image, then set the transformation points; this can be either in the original image or in a new document. It is this latter feature that gives Painter's cloning tools tremendous power.

One interesting feature is that as your cloned image is being built up, it can itself become the source material for more cloning.

The examples below illustrate just how far it is possible to move away from the source material, as well as how diverse the results can be. Remember, though: with all cloning experiments, you should work on a copy of the original image.

Original images
Both of these originals (*left*) were taken in New Zealand. Note that images do not have to be the same size or shape for cloning to take place, but look for originals with strong, simple shapes. Sharpness and color were improved prior to the cloning: increasing sharpness after cloning can exaggerate the patches of cloned material.

Manipulated images
The originals were first cloned into a new file, but with added textures and overlaid with several layers. The first image (*below*) is intended to give a modern feel to the Chinese character "good fortune"; the other (*right*) has been given a distressed look.

Original image

Any original image can be cloned onto itself to make complexes of line and form. Starting with an image with clear-cut lines and simple colors, such as this, special cloning techniques can make images that are difficult to produce in any other way.

Rotation and scale

Cloning with rotation and scale calls for two points to be set to define the source, and a corresponding two points to determine the clone. By experimenting with different positions of the source and clone points, you can create a wide range of effects: here, the boy appears to be spinning into an abyss.

Perspective tiling

Here, the boy was cloned with perspective tiling applied twice to different parts of the image. This requires four points to be set as the source, and four for the clone. Switching around the positions of the reference points produces wild perspective distortions that could have come from a science-fiction comic.

Photomosaics

Since digital pictures are composed of an array of individual pixels, it is only a short step to making up an image from an array of individual pictures. This is the principle behind photomosaics: you can replace an image's pixels with tiny individual images, like the tiles of a traditional mosaic.

Preparation

First, you need to prepare images with which to create the mosaic. The small "mosaic pieces" may be tiny versions of the larger one or different images. Photomosaic software treats individual pictures as if they are pixels, looking for best matches between the density and color of the small images to the pixel of the larger image that is to be replaced.

Specialty stand-alone photomosaic software usually provides libraries of mosaic pieces for you to work with, but it is more fun to create your own. However, the large numbers of images needed mean that this can be a long process. Advanced users can create batch processing sets to automate the process of rendering files into the specific pixel dimensions needed for the mosaic pieces. Other sources are the thumbnails (small files) found in some collections of royalty-free CDs.

Composite photomosaic
The original image was relatively complicated, but its clear lines and shapes, as well as the repeated elements it contained, made it a suitable candidate for photomosaic techniques. By selecting a small size for the mosaic "tiles" the resulting image still, overall, retains many details, but with an added richness of texture that invites closer inspection. The close-up view of the photomosaic (*below*) shows an intriguing mixture of images. Varying the component images is one way to produce an entirely different feeling to the image, while still retaining the outlines of the originals.

HINTS AND TIPS

If you are thinking of producing a photomosaic, bear the following points in mind.

- Provide a wide range of images from which to make up the mosaic pieces.
- Remember that smaller mosaic pieces produce finer, more detailed photomosaics.
- Use subjects with very clear or recognizable outlines;

avoid complicated subjects lacking clear outlines, since the process destroys all but the largest details.

- Bear in mind that if you create images in which a high level of detail is replaced with large mosaics, the resulting files will be very large.
- The rendering process that creates the photomosaic can take some time for your machine to carry out.

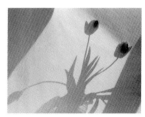 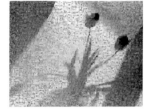

High-key photomosaic
The large, even spread of tones presents a challenge to photomosaic software, as identical images next to each other must be avoided, or else false patterns are created. However, the photomosaic has superimposed an attractive texture over this image. The close-up view (*below*) is richly rewarding.

Image stitching

Panoramic views can be created by "stitching," or overlaying, images side by side (*see pp. 78–81*). Essentially, a sequence of images is taken from one side of the scene to the other (or from the top to the bottom). The individual images are then overlapped to create a seamless composite.

You do not need special software to achieve panoramas if the original shots are taken with care. You simply create a long canvas and drop the images in, overlapping them. However, small errors in framing can make this a slow process, since you must blend the overlaps to hide seams.

Appropriate software

Special panoramic software makes connecting component shots far easier, especially if they were taken without a tripod. Different software packages offer various approaches. Some try to match overlaps automatically and blend shots together by blurring the overlaps. Results look crude but are effective for low-resolution use. Other software applications recognize if the overlaps do not match and try to accommodate the problem—some by distorting the image, others by trying to correct perspective. Many digital cameras are supplied with panorama-creation software.

For more unusual effects, experiment with placing incongruous images together, or deliberately distort the perspective or overlaps so that the components clash instead of blend. There is a great deal of interesting work still to be done.

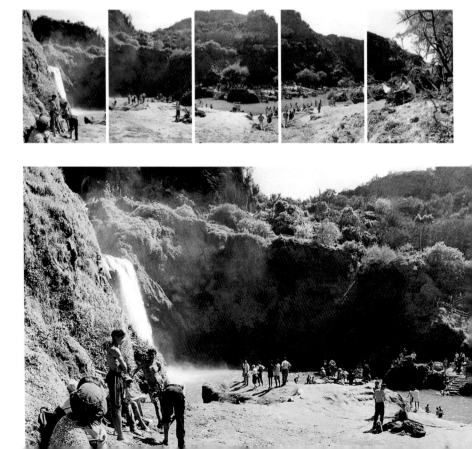

Assembly

To start the assembly (*left*), move the component images into a single folder where the software can access them. With some software, you will be able to move images around to change their order, while in others you will have to open the images in the correct order. To merge the images, the software may need extra instructions, such as the equivalent focal length of the lens used.

Final version

The component images show very generous overlaps, which make it easier for the software to create smooth blends. Once the component images are all combined on one canvas, you can use the facilities offered by the particular software to blend and disguise the overlaps to create a seamless, single image (*below*). Once you are happy with your work, save the file as a TIFF, not as a JPEG, for best-quality results.

The output adventure

Proofing and printing

It is an exciting moment. You have worked for hours at your computer, using all your know-how to create an image that looks just the way you want it, and now you are ready to print. You take a deep breath and press the button to send the file to the printer. If, then, the printer produces satisfactory results for most images, without any intervention on your part or setting up, you are lucky (make sure you note the settings in the printer driver for future reference). Unfortunately, the experience for many digital photographers is that the results of printing will be disappointing.

An important point is that mismatch between the monitor image and the printer is not, in the first instance, caused by any malfunctioning of your printer or monitor. The basic problem is that the monitor produces colors by emitting a mix of red, green, and blue light, while a print reflects a mix of light to produce the colors you perceive. These fundamentally different ways of producing color lead to a difference in gamut, which is the range of colors which can be produced by a device (*see p. 41*).

There are two main approaches open to you. You can adjust the image to compensate for the differences between what you see on screen and the resulting print, then print again and again, repeating the process until the print is satisfactory. This is not only unscientific, but the adjustments apply only to one image. The best way is to use software, such as Photoshop, that offers color-management facilities.

Printing with color management

To use color management for printing, you must first calibrate your monitor (*see pp. 94–5*). Note, too, that for the highest reliability, settings will apply only for the paper and inks with which you make the test. The basic idea is that you will first specify the source color space containing the colors you want to send to your printer—those that typically relate to your monitor. Second, you specify the color space of the printer, usually tied to the material being used. This gives

the software the information it needs in order to make the necessary conversions.

A typical task is to proof an image currently in the monitor RGB space as it will appear on an offset printer (a commercial machine). The source color space uses the soft-proof profile while your printer profile is the printer space. The following description details the steps for modern versions of Photoshop.

The Print menu offers a panel for color management. With the top-most drop-down menu set to Color Management select Document to reproduce colors as interpreted by the profile currently assigned to the image. Alternatively, select Proof to reproduce document colors as interpreted by the current output or proof profile, i.e. that of the printer/paper combination. You

Color settings

The dialog box controlling color settings looks complex, and careful attention is needed to make full sense of it. However, there are many guides—such as those provided in printer and software manuals—which should help you master it. The crucial point to keep in mind is that, unless you are producing work to be printed by a commercial press for a mass market, you need not worry about these settings. You can get by without touching them: however, if you can control them, it will be far easier to obtain reliably good prints from your desktop printer.

Printer settings

A driver that complies with the ColorSync protocol for color management will offer a dialog such as that shown here. The Source Space is the color space or profile for the image: here I have specified a commercially defined standard, which defines an RGB space in a way that is optimized for print. The Print Space is not only that of the printer but of the paper and print quality being set. "Perceptual" has been chosen for the Intent, or preference for color conversions of colors that fall out of gamut, as that is most likely to give a photographically acceptable print.

What are output profiles?

Also misleadingly known as "printer" profiles, output profiles describe the meaning of color data in terms of the behavior not only of the printer, but a specific ink-set with a specified paper. It is a text file compliant with International Color Consortium (ICC) definitions, which tells the system how to output the color data of the image. For critical applications, it is best to create custom output profiles for a specific printer, ink, and paper combination. These are created by analysing the printed color patches of standard color charts: the more patches used for the calibration, the more accurate the profile. Also, set the appropriate rendering intents (*see p.188*) for best results with output profiles.

Fantasy colors

When you produce highly manipulated images, even a large error in color accuracy is unlikely to damage the effectiveness of the image, since most viewers will not ever know what the right colors were supposed to be. Of course, for the sake of artistic integrity, you will strive to produce the exact color you have in your mind's eye, but the impact of images such as that shown here, with its artificial colors and fantasy content, does not depend on precise color reproduction.

Proofing and printing continued

can also set other printer marks such as crop or registration marks by choosing the Output drop-down: one choice does not cancel the other.

In the Color Handling drop-down menu, you choose either to have the printer or Photoshop manage the colors. If you ask the printer to manage colors, ensure that in its own print dialog you turn on printer color management. If you elect Photoshop to manage, you need to set an appropriate printer or output profile.

You are now ready to print, but before you hit the Print button, check that:

● You are using the type of paper that matches the output profile and it is the same as that intended for the final output.

● You are using the correct side of the paper.

● There is a good supply of ink (check the level using the printer's controls).

● Your image has been sized to the correct output dimensions.

Previewing

The key to efficient printing practise is to employ soft-proofing as much as possible—that is, checking and confirming everything you can on the

Textile color
For accurate records of valuable artefacts, such as this piece of textile (*above*), precise color control is essential. Reds are visually very important but deep reds can vary considerably between monitor image and paper output. The subtle variations in deep tone are easily lost if a print-out is too dark.

What are rendering intents?

Converting from one color space to another involves an adjustment to accommodate the gamut of the destination color space. The rendering intent determines the rules for adjusting source colors to destination gamut: those that fall outside the gamut may be ignored, or they may be adjusted to preserve the original range of visual relationships. Printers that are ColorSync-compliant will offer a choice of rendering intents that determine the way in which the color is reproduced.

● Perceptual (or image or photo-realistic) aims to preserve the visual relationship between colors in a way that appears natural to the human eye, although value (in other words, brightness) may change. It is most suitable for photographic images.

● Saturation (or graphics or vivid) aims to create vivid colour at the expense of color accuracy. It preserves relative saturation, so hues may shift. This is suitable for business graphics, where the presence of bright, saturated colors may be important.

● Absolute Colorimetric leaves colors that fall inside the destination gamut unchanged. This intent aims to maintain color accuracy at the expense of preserving relationships between colors (as two colors different in the source space—usually out-of-gamut—may be mapped to the same color in the destination space).

● Relative Colorimetric is similar to Absolute Colorimetric, but it compares the white or black point of the source color space to that of the destination color space in order to shift all colors in proportion. It is suitable for photographic images, provided that you first select "Use Black Point Compensation."

monitor screen before committing the image to print. If you have implemented the color management suggested in this book (*see pp. 120–3*), the on-screen image should be similar to the print you obtain. It is good practice to check your image's colors by viewing it in Print Preview mode which displays the image with the output profile applied to the image data, showing how the color data will be interpreted by the output device.

Another important preview is of the output size: image applications and print drivers will show a preview of the size and/or position of the image on the page before printing. It is good practice always to invoke print preview to check. The print preview shown below, from Photoshop, shows an image that is too large: the corners of the image extend beyond the margins of the paper. The screen shot (*see bottom*), shows the image enlarged 300 percent to better fill the paper.

Original image
All digital images are virtual and thus have no dimensions until they are sized for output, with a suitable output resolution. Ideally, there are sufficient pixels in the image for the combination of output resolution and output size, otherwise interpolation (*pp. 114–5*) is needed to increase resolution.

Photoshop print preview
Some software provides a quick way to check the print size in relation to the paper size set for the printer. Here (*right*) is Photoshop's way of displaying it. The corners of the image fall outside the paper as can be seen by the diagonals not meeting the corners of the white rectangle, which pops up when you click on a bar at the bottom of the frame: the image is clearly far too large for the paper.

Print Options preview
This screen shot (*left*), taken from a printer driver, shows how a printer expects to produce a given file. The image has been enlarged by 300 percent to make better use of the paper and has been centred (ensure your image has sufficient data to print at this enlargement). Note how the preview shows the image on paper and that it provides you with handy functions, such as being able to position the image as well as a choice of units of measurement. Modern printers can place an image with great and repeatable precision.

Output to paper

One great advantage of inkjet printers is that they can print on a wide variety of surfaces. In fact, some desktop models will print on anything from fine paper to thin cardboard.

For the digital photographer, there are three main types of paper available. Most papers are a bright white or a near-white base tint, but some art materials may be closer to cream.

Paper types

Office stationery is suitable for letters, notes, or drafts of designs. Quality is low by photographic standards, and the printed images cannot be high in resolution or color saturation. Inkjet paper that is described as 360 dpi or 720 dpi is a good compromise between quality and cost for many purposes.

Near-photographic quality is suitable for final printouts or proofs for mass printing. These papers range from ultra-glossy or smooth to the slightly textured surface of glossy photographic paper. Paper thickness varies from very thin (suitable for pasting in a presentation album) to the thickness of good-quality photographic paper. Image quality can be the best a printer can deliver with excellent sharpness and color saturation. However, paper and ink costs may be high.

Art papers are suitable for presentation prints or for special effects and include materials such as handmade papers, watercolor papers, or papers with burlap or canvaslike surfaces. With these papers, it is not necessary to use high-resolution images or large files that are full of detail.

Paper qualities

If you want to experiment with different papers, just ensure that the paper does not easily shred and damage your machine and clog the nozzles of the inkjet cartridge. If using flimsy papers, it is a good idea to support them on thin cardboard or a more rigid piece of paper of the same size or slightly larger. The main problem with paper not designed for inkjets is that the ink either spreads too much on contact, or pools and fails to dry.

Dye-sublimation printers will print only on specially designed paper—indeed, some printers will even refuse to print at all when offered the wrong type of paper. Laser printers are designed only for office stationery and so there is little point in using other types of paper.

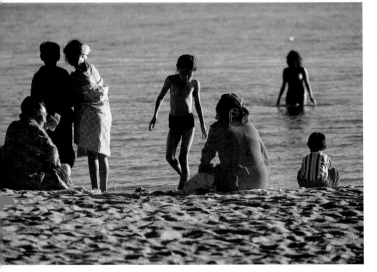

Crucial color
Not only does the blue of this scene test the evenness of printing, it also tests color accuracy. Very slight shifts away from blue will make the image look unbalanced in color and distract the viewer's attention from the relaxed, sun-filled scene. In fact, blue ranks with skin tones as the most important of colors that must be correctly printed, or else the foundation of an image will be seen as unsound.

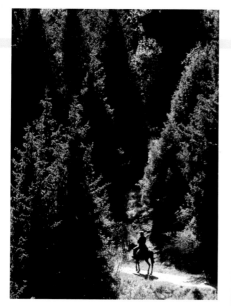

Dark subjects

The blacker a color image, the more ink will be needed to print it. If your subject is full of very dark areas, such as this scene, the paper could easily be overloaded with ink. The ink may then pool if it is not absorbed and the paper could buckle or become corrugated. To minimize this problem, use the best-quality paper and tone down the maximum of black as much as possible by reducing the black output level in the Levels control.

TRY THIS

To determine the minimum resolution that gives acceptable results on your printer, you need to make a series of test prints with the same image printed to the same size but saved to different resolutions. Start by printing out a good-quality image of about 10 x 8 in (25 x 20 cm) or letter (A4) size at a resolution of 300 dpi—its file size is about 18 MB. Now reduce resolution to 200 dpi (the file size will get smaller but the output size should be the same) and print the file, using the same paper as for the first print. Repeat with resolutions at 100 dpi and 50 dpi. Compare your results and you might be pleasantly surprised: depending on the paper and printer, files with low output resolution can print to virtually the same quality as much higher-resolution files. With low-quality or art materials, you can set very low resolutions and obtain results that are indistinguishable from high-resolution files. In fact, low resolutions can sometimes give better results, especially if you want brighter colors.

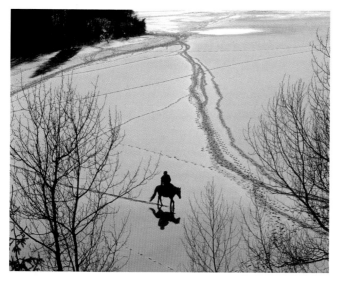

Even tones

Subjects with large expanses of even and subtly shifting tone present a challenge to inkjet printers in terms of preventing gaps and unevenness in coverage. However, in this image of a frozen lake in a Kazakh winter, the challenge is not so great because the color is nearly gray, which means that the printer will print from all its ink reservoirs. If there is only one color, most often the blues of skies, you are more likely to see uneven ink coverage.

Quick fix Printer problems

A great deal of computation is needed before your printer can translate the image on screen or captured in a digital camera into a print. Not only must the pixel data be translated to individual dots or sets of dots of color, that translation must ensure that the final print is sized correctly for the page and is the right way around. Everybody has problems with printers; the real surprise is that people do not experience more printer problems than they do.

Troubleshooting

The most common causes of problems with the printer are often the easiest to deal with. As a routine response to problems, check that the power cord and printer cable are securely inserted at both ends, check that your printer has not run out of ink, and make sure that the paper is properly inserted, with nothing jammed inside.

Problem	Cause and solution
Prints show poor quality—dull colors or unsharp results.	If you run the self-check or diagnostic test for the printer and nothing appears to be mechanically at fault, then the cause is a user setting. You may have set an economy or high-speed printing mode. If so, set a high-quality mode. You may be using a low-quality paper or one unsuitable for the printer, or you could be using the wrong side of the paper: change the paper and see what happens. You may be using an uncertified ink cartridge instead of the manufacturer's: use the manufacturer's own brand.
Prints do not match the image seen on the monitor.	Your printer and monitor are not calibrated. Go through the calibration steps (see pp. 94–5). Your image may contain very little color data: check the image using Levels—rescanning may be necessary.
A large file was printed very small.	File size does not alone determine printed size. Change the output dimensions using the Image Size dialog box.
An image does not fully print, with one or more edges missing.	Output size is larger than the printable area of the printer—most printers cannot print to the edge of the paper. Reduce the output or print size of the image in the Image Size dialog box and try again.
The printer works very slowly when it is printing images.	You may have asked the printer to do something complicated. If your graphic has paths, simplify them. If your image has many layers, flatten the image prior to printing. To print landscape-format pictures, rotate the picture in your image-manipulation software prior to printing. If you set the magnification to anything other than 100 percent, the printer must resize the entire image. Change the image size using image-manipulation software before printing.
The print suddenly changes color part of the way through.	Either one of the colors in the ink cartridge has run out or it has become blocked during printing. Clean the nozzles using the driver utilities and try to print again. You may need to repeat the cleaning cycle several times.

Problem	Cause and solution
The printer works slowly even when printing text.	You have set the printer to a high-quality setting, such as high resolution or fine, or the high-speed or economy mode has been turned off, or you have set the printer to unidirectional or to print on high-quality (photorealistic) paper. Check and reset the printer to high-speed, bidirectional, and reduce the resolution or choose a normal or standard paper.
The printer cannot be found or nothing happens when "OK" is pressed at the printer dialog box.	You may have a conflict—especially if you have just installed a new scanner, mouse, or similar. Reinstall the printer driver software. Ensure you have the latest drivers for the USB ports from the manufacturer's website.
Prints appear smudged, with colors bleeding into each other.	The paper is damp, you have made settings for the wrong paper type, or there may be ink on the printer's rollers. Store paper in dry conditions inside its original packaging. Check the settings against the paper type. Clean the rollers using a cloth and run the printer cleaner sheets, which are supplied by the manufacturer, through the printer.
The computer shows an error; the printer does not print or takes a long time to start.	The software used by your computer to store print jobs in a queue may malfunction from time to time. Restart the computer or open the Print Spooler control panel and restart. You may need to delete any print jobs waiting.
The print is missing lines or there are gaps.	The printer head nozzles have almost certainly become blocked with ink or the printer head may need to be recalibrated. Clean the nozzles using the driver utilities supplied with the printer and try to print again. You may need to repeat the cleaning cycle several times to solve the problem.
The printer produces garbled text.	You may have connected the printer to the wrong computer port or you may have tried to use the printer port to send a file, fax, or similar. This problem can also occur if you have aborted a print operation some time earlier. If so, turn the printer off, wait a few seconds, turn the printer back on, and try the operation again. With Windows machines, ensure the spool or print manager has no jobs waiting to be processed—delete them and start again.
The printer produces banded lines in areas of even tone.	The paper transport is not properly synchronized with the print head. This could be a printer fault. If it is not, try changing the weight of the paper used or the thickness setting (usually with a lever on the printer). You could also try adding noise to the image (see pp. 112–3) to hide the unevenness of tone.
Prints appear blurred and dull—despite printing at high resolution and on good paper.	You may be using the wrong side of the paper. Most inkjet papers have a good, receiving side and a support side. Manufacturers often pack their paper with the receiving side facing the back of the pack.

Art printing

It is thrilling to see your images enlarged to poster size and displayed as a work of art. The subject of the poster need not be unusual—sometimes the simplest image is the most effective—and the digital file from which it is output may not even need to be of the highest resolution. This is because large prints tend to be viewed from a distance, so finely rendered detail is not necessarily an issue.

Permanence

The two main factors governing the permanence of photographic images are the characteristics of the materials used and the storage conditions. Both of the main components of the materials—the ink that makes up the image and the substrate, or supporting layer—are important.

For the ink to be stable, its colors must be fast and not fade in light or when exposed to the normal range of chemicals in the atmosphere. In general, pigment-based inks—those using solid particles for colorants—are more stable than dye-based inks—those using colored liquids. For the paper to be stable, it should be neutral and "buffered" (able to remain neutral when attacked with a small amount of acidic chemicals), and should not depend on volatile chemicals for its color or physical state. Materials used range from cotton rag to alpha-cellulose and bamboo. The substrate may be a source of impermanence: papers fade or become brittle; papers with a laminated structure are prone to one layer cracking or peeling.

When colors fade, one is likely to fade more rapidly than others, which quickly becomes obvious as a color shift. Black-and-white materials do not suffer from color shift, so they therefore appear more stable.

The careful design of storage conditions can ensure that even highly unstable images are preserved. Ideally, images should be stored in chilled conditions—almost at freezing point—

Faded print
With half the print shielded, the exposed half faded after only one week's constant exposure to bright sunlight.

Since some colors are more fast, or resistant to fading, than others, there will be a color shift in addition to an overall loss of density.

Archival storage

Digital photographers have two strategies for the archival storage of images. The first is to store images in the form of prints in the best possible conditions—specifically, in total darkness, low humidity, chilled (to temperatures close to freezing point) with slow air circulation in archivally safe containers. These containers—boxes made from museum board—should emit no chemicals or radiation, be pH-neutral (neither acidic nor alkaline), and, preferably, incorporate a buffer (a substance that helps maintain

chemical neutrality). These conditions are ideal for any silver-based or gelatin-based film or print.

The alternative strategy is to store images as computer files in archivally safe media. The current preferred option is the MO (magneto-optical) disk, but nobody really knows how long they will last. Next down are media such as CDs or DVDs, which are, in turn, more durable than magnetic media such as tapes or hard disks. But you can never be sure: a fungus found in hot, humid conditions has developed a taste for CDs, rendering them useless.

with low humidity and in total darkness. To ensure the best color stability, exposure to light and chemicals should be kept to a minimum, temperature should be chilled, and humidity low but not zero. In normal room conditions, most materials will last several years, but if kept in a kitchen or bathroom, your prints will have a much-reduced life expectancy.

Large prints

There are two main approaches to outputting prints larger than tabloid size (A3) , the maximum that can be easily printed on a desktop printer. The first is to use a large-format printer: these range from self-standing machines to monsters capable of printing advertisements for the side of a bus. If you cannot afford a large-format printer, you need to take your file to a bureau.

Before you prepare your file, ask the bureau for its preferred format (usually RGB TIFF uncompressed), and ask which color profile they expect embedded in the image. Find out which type of removable media is acceptable—all will read from a CD or DVD, and many accept portable hard-discs. You also need to check the resolution the bureau prefers, and you should adjust the file to the output size you require (although some bureaus do that for you).

There are different printers that produce prints appropriate for different markets. The preferred type of printing for the art and fine-art exhibition market uses pigment-based inks for its greater permanence, but dye-based inks may produce subtly superior results. However, bear in mind that the choice of paper is more limited in large sizes than in smaller, cut-sheet sizes. The best of ink-jet printers manufactured by, for example, Mimaki, Epson, Roland, Canon, or Hewlett-Packard can produce extremely high-quality prints suitable for commercial display and trade exhibitions.

The other approach is a hybrid one, based on the digital manipulation of true photographic materials. Your file is used to control a laser that exposes a roll of photographic paper. This is then processed in normal color-processing chemicals to produce a photographic print. Many offline printing services use the same method to produce small photographic prints or books from digital image files. The results can be extremely effective and look very much as if they are traditional photographic images from start to finish. Another advantage to this method is that relatively small image files can produce excellent results: 20 MB of detail may be fine for a poster-size (A2) print.

Tiling a printout

One way to make prints larger than your printer can print is to output the image in sections, or tiles, which you then join. This is straightforward in desktop publishing applications such as QuarkXPress and InDesign: you simply create a large document size, set up the page for the available paper dimensions, and tell the software to print out each section on the paper supplied. You can then trim the prints to remove the overlaps and butt the edges together to produce a seamless, large-size image. For those occasions when economy is important and critical image quality is not required, tiling is worth considering.

Tiling option
Modern printers work with great precision and consistency, so it is possible to combine tiles almost seamlessly. Use heavier-weight papers, plastic, or filmlike material to help retain shape. Then the overlaps need be only sufficient to allow you to trim off the excess and butt the images together before fixing.

Publishing on the web

The internet is now the main method of distributing, viewing, and using photographs. This has opened up exciting opportunities for photographers the world over. The number of images on the web is truly astronomical, and by visiting just two of the most popular photo-sharing websites, you have access to more than a billion images.

This situation is due to three factors: the seemingly infinite ability of the web to expand its capacity; powerful new applications for handling images online; and wide access to high bandwidth to allow high-quality images to be downloaded.

Sharing and storage

There are now numerous sites where you can send images to store them, to share them, or to promote your own photography.

Storing your images on a remote hard-disc farm offers security and worldwide access, but the access is slowed down. Picture sharing is good for promoting work or sharing images, but it exposes the image to unscrupulous exploitation. Check the terms and conditions of any website to which you upload: you may be asked to give up rights or provide warranties that you find onerous. It is advisable not to sign up to any service that expects you to give up any rights to your images.

Preparing images

The size of the images you show on a website always depends on balancing quality with the speed of loading the web page. Quality depends on both the pixel dimension of the image and the level of compression: fewer pixels and higher compression make for smaller files and quicker loading; the downside is compromised image quality. Using high-quality images—measuring 1,024 pixels or more on the long side—may also expose your images to unlicensed use.

There are four main steps in preparing images for use on the web:

- **Evaluation** Assess the image quality and content. If it is photographic, you can convert it to JPEG; if it is a graphic with few subtle color gradations, you can convert to GIF. Also adjust brightness and color so the image will be acceptable on a wide range of monitors.
- **Resizing** Change the size of copies of the images (not the original files) to the viewing size intended, so that the file size is no larger than necessary. Images may be tiny, perhaps 10 x 10 pixels (for use as buttons), or large, say 640 pixels on the longest side (for displaying work).
- **Conversion** Convert photographic images to JPEG. Set a compression slightly greater than you would like (the image is degraded just a little more than you would wish) to optimize loading speed. (*See also the box below.*)
- **Naming** Give your files a descriptive name using letters and/or numbers. The only punctuation marks you should use, if desired for clarity, are dashes (-) or underscores (_). Always put a period before the jpg suffix (.jpg).

Optimizing your pictures on the Internet

You will want those who access your site to receive your images quickly and to have the best experience of your images that the system permits. Here are some tips for optimizing your images on the Internet.

- Use Progressive JPEG if you can. This presents a low-resolution image first and gradually improves it as the file is downloaded. The idea is that it gives the viewer something to watch while waiting for the full-resolution image to appear.
- Use the WIDTH and HEIGHT attributes to force a small image to be shown on screen at a larger size than the actual image size.
- Use lower-resolution color—for example, indexed-color files are much smaller than full-color equivalents. An indexed-color file uses only a limited palette of colors (typically 256 or fewer), and you would be surprised at how acceptable many images look when reproduced even with only 60 or so colors (see p. 130).

Original | JPEG compression

JPEG compression

With minimum JPEG compression, you get maximum quality. In fact, at the highest magnification, it is very hard to see any loss in detail, but at the magnification shown here you can make out, with careful examination, a very slight smoothing of detail in the right-hand image compared with the original on the left. The cost, of course, is that the file is compressed from nearly 7 MB to about half the size, 3.7 MB.

Original | Minimum quality

Quality setting

At the minimum quality setting, the file size is pared down to an impressive 100 K from 7 MB—to just 2 percent of the original size—a reduction of nearly 50 times, and the download time has dropped to an acceptable 16 seconds. The loss of image quality is more evident: notice how the grain in the original (*far left*) has been smoothed out and the girl's arm is altered, with slightly exaggerated borders. But when it is used at its normal size on screen, it is a perfectly acceptable image.

Original | Medium quality

Medium quality

With a medium-quality setting, here showing a different part of the same image, there is a substantial and useful reduction in file size—from nearly 7 MB to just 265 K—some 20 times smaller, or 5 percent of the original file size. The download time is accordingly reduced from over 15 minutes to 50 seconds. This latter figure is still uncomfortably long and the image quality is arguably better than needed for viewing on screen, while being just adequate for printing at postcard size.

Creating your own website

Photo-sharing websites such as Flickr, Fotki, and Webshots have removed virtually all obstacles to publishing images for worldwide viewing. However, these are essentially a collection of picture albums: your work is presented on pages identical to millions of others—opportunities to individualize page design are nonexistent or very limited. If you feel this is a constraint, you can create your own website instead.

Hosting

There are thousands of services that will host your site—that is, your files are physically located on their computers, which serve out pages to visitors to your site. And there are hundreds that offer free hosting. Check the terms of service, that you do not have to include advertisements, and that you do not lose any picture rights. You will also want secure ways in which people can communicate to you via the site. Ensure that the host has sufficient capacity to hold your pictures and that the monthly data-transfer limit is sufficient for your photographic needs.

Site design

The advantages of running your own site include: control over the look and feel, no restraints over use of your images (within legal limits), and the ability to organize images however you like. The main disadvantage compared to picture-sharing sites is that you have to do quite a bit more work.

Nonetheless, there is a considerable amount of help available for the design and construction of your website. Free design applications can be downloaded, there are hundreds of web-based tutorials, and some services help you construct sites directly online. In addition, major image-manipulation (such as Adobe Photoshop) and management software (such as iView, FotoStation, Lightroom, and Apple Aperture) offer templates for design, and publishing the site—that is, uploading the HTML pages and resources to your hosting server—can be virtually a one-click process.

For more sophisticated sites on which you can present Flash or animated content with more features, WYSIWYG ("what you see is what you get," supposedly) web-design software such as Adobe Dreamweaver (Mac OS and Windows), CoffeeCup (Windows), and Serif WebPlus (Windows) will help you get started.

Once you have created a site, don't forget to tell everyone about it: send links to all your friends and colleagues, and post announcements on blogs.

Professional sites

Websites such as Digital Railroad, DigiProofs, and Zenfolio provide paid-for picture hosting and different features to suit markets as varied as photojournalism and wedding photography. In return for a fee, you can store large numbers of high-resolution files and you can individualize your own pages. In addition, these sites actively market your work by offering your images as part of the collective inventory of stock photography and may also handle management of the picture rights. However, there are no shortcuts to the work needed to add keywords, captions, and other metadata to images, then uploading them all to the hosting site.

Digital Railroad
The home page of a photographer features details and links to other pictures in the photo collection. Visitors can click on an image to view an enlargement and search by keywords. If they wish to purchase usage rights, they can select the images and complete the whole transaction online.

Adobe Lightroom templates

While primarily an image-enhancement and management application, Lightroom also offers website-design features. These include a range of templates, plus the ability to choose a color scheme and some other design details as well, including Flash content. Similar but much more limited facilities are offered in Apple Aperture.

Personal website

A personal site can be simple in appearance yet tricky to update and maintain. This site contains only text and images, but the tendency is to allow it to languish. It depends on whether it is more important to have an up-to-date site that is not individual, or a personal site that is a little dog-eared.

A buying guide

5

Choosing a digital camera

The range of digital cameras available all but guarantees that any requirement can be met—from point-and-shoot needs, to specialized tasks such as astronomy and infrared photography.

One way to decide on a camera is by following the recommendation of a knowledgeable friend. You may also consult the numerous reviews available on the web: these range from the technically complete to superficial comments from unqualified, inexperienced testers. But it is easy to become confused when trying to balance many opinions. Thanks to unrelenting competition between reputable manufacturers, it is safe to say that all modern models will function well and reliably within their specifications.

Guidelines

The best way to avoid disappointment in your choice of camera is to handle it and obtain advice from a knowledgeable salesperson in a photography store. It is important to note that cameras with high resolution (the megapixel, or MP, figure) offer no guarantee of image quality: an 8 MP phone camera is likely to produce images markedly inferior to those from a 5 MP compact camera. High-megapixel cameras also tend to work more slowly than lower-specification cameras of similar cost. In general, cameras with larger sensor chips produce superior image quality. Zooms with modest zoom ratios—say, 24–60 mm, compared to 35–350 mm—will deliver much better images.

Autofocus compact
These small cameras offer a winning combination of high performance in a stylish and compact design. The trend is to rely entirely on a display screen on the back for viewfinding.

Always ensure the flash can be turned off if required.

The shutter release is always sited for the right forefinger.

A high-quality 5x zoom makes for a versatile camera.

Sensor size and field of view

A camera lens projects a circular image. The sensor captures a rectangular area centered on this image. If the rectangle extends to the edge of the circle of light, the sensor captures the full field of view. But if the capture area falls short of the edge, the field of view is smaller. Many dSLR cameras accept conventional 35 mm format lenses but use sensors that are smaller than the 35 mm format (around APS, or about 24 x 16 mm). The result is that the field of view is reduced, which in turn means the focal length is effectively increased, usually by a factor of around 1.5x. This means that a 100 mm lens used on full-frame 35 mm is effectively a 150 mm lens when used with an APS-sized sensor. The convention is to relate the actual focal length to the 35 mm format equivalent.

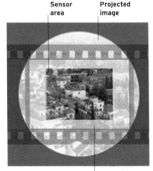

Sensor area Projected image

35 mm film area

Cell-phone cameras

Digital cameras in cell phones are the product of numerous engineering and cost compromises. In general, you sacrifice image quality, focusing and zoom range, speed of operation, and versatility of control for the convenience of a camera incorporated into your phone. The flash power, if available, is also limited. While a few use true zoom optics, the zoom function is generally obtained through digital zooming. However, the phone camera makes it easy to send images to friends and colleagues, and its importance in news gathering can only grow.

Entry-level compacts

With constant improvements in quality and the pressure of price competition, entry-level compacts offer good value for money. They don't necessarily have the lowest specification, but they may be less robust and not as compact, and offer inferior LCD screens and a limited set of features. They may also operate less quickly than high-quality cameras. But they can still deliver good image quality. Entry-level cameras from respected manufacturers offer an excellent ratio of quality to price.

Lifestyle and fashion compacts

Because the digital camera does not need to hold a roll of film, the form is flexible, so designers can create a stylish look and a level of compactness limited only by the necessity for a display and control buttons. This has led to the rise of the chic, ultra-slim, eminently pocketable "lifestyle" compact. Within this category you can find environment-proof models—sealed against dust and water splashes—that sacrifice little, if anything, in picture-making capability.

The performance of both the lifestyle compacts and the brightly colored "fashion" versions compares well with entry-level compacts, but their cost is somewhat higher, in return for which you obtain an attractive piece of modern technology. However, before parting with your money, handle the camera to ensure it is not too small for you to operate comfortably.

Resolution and quality

The word "resolution" is used in several different senses in photography. Applied to camera sensors, it measures the number of photo-sites used to capture the image. The resolution of the image itself is often equated with image size, or its number of pixels. In the context of lens performance or image quality, it is a measure of how well a system separates out fine detail.

These measures are related, but not directly. For example, the resolution of a sensor sets the upper limit of image quality, but not the lower limit: a high-resolution sensor may deliver a poor-resolution image if the quality of capture, lens, or image processing is poor.

Lifestyle camera
In a bid to offer more than their competitors, some manufacturers seal their cameras against dust and water, while providing all the usual compact features. These models are excellent for taking everywhere with you.

Fashion camera
Compact cameras share so many features and are of such uniformly high quality that you may choose them simply on looks—and color is a large part of that. The range of colors goes from white to purple and everything in between.

Rugged camera
A compact camera can be made very rugged by adding rubber bumpers all around, sealing against dust and water to allow underwater operation, and with oversized controls to allow for use with gloves in cold weather conditions.

Choosing a digital camera continued

Enthusiast compacts

For the avid photographer on a relatively tight budget, enthusiast digital compact cameras offer high performance, excellent versatility, and affordability. Cameras in this range may offer wider angles of view (24 mm), longer focal length zooms, the ability to record images in raw format, synchronization with accessory flash, sturdier construction, and a larger range of accessories than is available for simpler cameras.

Most importantly, these cameras offer a full range of photographic controls over exposure, color balance, and focus. More attention is also given to lens and image processor design, with a significant improvement in picture quality compared to lifestyle compacts. Allied with typical pixel counts of 8 MP and more, these cameras are capable of tackling a wide range of photographic situations. You may also find cameras designed for special tasks, such as those capable of taking 60 frames per second and those adapted for infrared or astronomy.

When selecting a camera, try to ensure that the features you commonly use are easy to

Moiré patterns

One problem that can affect the quality of images recorded by a digital camera is known as "moiré." This occurs when the regular pattern of the sensor array in the camera interacts with some regular pattern in the image area, such as the weave of the cloth worn by your subject. The overlapping of two regular patterns, which are dissimilar and not perfectly aligned, leads to the creation of a new set of patterns—the moiré pattern—which is sometimes seen as bands of color or light and dark. Some digital SLR cameras (see pp. 206–7) offer a sophisticated optical solution—the so-called "anti-aliasing" filter—

while some other manufacturers use a filter—known as a "low-pass" filter—that very slightly softens the image by cutting out detail.

The appearance of the moiré pattern is readily discernible in the open weave of this fabric.

Wide-angle compact
Small digital cameras with a 24 mm equivalent focal length at the widest setting and a fast maximum aperture of f/2 offer real potential for documentary photography. An optical viewfinder can be fitted as an option.

Enthusiast compact
Compact cameras aimed at the experienced photographer may pack numerous features—from GPS (Global Positioning System) geotagging, to raw recording with high sensitivity, a high-quality lens, and high pixel count.

Wide-zoom-range compact
Modern compact cameras can carry zoom lenses with ratios of 10x or greater, along with relatively fast aperture at wide settings, high resolution, and other features such as video recording and image stabilization.

access, preferably with one click of a button. The size of a camera can be hard to gauge just by looking at pictures, so check the actual dimensions before you make a purchase. If speed of operation is important, test it on the camera itself, because some models operate very slowly, especially when recording in raw format.

Prosumer cameras

Prosumer cameras are models that are able to produce results to professional standards but may lack interchangeable lenses and are not built to professional standards of sturdiness and durability. There are two main types. Compact models—such as the top-of-the-line compacts from, for example, Ricoh, Panasonic/Leica, Canon, and Nikon—are excellent for photojournalism and candid street photography; and electronic-viewfinder models (also called bridge cameras) with wide-range zooms—such as models from Fujifilm, Panasonic, and Olympus—are excellent for travel and out-and-about photography. For the serious nonprofessional photographer, these cameras offer superb quality at affordable prices.

Prosumer models

Easy to carry, but offering a zoom lens with 18x or greater ratio (that is, a 27–486 mm equivalent), cameras such as this can cover a wide range of subjects. The design, with permanently attached lens, is particularly useful for travel photography since it is relatively well sealed against dust.

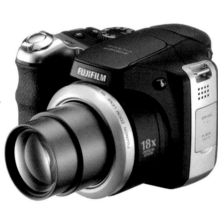

A click-stopped mode dial is the easiest type to use.

A shutter button that "clicks" confirms when a shot is taken.

Conveniently located sockets make handling easier.

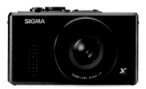

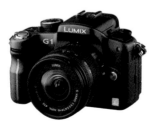

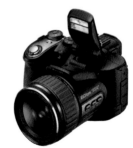

Prime-lens compact
For the enthusiast or purist who does not need a zoom lens, a compact such as this model, with a fixed zoom (28 mm or 35 mm equivalent), may be a good option. It is easy to operate and places an emphasis on quality of image capture.

Interchangeable-lens compact
This type of camera (and similar ones from Olympus) take interchangeable lenses that fit onto a small body. It uses an LCOS (liquid crystal on silicon) display for a high-quality electronic viewfinder.

High-speed camera
Digital cameras offer increasingly powerful speed and video features. This model (and others similar) can shoot 6 MP still images at 60 frames per second and standard-definition video at up to 1,000 frames per second.

Choosing a digital camera continued

Entry-level dSLRs

The entry-level dSLR (digital single lens reflex camera) is another type of prosumer camera in that it is capable of professional-quality results but is built to offer many features at low cost. All dSLR manufacturers contribute to this sector, including Nikon, Canon, Sony, Pentax/Samsung, Panasonic/Leica, Olympus, and Sigma. These cameras will accept most, if not all, of the lenses and accessories that can be used on larger SLRs but are smaller, lighter, and generally offer lower specifications than their professional equivalents.

However, they may offer more modern features, such as live view (*see box, opposite*). These cameras make good backups to professional gear. The majority of cameras use APS-C–sized sensors, giving a focal length factor of around 1.5x the 35 mm equivalent.

Professional dSLRs

There is no clear line between entry-level dSLR and professional-level, as different models are used by both amateur and professional photographers. The larger cameras—such as the EOS-1 series

Digital SLR

Some fully interchangeable SLR cameras are significantly smaller than EVF cameras with fixed lenses. Models such as this offer good image quality with APS-sized chips of 10 or more megapixels, rapid response, and a versatility available only to cameras with interchangeable lenses.

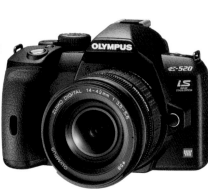

Pentaprism cover conceals a pop-up flash unit.

Interchangeable lenses give optimum versatility.

Rapid-fire shutters help capture fleeting moments.

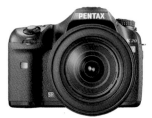

Enthusiast camera

Easily capable of professional-quality results and incredibly good value for money, these models offer 15 MP or greater resolution, 6 frames per second motor drive, live view on large displays, and sensitivities that reach ISO 12,800.

Image-stabilized camera

Some high-resolution cameras have image stabilization built into the body, rather than into the lens. The advantage of this is that any lens fitted to the body is image-stabilized, leading to a higher percentage of sharp images.

Semiprofessional camera

Affordable semipro models can be built to high standards, with dust sealing and solid construction. Some models may also offer built-in image stabilization and high-grade image processing, which makes them excellent value for money.

from Canon, the D3 series from Nikon, and certain models from Sony and Olympus—are designed for the professional. This involves high-specification shutters, a sturdy build, seals against dust and moisture, as well as a superior quality of viewfinder and features. Some cameras use a full-frame, 36 x 24 mm sensor; others use smaller ones, with resolutions ranging from 10 MP to 25 MP or more, depending on whether the emphasis is on quality or speed of operation. The Leica M8 is exceptional in offering professional-grade images using manual focusing through a rangefinder.

Top-level dSLRs

At the top of the digital photography world are the medium-format cameras, which combine a medium-format back with a large sensor—more than twice the size of a full-frame dSLR sensor. Resolutions range from 22 MP to extremely high figures of 60 MP and even greater. These cameras, from Sinar/Rollei/Leaf, Hasselblad, and Mamiya/Phase One are built to extremely exacting standards and employ supremely high-quality lenses—some matched by software to the cameras—but they cost several times more than the most costly full-frame dSLRs.

Live view

The normal way to view through a dSLR is to examine the image reflected onto the focusing screen by the mirror. In some models, you can view the image via the LCD display, just like using a compact camera: this is called live view, and it gives you more viewing options. To enable this, either the mirror is raised and shutter opened to allow light to fall on the sensors, or the focusing screen image is reflected onto a sensor. Depending on the model, the LCD screen may be fixed in position or, as shown, can be tilted.

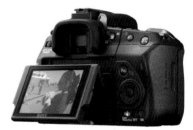

Live viewfinder
The most convenient displays are mounted on a flip-out panel that allows you to vary the angle and therefore hold the camera in different positions.

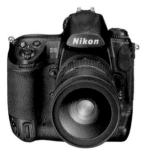

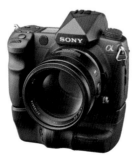

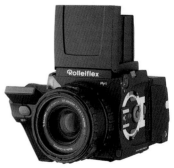

Professional camera
Models that are built for rigorous work are well sealed against dust and moisture, solidly constructed, and also respond very quickly with rapid motor-drive and autofocusing. However, the end result is large, heavy cameras.

High-resolution, full-frame
Sensor sizes of 24 x 36 mm allow the widest-angle photography with 35 mm format lenses. Coupled with resolutions of 24 MP or more, image stabilization, and rapid responses, the package appeals to both enthusiasts and professionals.

Medium-format digital
For the most demanding photography, medium-format lenses and large sensors with resolutions of 37 MP or greater are the solution. The results can be stunning, but they require great skill and high computing power to achieve.

Accessories

Carefully chosen accessories can make a big difference to the quality and enjoyment of your photography. It is tempting to load up with numerous accessories, but too many items can slow you down more than they aid you.

Tripods

Tripods can make the biggest single contribution to improving the technical quality of your photography. The best are heavy, large, and rigid, while small, lightweight ones can be next to useless. As a rough guide, a tripod should weigh twice as much as the heaviest item you put on it.

For the best balance between weight and stability, look for a tripod made from carbon fiber. Those that telescope with three or more sections are more compact when folded but less rigid than those with fewer sections. Collars that twist to lock a section are compact but slower to use than lever locks. A good, less-expensive compromise is a tripod made from aluminum alloy. Very small tabletop tripods are handy for steadying the camera, and shoulder stocks, which enable you to brace the camera against your shoulder, can help reduce camera shake.

The choice of tripod head is as important as the choice of tripod itself. Choose one that is quick and easy to use but that holds the camera firmly. Ball-and-socket heads are quick to adjust but difficult to use with heavy equipment, while 3-D heads are easy to adjust with fair precision but are slower to operate than ball-and-socket heads. The slowest heads to operate are the geared type, but precision adjustment is very easy. For extremely heavy lenses, use center-of-gravity pivots such as the Wimberley head. Attach the camera to the head with a quick-release mount, as these are most convenient. However, when a mount is attached, it makes it more awkward to handle the camera.

Exposure meters

While almost all cameras made today have built-in exposure meters, handheld meters are still the best way to make incident-light readings (of the light falling on the subject). Some handheld

Tripods
Although often bulky and heavy, a tripod is simply the best way to ensure that images are free from camera shake. Carbon-fiber models are expensive but lighter than metal types.

3-D tripod head
For the flexible control of a heavy camera, a tripod head that adjusts in three directions is best.

Ball-and-socket head
Compact and lightweight, this type of tripod head is ideal for travel photography.

Wimberley head
An off-axis head balances heavy extreme-telephoto lenses around their center of gravity, making it easier to line up shots.

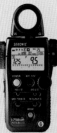

Combined exposure meter
Professional exposure meters can measure flash as well as ambient light and accept a range of accessories.

Spot meter
For the most precise measurement of light, a hand-held spot meter is needed.

Simple meter
A simple exposure meter is excellent for checking camera performance and in teaching you to judge lighting by eye.

Camera bag
Traditional-style bags or backpack designs are useful for carrying and organizing your equipment.

Camera case
Rigid cases can be waterproof and provide sturdy protection for rough conditions, but they may be very heavy even when empty.

Waterproof housing
Inexpensive plastic housings allow you to use your digital camera for underwater photography.

meters also offer far greater accuracy, especially in low-light conditions. And spot meters, which read reflected light from a very narrow field of view—commonly 1° or less—offer unsurpassed accuracy in tricky lighting.

Flash meters are designed to measure electronic flash exposures. Most modern handheld meters can measure flash exposures as well as ambient light and, indeed, indicate the balance between the two. A flash meter is an essential accessory for serious still-life and portrait work.

Bags
Modern, padded soft bags combine high levels of protection with lightweight construction: those from Lowepro, Think Tank, Tamrac, Tenba, Domke, and Billingham will all give excellent service for many years.

For carrying heavy loads over long distances, the backpack design puts the least stress on your back, but accessing equipment is slow. Bags slung over the shoulder are quick and easy to use but can strain the back. A good compromise is a shoulder bag with waist-strap, so that some weight is carried on the hips.

For work in highly challenging conditions, or if you fear your precious lenses and laptop might have to travel in cargo holds or be slung into the backs of overlander trucks, a hard case with waterproof and dustproof seal—such as a Pelican Case—is essential. However, even when empty they are heavy, so expect to have to pay excess-baggage charges.

Waterproofing
A waterproof camera housing is needed in situations such as shooting from a canoe or when sailing—not just if total immersion is likely. Camera housings are also ideal for particularly dusty conditions, such as industrial sites and deserts. Housings vary from flexible plastic cases for shallow water, to sturdy cases for deep water. They are available for compact cameras through to professional models, but they may cost at least as much as the camera they protect.

Digital accessories

The modern digital camera has to work with a retinue of digital accessories to ensure that it is powered and has the capacity to record images.

Memory cards

Memory cards use banks of memory registers that hold their state—on or off—without needing power. They can hold data indefinitely yet can easily write new or altered data. Their compact size, low power requirements, and large capacity make them ideal for image data. When an image is written to them, the registers are flipped on or off according to the data. To read the memory, the registers are turned into a stream of data. Modern cards can hold more than 16 GB of information and read or write 300x faster than a standard CD.

There are many card types in circulation: some are extra-compact for use in cell phones, others are optimized for speed or sturdiness. If you own more than one camera or want to use another device, try to ensure intercompatibility.

CompactFlash

The most widely used memory card for digital photography is the CompactFlash. All cards have to be slotted into the camera so that recorded

Using the memory card
Memory cards are easily replaced in a camera, but do not try to change cards when the camera is reading from or writing to the card—usually a light warns you when the card is in use.

images can be saved onto them. You can remove the card at any stage before it is full and slot it into a reader to transfer files to a computer, but do not remove it while the camera is trying to read the card, usually indicated by a red light. You can also erase images at any time to make room for more.

Digital image storage

When traveling with a digital camera it is often impractical, and always inconvenient, to carry a laptop computer for storing image files. One

CompactFlash
Very widely used in dSLR cameras and others, this is a sturdy card in a range of capacities, up to at least 32 GB, and speeds to suit different budgets.

Secure Digital (SD)
Very widely used in compact and dSLR cameras, SD (and SDHC) cards are very small yet offer capacities as high as 32 GB with low draw on current. They are also sturdy, both electrostatically and physically.

Micro SD
These cards are widely used in cell-phone cameras and offer capacities up to 8 GB. Via an adaptor, they can also be used in devices that take the larger Mini SD and SD cards.

xD-Picture Card
These very small cards with capacities up to 8 GB offer good performance with low power consumption but are not widely supported. Proprietary to Olympus and Fujifilm.

MemoryStick
Proprietary to Sony, this family of cards is used in a variety of digital equipment, including Sony video cameras, allowing interchange with good capacities and performance.

option is what is essentially a portable hard-disc equipped with an LCD screen and card-reading slots. The screen may be color for reviewing images on the device, or it may simply show the copying status and basic file data. Some of these units can hold more than 100 GB of data and are equipped with slots for reading memory card devices. Data can be copied straight from the card devices onto the drive, then the drive can be connected to your computer to transfer your images once you are back at home.

Card care

- Keep memory cards far away from magnetic fields, such as television monitors, audio speakers, and so on.
- Keep cards dry.
- Keep cards dust-free.
- Keep cards in protective cases when not in use.
- Do not bend or flex cards.
- Avoid touching the contacts with your fingers.

Memory card readers

There are two ways of transferring images taken on your digital camera to your computer. You can connect the camera to your computer and instruct the camera's software to download images, or you can take the memory card out of the camera and read it to the computer. To do this, you need a memory card reader, a device with circuitry to take the data and send it to the computer, via a USB, USB 2.0, or FireWire cable—the latter two transmit data fastest. There are many card readers on the market that can read almost every type of memory card.

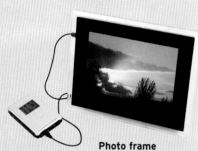

Photo frame
These devices display a single image or a slide show of images downloaded from a memory card or picture store. Useful in store displays and gallery exhibitions.

Mobile storage
Freeing you from taking a computer outdoors, these small hard-disc drives allow you to back up photos and so continue using your memory cards. They also allow you to review and show images as you shoot.

USB drive
A most convenient way to transfer quantities of files from one machine to another, USB drives are solid-state memory devices with impressive storage capacities.

Multitype card reader

Using a reader
When slotted in, the reader opens the card as a volume or disc. You can then copy images straight into the computer.

CompactFlash card reader

Portable flash

The invention of portable flash had a tremendous impact on photography: it opened the night world to the camera, with compact, easily carried equipment. Today, electronic flash is standard to all compact digital cameras, even to cell-phone cameras, and can even be found on most dSLR cameras. So what is the need for portable flash? (*See also pp. 48–9 for use of flash.*)

Power and recycling
Flash built into a camera relies on the camera's own batteries for power. To curb their hunger for energy, built-in flashes are designed to be low-powered—usually sufficient to light to a distance of 3–7 ft(1–2 m) but little farther. In addition, the recycling rates—how quickly the flash can be fired in sequence—is also limited. Overenthusiastic use of built-in flash can render the camera literally powerless to work.

Flash power
Portable, or accessory, flash units overcome the limitations of built-in flash by carrying their own power and circuitry; this makes the units much larger than compact cameras. Accessory flash

units also offer more control over flash power, direction of flash, and angle of coverage.

Accessory flashes fit onto the hot shoe, which combines electrical contacts with a slot that "mates" with a corresponding, locking part on the bottom of the flash unit. While the majority of cameras use a standard hot-shoe design, the contacts may be specific to the camera producer, and some manufacturers—such as Sony—use proprietary hot-shoe designs.

Adjustable angle
Many portable flash units place the flash on a swiveling turret so that it can be directed to the sides, or even backward, according to the nearest surface for bounce flash (*see pp. 51 and 127*). Some offer a tilting head so that you can point the flash upward, or downward for close-up work. A fully adjustable head increases flexibility, so is a must for wedding and paparazzi photography.

Adjustable coverage
On many flash units you can also adjust the coverage, or the angle over which light is spread. This ensures that when you use a wide-angle lens

Small supplementary flash
Units like this can augment the power of built-in flash units. It is triggered by the camera's own flash and adds its output to that of the camera's unit. It is an inexpensive solution to lighting problems, but control is limited.

Slave flash unit
Slave units can add to the power of built-in flash units. This unit synchs with the on-camera flash for the most accurate exposure, after which operation is fully automatic. Position it to one side of the camera to control lighting direction.

Powerful on-camera flash
Accessory flash mounted on a camera's hot shoe can be sufficiently powerful for all normal needs, offering a tilt-and-swivel head for bounce, multiple-exposure facilities, and focusing aids for working in complete darkness.

or setting, the flash coverage is sufficient to light the angle of view: this causes a lowering in the maximum power of the flash. When you make a telephoto setting or use a long focal length lens, the coverage is narrowed to match, approximately, the angle of view. This causes a gain in the maximum power of the flash, since the light is concentrated into a narrower beam.

Adjustment may be carried out automatically, with the camera instructing the flash according to the zoom setting on the lens, or it can be manually set. Zoomlike optics in the flash tube alter coverage, and a diffuser may be used for ultra-wide-angle coverage.

Red-eye

The unsightly red dot in the middle of eyes lit by flash—commonly known as red-eye—is caused by two factors: the flash being so close to the optical axis that the light reflects off the blood-rich retina of the eye, while, at the same time, the eye's pupil is dilated in dark conditions. Accessory flash mounted on the hot shoe or to one side moves the source of flash relatively far from the optical axis, with the result that red-eye is avoided.

Guide Number

The light output of accessory flash units is usually measured by the Guide Number (GN). The figure is for a specific film/sensor speed—usually ISO 100—in either feet (ft) or meters (m), and for a specified angle of coverage. The GN for a unit will be higher for narrow coverage—suitable for medium-telephoto lenses—and lower for wide coverage—suitable for wide-angle lenses. A Guide Number may be quoted as, for example, GN45 (m), indicating the distance scale is meters. A typical small camera GN is 5–10 (m); accessory flash units offer 30–50 (m). The standard practice is that that the GN figure is quoted for the coverage of a standard lens but may be inflated in specifications by being quoted for a narrow coverage. The Guide Number scale is defined:

Guide Number = subject distance x f/number

The f/number for a correct exposure is the result of dividing the GN of your unit by the distance between the flash/camera and the subject. Using GN to set an f/number is generally more accurate than relying on automatic systems.

Macro ring-flash
For shadowless flash photography of insects, flowers, and other small objects, a ring-flash is ideal. The brief flash can stop inadvertent movement, and very small apertures can be set for maximum depth of field.

Adjustable macro flash
For controlled lighting in macro work, units with two or more small flash units that can be set to different positions around the lens give the most flexibility. They can be set to different power levels and point in different directions.

Powerful handle-bar unit
Units designed around a large handle offer great power output and high endurance. They also have many other functions, such as adaptors for dedicated operation, zoom reflector, and modeling light, as well as rapid firing rates.

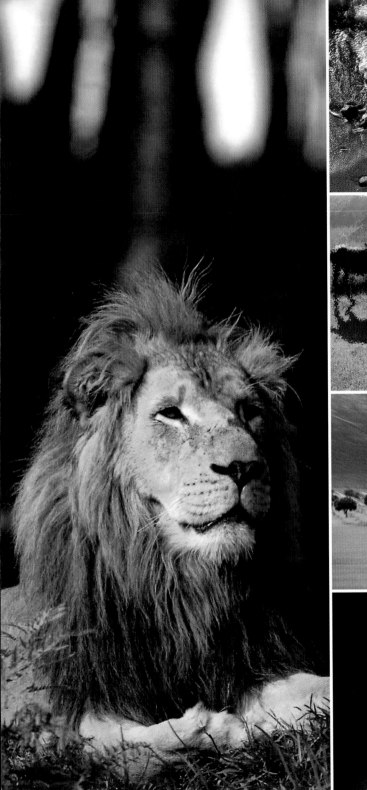

Glossary

133x speed The device reads or writes data at 133x the data rate of CDs or 150 KB per second (and similar figures, such as 24x, 48x, etc).

24-bit A color image made up of 8-bit color over three color channels.

6,500 The white balance standard corresponding to normal daylight. It appears to be a warm white compared with 9,300.

9,300 The white balance standard close to normal daylight.

A

aberration In optics, a defect in the image caused by a failure of a lens system to form a perfect image.

aberration, chromatic An image defect that shows up as colored fringes when a subject is illuminated by white light, caused by the dispersion of white light as it passes through the glass lens elements.

absolute colorimetric A method of matching color gamuts that tries to preserve color values as close to the originals as possible.

achromatic color Color that is distinguished by differences in lightness but is devoid of hue, such as black, white, or grays.

ADC Analogue-to-Digital Conversion. A process of converting or representing a continuously varying signal into a set of digital values or code.

additive color synthesis Combining or blending two or more colored lights in order to simulate or give the sensation of another color.

addressable The property of a point in space that allows it to be identified and referenced by some device, such as an inkjet printer.

addressable The property of a point in space that allows it to be identified and referenced by some device, such as an inkjet printer.

alias A representation, or "stand-in", for the continuous original signal: it is the product of sampling and measuring the signal to convert it into a digital form.

alpha channel A normally unused portion of a file format. It is designed so that changing the value of the alpha channel changes the properties—transparency/opacity, for example—of the rest of the file.

antialiasing Smoothing away the stair-stepping, or jagged edge, in an image or in computer typesetting.

aperture The size of the hole in the lens that is letting light through. *See* f/numbers.

apps A commonly used abbreviation for application software.

aspect ratio The ratio between width and height (or depth).

B

back up To make and store second or further copies of computer files to protect against loss, corruption, or damage of the originals.

bicubic interpolation A type of interpolation in which the value of a new pixel is calculated from the values of its eight near neighbors. It gives superior results to bilinear or nearest-neighbor interpolation, with more contrast to offset the blurring induced by interpolation.

bilinear interpolation A type of interpolation in which the value of a new pixel is calculated from the values of four of its near neighbors: left, right, top, and bottom. It gives results that are less satisfactory than bicubic interpolation, but requires less processing.

bit The fundamental unit of computer information. It has only two possible values—1 or 0—representing, for example, on or off, up or down.

bokeh The subjective quality of an out-of-focus image projected by an optical system—usually a photographic lens.

bracketing To take several photos of the same image at slightly different exposure settings, to ensure at least one picture is correctly exposed.

brightness *1* A quality of visual perception that varies with the amount, or intensity, of light that a given element appears to send out, or transmit. *2* The brilliance of a color, related to hue or color saturation—for example, bright pink as opposed to pale pink.

brightness range The difference between the lightness of the brightest part of a subject and the lightness of the darkest part.

Brush An image-editing tool used to apply effects, such as color, blurring, burn, or dodge, that are limited to the areas the brush is applied to, in imitation of a real brush.

buffer A memory component in an output device, such as printer, CD writer, or digital camera, that stores data temporarily, which it then feeds to the

Glossary continued

device at a rate the data can be turned into, for example, a printed page.

burning-in A digital image-manipulation technique that mimics the darkroom technique of the same name.

C

C An abbreviation for cyan. A secondary color made by combining the two primary colors red and blue.

calibration The process of matching characteristics or behavior of a device to a standard.

camera exposure The total amount of the light reaching the sensors. It is determined by the effective aperture of the lens and the duration of the exposure to light.

catch light A small, localized highlight.

CCD Charge Coupled Device. A semiconductor device used as an image detector.

chroma The color value of a given light source or patch. It is approximately equivalent to the perceived hue of a color.

CIE LAB A color model in which the color space is spherical. The vertical axis is L for lightness (for achromatic colors) with black at the bottom and white at the top. The a axis runs horizontally, from red (positive values) to green (negative values). At right-angles to this, the b axis runs from yellow (positive values) to blue (negative values).

clipboard An area of memory reserved for holding items temporarily during the editing process.

CMOS Complementary Metal Oxide Semiconductor. Type of image detector used in digital cameras.

CMYK Cyan Magenta Yellow Key. The first three are the primary colors of subtractive mixing. For good-quality blacks, it is necessary to use a separate black, or key, ink.

cold colors A subjective term referring to blues and cyans.

colorize To add color to a grayscale image without changing the original lightness values.

ColorSync A proprietary color-management software system.

color Denoting the quality of the visual perception of things seen, characterized by hue, saturation, and lightness.

color cast A tint or hint of a color that evenly covers an image.

color gamut The range of colors that can be reproduced by a device or reproduction system.

color management The process of controlling the output of all the devices in a production chain to ensure that the final results are reliable and repeatable.

color picker The part of an operating system (OS) or application that enables the user to select a color for use—as in painting, for example.

color profile The way one device—screen, scanner, printer, etc—handles color as defined by the differences between its own set of colors and that of the profile connection space.

color space Defines a range of colors that can be reproduced by a given output device or be seen by the human eye under certain conditions.

color temperature The measure of color quality of a source of light, expressed in degrees Kelvin.

complementary colors Pairs of colors that produce white when added together as lights.

compositing A picture-processing technique that combines one or more images with a basic image. Also known as montaging.

compression *1* A process by which digital files are reduced in size by changing the way the data is coded. *2* A reduction in tonal range.

contrast *1* Of ambient light: the brightness range found in a scene. In other words, the difference between the highest and lowest luminance values. High contrast indicates a large range of subject brightnesses. *2* Of color: colors positioned opposite each other on the color wheel are regarded as contrasting—for example, blue and yellow, green and red.

copyright Rights that subsist in original literary, dramatic, musical, or artistic works to alter, reproduce, publish, or broadcast. Artistic works include photographs—recordings of light or other radiation on any medium on which an image is produced or from which an image may by any means be produced.

crop To use part of an image for the purpose of, for example, improving composition or fitting an image to the available space or format.

curve A graph relating input values to output values for a manipulated image.

cut and paste To remove a selected part of a graphic, image, or section of text from a file and store it temporarily in a clipboard ("cutting") and then to insert it elsewhere ("pasting").

cyan The color blue-green. It is a primary color of subtractive mixing or a secondary color of additive mixing. Also, the complementary to red.

D

D65 The white illuminant standard used to calibrate monitor screens. It is used primarily for domestic television sets.

definition The subjective assessment of clarity and the quality of detail that is visible in an image or photograph.

delete *1* To render an electronic file invisible and capable of being overwritten. *2* To remove an item, such as a letter, selected block of words or cells, or a selected part of a graphic or an image.

density *1* The measure of darkness, blackening, or "strength" of an image in terms of its ability to stop light—in other words, its opacity. *2* The number of dots per unit area produced by a printing process.

depth *1* The sharpness of an image—loosely synonymous with depth of field. *2* A subjective assessment of the richness of the black areas of a print or transparency.

depth of field The measure of the zone or distance over which any object in front of a lens will appear acceptably sharp. It lies both in front of and behind the plane of best focus, and is affected by three factors: lens aperture; lens focal length; and image magnification.

display A device—such as a monitor screen, LCD projector, or an information panel on a camera—that provides a temporary visual representation of data.

distortion, tonal A property of an image in which the contrast, range of brightness, or colors appear to be markedly different from that of the subject.

dithering Simulating many colors or shades by using a smaller number of colors or shades.

d-max The measure of the greatest, or maximum, density of silver or dye image attained by a film or print in a given sample.

dodging A digital image-manipulation technique for controlling local contrast by selectively lightening an area that would otherwise be too dark.

dpi Dots per inch. The measure of resolution of an output device as the number of dots or points that can be addressed or printed by that device.

duotone A mode of working in image-manipulation software that simulates the printing of an image with two inks.

dynamic range *1* The measure of spread of the lowest to the highest energy levels in a scene. *2* The range that can be captured by a device, such as a camera or scanner.

E

electronic viewfinder (EVF) An LCD or LCOS screen, viewed under the eyepiece and showing the view through a camera lens.

enhancement *1* Change in one or more qualities of an image, such as color saturation or sharpness, in order to improve its appearance or alter some other visual property. *2* The effect produced by a device or software designed to increase the apparent resolution of a TV monitor screen.

erase To remove, or wipe, a recording from a disk, tape, or other recording media (usually magnetic) so that it is impossible to reconstruct the original record.

exposure *1* A process whereby light reaches light-sensitive material or sensor to create a latent image. *2* The amount of light energy that reaches a light-sensitive material.

F

f/numbers Settings of the lens diaphragm that determine the amount of light transmitted by it. Each f/number is equal to the focal length of the lens divided by diameter of the entrance pupil.

fall-off The loss of light in the corners of an image as projected by a lens system.

feathering The blurring of a border or boundary by reducing the sharpness or suddenness of the change in value of, for example, color.

file format A method of organizing or structuring computer data. File formats may be generic—shared by different software—or native to a specific software application.

fill-in *1* To illuminate shadows cast by the main light by using another light source or reflector to bounce light from the main source into the shadows. *2* A light used to brighten or illuminate shadows cast by the main light. *3* In image manipulation, to cover an area with color—as achieved by using a Bucket tool.

filter *1* An optical accessory used to remove a

Glossary continued

certain waveband of light and transmit others.
2 Part of image-manipulation software written
to produce special effects.

FireWire A standard providing for rapid
communication between computers and devices.
Also known as IEE 1394 or iLink.

fixed focus A type of lens mounting that fixes a
lens at a set distance from the film. This distance
is usually the hyperfocal distance. For normal to
slightly wide-angle lenses, this is at between 6½
and 13 ft (2 and 4 m) from the camera.

flash *1* To provide illumination using a very brief
burst of light. *2* The equipment used to provide
a brief burst, or flash, of light.

flatten To combine multiple layers and other
elements of a digitally manipulated or composited
image into one.

focal length For a simple lens, the distance
between the center of the lens and the sharp
image of an object at infinity projected by it.

G

gamma In monitors, a measure of the correction
to the color signal prior to its projection on
the screen.

graphics tablet An input device allowing fine or
variable control of the image appearance in an
image-manipulation program.

grayscale The measure of the number of
distinct steps between black and white that
can be recorded or reproduced by a system.

H

halftone cell The unit used by a halftone
printing or reproduction system to simulate a
grayscale or continuous-tone reproduction.

HDR High Dynamic Range. An image created by
blending two or more differing exposures of the
same scene in order to enable one image to
capture the scene's dynamic range.

highlights The brightest (whitest) values in an
image or image file.

histogram A graphical representation showing the
relative numbers of variables over a range of values.

hue The name given to the visual perception of
a color.

I

IEEE 1394 *see* Firewire

image aspect ratio The comparison of the depth
of an image to its width.

interpolation The insertion of pixels into a digital
image based on existing data. It is used to resize
an image file, for example, to give an apparent
increase in resolution, to rotate an image, or to
animate an image.

ISO International Organization for Standardization.
Scale of sensitivity of digital cameras.

J K

jaggies The appearance of stair-stepping artifacts.

JPEG Joint Photographic Expert Group. A data-
compression technique that reduces file sizes with
loss of information.

k *1* An abbreviation for kilo, a prefix denoting
1,000. *2* A binary thousand: in other words
1024, as used, for example, when 1024 bytes
is abbreviated to KB.

key tone *1* The black in a CMYK image. *2* The
principal or most important tone in an image,
usually the midtone between white and black.

L

layer mode An image-manipulation technique
that determines the way that a layer combines
with the layer below.

lightness The amount of white in a color.
This affects the perceived saturation of a
color: the lighter the color, the less saturated
it appears to be.

lossless compression A computing routine, such
as LZW, that reduces the size of a digital file
without reducing the information in the file.

lossy compression A computing routine, such as
JPEG, that reduces the size of a digital file but
also loses information or data.

lpi Lines per inch. A measure of resolution or
fineness of photomechanical reproduction.

M

macro The close-up range giving reproduction
ratios within the range of about 1:10 to 1:1 (life-
size).

marquee A selection tool used in image-
manipulation and graphics software.

mask A technique used to obscure selectively or
hold back parts of an image while allowing other
parts to show.

megapixel A million pixels. A measure of the resolution of a digital camera's sensor.

monochrome An image made up of black, white, and grays, which may or may not be tinted.

N

nearest neighbor The type of interpolation in which the value of the new pixel is copied from the nearest pixel.

noise Unwanted signals or disturbances in a system that tend to reduce the amount of information being recorded or transmitted.

O

opacity The measure of how much can be "seen" through a layer.

out-of-gamut The color or colors that cannot be reproduced in one color space but are visible or reproducible in another.

output A hard-copy printout of a digital file, such as an inkjet print or separation films.

P

paint To apply color, texture, or an effect with a digital Brush or the color itself.

palette *1* A set of tools, colors, or shapes that is presented in a small window of a software application. *2* The range or selection of colors available to a color-reproduction system.

pixel The smallest unit of digital imaging used or produced by a given device. An abbreviation of "picture element".

pixelated The appearance of a digital image whose individual pixels are clearly discernible.

plug-in Application software that works in conjunction with a host program into which it is "plugged".

posterization The representation of an image using a relatively small number of different tones or colors.

ppi Points per inch. The number of points seen or resolved by a scanning device per linear inch.

primary color One of the colors (red, green, or blue) to which the human eye has peak sensitivity.

prime lens A fixed focal length lens, in contrast to a zoom lens.

proofing The process of checking or confirming the quality of a digital image before final output.

R

raw Image file produced by camera with minimum amount of processing.

resize To change a file's resolution or size.

RGB Red Green Blue. A color model that defines colors in terms of the relative amounts of red, green, and blue components they contain.

S

shutter lag Time between pressing a shutter button fully and the exposure being made.

shutter time Duration of exposure of film or sensor to light.

soft proofing The use of a monitor screen to proof or confirm the quality of an image.

stair-stepping A jagged or steplike reproduction of a line or boundary that is, in fact, smooth.

subtractive color synthesis Combining of dyes or pigments to create new colors.

T

thumbnail The representation of an image in a small, low-resolution version.

TIFF A widely used image file format that supports up to 24-bit color per pixel. Tags are used to store such image information as dimensions.

transparency The degree to which background color can be seen through the foreground layer.

U V W Z

USB Universal Serial Bus. A standard for connecting peripheral devices.

USM UnSharp Mask. An image-processing technique that has the effect of improving the apparent sharpness of an image.

vignetting *1* A defect of an optical system in which light at the edges of an image is cut off or reduced. *2* Deliberately darkened corners—used to help frame an image or soften the frame outline.

warm colors A subjective term referring to reds, oranges, and yellows.

watermark *1* A mark left on paper to identify the maker or paper type. *2* An element in a digital image file used to identify the copyright holder.

zoom *1* Type of lens that can vary its focal length (field of view) without changing the focus. *2* To change the magnification for onscreen viewing.

Index

Index continued

Acknowledgments

Author's acknowledgments

My first thanks go to Judith More for commissioning this book, and secondly to Nicky Munro for her careful revision and editing of this edition. Principally, my thanks go to the thousands of readers of earlier editions who have enabled us to produce a new edition that is up-to-date and responds to readers' comments to ensure the book continues to be a helpful and valued resource.

Comments on the book sent by email will be most gratefully received at info@tomang.com

Tom Ang

London 2010

Publisher's acknowledgments

First edition produced by: **Senior Editor:** Neil Lockley; **Project Editor:** Richard Gilbert; **Senior Art Editors:** Kevin Ryan, Alison Shackleton; **Project Art Editor:** Jenisa Patel; **DTP Designers:** Sonia Charbonnier, Vânia Cunha, Adam Shepherd; **Picture Research:** Anna Bedewell, Samantha Nunn, Carlo Ortu; **Picture library:** Richard Dabb; **Production Controllers:** Heather Hughes, Tony Phipps; **Managing Editors:** Sharon Lucas, Adèle Hayward; **Managing Art Editor:** Karen Self; **Art Director:** Carole Ash.

Dorling Kindersley would like to thank the following for their contributions to this edition: **Designer:** Katie Eke; **Jacket Designer:** Duncan Turner; **Production Editor:** Kavita Varma; **Indexer:** Sue Bosanko.

Picture credits

All photographs: © Tom Ang. All other images © Dorling Kindersley. For further information see www.dkimages.com

The publisher would like to thank the following for their kind assistance and for permission to reproduce their photographs:

Adobe Inc, Louise Ang, Apple, Aquapac International Ltd, Belkin Components Ltd, M Billingham & Co Ltd, Bite Communications Ltd, Blitz PR, Broncolor, Calumet International, Canon UK Ltd, Casio UK, Centon, ColorVision Europe, Companycare Communications, Compaq UK, Contax, Corel, Andy Crawford, Epson UK, Extensis, Firefly Communications, Fuji, Fujifilm UK, FutureWorks, Inc, Gateway, Goodmans Industries Ltd, Gossen, Wendy Gray, Hasselblad, Heidelberg USA, Hewlett-Packard, IBM, Ilford Imaging UK Ltd, Iomega, JASC, Johnsons Photopia Ltd, Kodak, LaCie, Leica, Lexar, Lexmark, Logitech Europe SA, Lowepro UK Ltd, Macromedia Europe, Mamiya, Manfrotto, Megavision, Mesh, Metz, Micron, Microsoft, Microtek, Mitsubishi, Nikon UK Ltd, Nixvue Systems, Nokia, Olympus UK Ltd, Packard Bell, Panasonic Industrial Europe Ltd, Peli Cases, Pentax UK Ltd, Phillips, Ricoh EPMMC UK, Rollei, Roxio, Sigma Corporation, Smartdisk Europe, Sony United Kingdom Ltd, Tamrom UK, Tenba Quality Cases, Tokina, Ulead, Umax, Wacom.

Jacket picture credits

Front and spine: Corbis. Back: All images Tom Ang.